THE SOCIAL HISTORY OF ROMAN ART

The character of Roman art history has changed in recent years. More than ever before, it is concerned with the role of art in ancient society, including the functions that it served and the values and assumptions that it reflects. At the same time, images have become centrally important to the study of ancient history in general. This book offers a new, critical introduction to Roman art against the background of these developments. Focusing on selected examples and themes, it sets the images in context, explains how they have been interpreted, and explodes some of the modern myths that surround them. It also explores some of the problems and contradictions that we face when we try to deal with ancient art in this manner. From wall-paintings to statues, from coins to the gravestones, this is a lucid and often provocative reappraisal of the world of Roman images.

PETER STEWART is Senior Lecturer in Classical Art and its Heritage at the Courtauld Institute of Art, London. His previous publications include *Statues in Roman Society: Representation and Response* (2003) and *Roman Art* (2004).

KEY THEMES IN ANCIENT HISTORY

EDITORS

P. A. Cartledge
Clare College, Cambridge

P. D. A. Garnsey
Jesus College, Cambridge

Key Themes in Ancient History aims to provide readable, informed and original studies of various basic topics, designed in the first instance for students and teachers of Classics and Ancient History, but also for those engaged in related disciplines. Each volume is devoted to a general theme in Greek, Roman, or where appropriate, Graeco-Roman history, or to some salient aspect or aspects of it. Besides indicating the state of current research in the relevant area, authors seek to show how the theme is significant for our own as well as ancient culture and society. By providing books for courses that are oriented around themes it is hoped to encourage and stimulate promising new developments in teaching and research in ancient history.

Other books in the series

Death-ritual and social structure in classical antiquity, by Ian Morris
978 0 521 37465 1 (hardback) 978 0 521 37611 2 (paperback)

Literacy and orality in ancient Greece, by Rosalind Thomas
978 0 521 37346 3 (hardback) 978 0 521 37742 3 (paperback)

Slavery and society at Rome, by Keith Bradley
978 0 521 37287 9 (hardback) 978 0 521 37887 1 (paperback)

Law, violence, and community in classical Athens, by David Cohen
978 0 521 38167 3 (hardback) 978 0 521 38837 5 (paperback)

Public order in ancient Rome, by Wilfried Nippel
978 0 521 38327 1 (hardback) 978 0 521 38749 1 (paperback)

Friendship in the classical world, by David Konstan
978 0 521 45402 5 (hardback) 978 0 521 45998 3 (paperback)

Sport and society in ancient Greece, by Mark Golden
978 0 521 49698 8 (hardback) 978 0 521 49790 9 (paperback)

Food and society in classical antiquity, by Peter Garnsey
978 0 521 64182 1 (hardback) 978 0 521 64588 1 (paperback)

Banking and business in the Roman world, by Jean Andreau
978 0 521 38031 7 (hardback) 978 0 521 38932 7 (paperback)

Roman law in context, by David Johnston
978 0 521 63046 7 (hardback) 978 0 521 63961 3 (paperback)

Religions of the ancient Greeks, by Simon Price
978 0 521 38201 4 (hardback) 978 0 521 38867 2 (paperback)

Christianity and Roman society, by Gillian Clark
978 0 521 63310 9 (hardback) 978 0 521 63386 4 (paperback)

Trade in classical antiquity, by Neville Morley
978 0 521 63279 9 (hardback) 978 0 521 63416 8 (paperback)

Technology and Culture in Greek and Roman antiquity, by Serafina Cuomo
978 0 521 81073 9 (hardback) 978 0 521 00903 4 (paperback)

Law and crime in the Roman world, by Jill Harries
978 0 521 82820 8 (hardback) 978 0 521 53532 8 (paperback)

THE SOCIAL HISTORY OF ROMAN ART

PETER STEWART

CAMBRIDGE
UNIVERSITY PRESS

CAMBRIDGE
UNIVERSITY PRESS

University Printing House, Cambridge CB2 8BS, United Kingdom

Cambridge University Press is part of the University of Cambridge.

It furthers the University's mission by disseminating knowledge in the pursuit of education, learning and research at the highest international levels of excellence.

www.cambridge.org
Information on this title: www.cambridge.org/9780521016599

© Cambridge University Press 2008

First published 2008
5th printing 2014

A catalogue record for this publication is available from the British Library

Library of Congress Cataloguing in Publication data
Stewart, Peter, 1971–
The social history of Roman art / Peter Stewart.
p. cm. – (Key themes in ancient history)
Includes bibliographical references and index.
ISBN 978-0-521-81632-8 (hardback : alk. paper) – ISBN 978-0-521-01659-9 (pbk. : alk. paper)
1. Art, Roman. 2. Art and society–Rome. I. Title. II. Series.
N5760.S67 2008
709.37–dc22
2008006273

ISBN 978-0-521-81632-8 Hardback
ISBN 978-0-521-01659-9 Paperback

To Anita

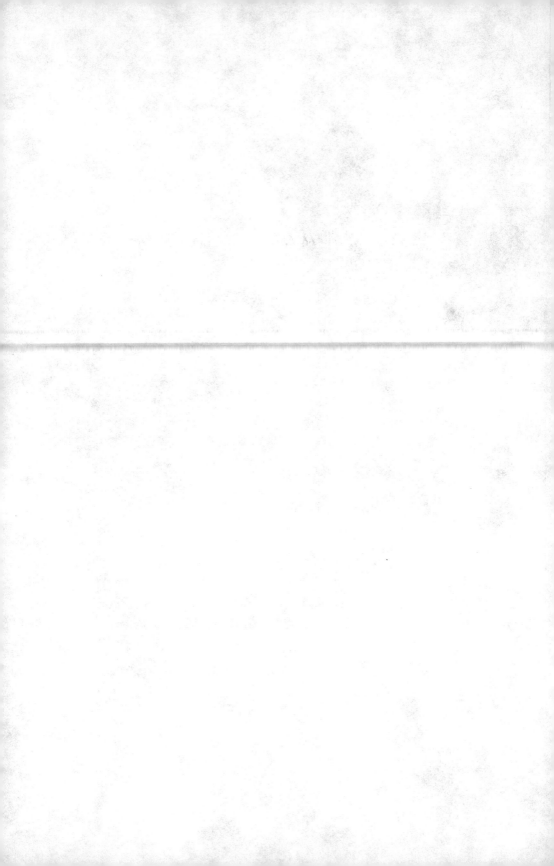

Contents

Figures

Every effort has been made to secure necessary permissions to reproduce copyright material in this work, though in some cases it has proved impossible to contact copyright holders. If any omissions are brought to our notice, we will be happy to include appropriate acknowledgements in any subsequent edition.

Acknowledgements

This book has been long in the writing and would not have been completed without the support and forbearance of Michael Sharp and the academic editors of the Key Themes series. Many other people – more than I could name – have contributed in some way, and I am immensely grateful for the inspiration of colleagues, for past discussions with my MA and doctoral students, for criticism and information from seminar audiences, and not least for the comments of the publisher's anonymous reviewer. Above all, I am grateful to Paul Cartledge and to Jeremy Tanner for reading and advising on drafts of the entire text, and to my wife, Anita, for every kind of support.

Unfortunately, my comments in the Introduction about the problems of acquiring images were borne out in the book's preparation, and I had very considerable difficulties and delays in acquiring most of the images reproduced here. I therefore owe a special debt to those who helped me to obtain pictures, and to those image-providers who waived or reduced reproduction fees. In particular I thank John Clarke, Eleanor Winsor Leach, and Uschi Payne. Acquisition of photographs was also made possible by non-discretionary research funds from the Courtauld Institute of Art.

Abbreviations

AArch	*Acta Archaeologica*
AE	*L'Année épigraphique*
AJA	*American Journal of Archaeology*
AJP	*American Journal of Philology*
AM	*Athenische Mitteilungen (Mitteilungen des Deutschen Archäologischen Instituts. Athenische Abteilung)*
ANRW	*Aufstieg und Niedergang der römischen Welt* (Berlin, 1972–)
CIG	*Corpus Inscriptionum Graecarum* (Berlin, 1828–77)
CIL	*Corpus Inscriptionum Latinarum* (Berlin, 1863–)
ILLRP	A. Degrassi (ed.), *Inscriptiones Latinae Liberae Reipublicae* (Florence, 1957–63)
ILS	H. Dessau (ed.), *Inscriptiones Latinae Selectae* (Berlin, 1892–1916)
JDAI	*Jahrbuch des Deutschen Archäologischen Instituts*
JRA	*Journal of Roman Archaeology*
JRS	*Journal of Roman Studies*
MAAR	*Memoirs of the American Academy in Rome*
MAMA	W. M. Calder et al. (eds.), *Monumenta Asiae Minoris Antiqua*, 8 vols. (Manchester, 1928–62)
NH	*Naturalis Historia*
PBSR	*Papers of the British School at Rome*
PCPhS	*Proceedings of the Cambridge Philological Society (= The Cambridge Classical Journal)*
RM	*Römische Mitteilungen (Mitteilungen des Deutschen Archäologischen Instituts. Römische Abteilung)*
TAPhA	*Transactions of the American Philological Association*
ZPE	*Zeitschrift für Papyrologie und Epigraphik*

Introduction

> The art of the Roman period, like Greek art, is part of a widely
> disseminated cultural pattern. It is precisely for this reason that the
> underlying historical truths have acquired such a thick incrustation
> of commonplace judgements, affecting the specialist as much as the
> man in the street. R. Bianchi Bandinelli 1970: ix

Thirty years ago, far from constituting a 'key theme', art had a marginal
place in ancient history. Its role was mainly illustrative.[1] Since then the
subject has changed. Increasingly historians of all periods recognise that
images are of the utmost importance as evidence, different from texts, but
deserving equally serious attention. And like historical texts, they are not
merely sources of information, but cultural artefacts and traces: part of the
very fabric of ancient life.[2]

The ancient world is often described as a world of images.[3] This is
partly because of the low level of literacy, which arguably made people
more sensitive to the communicative power of images, and partly because
manufactured imagery was simply everywhere. I am not convinced that
there is a meaningful contrast to be drawn between this ancient 'world of
images' and the modern world, but the basic claim holds true. Images –
including what we call 'art', as well as more humble decorations and
representations – were absolutely ubiquitous. In the Roman empire, for
example, we are potentially dealing with a spectrum of material that
includes coins, frescoes, patches and appliqués on textiles, paintings on
wood, silver cups, mould-made terracotta lamps, carved hairpin heads,
gravestones, military parade helmets, marble busts, monumental reliefs,
ivory boxes, waxworks, stuccoed ceilings, temple friezes, engraved

[1] On the general historical neglect of images, as well as many important exceptions, see Burke 2001:
9–13. Within Roman history, Brown 1971 was a remarkable, early attempt to integrate art fully into
a historical survey.
[2] Burke 2001: 13–14. Cf. Smith 2002, from a classical archaeologist's perspective.
[3] E.g. Elsner 1998b: 11–14. Cf. Stewart 2003: 6–7 with n. 25.

gemstones, gold jewellery, bronze figurines, and very many other, diverse objects.

This book focuses mainly on those works that attract most attention from historians and art historians, especially larger-scale sculptures and paintings; these are regarded as visually most interesting and illuminating, and they were generally more important and prominent in ancient life, a fact attested at the very least by the sheer, disproportionate financial investment that they represent. But I have not hesitated to gather all the images addressed here, both the large and prominent monuments and the more obscure and insignificant objects, under the loose heading of 'art'. That choice maybe requires some explanation, because there is growing dissatisfaction with the very concept of 'art' in the study of classical antiquity, and indeed we shall return later to the consequences that aesthetic assumptions have had for the shape of Roman art history.[4] Scholars point out that the Romans did not have a clear notion of art in the modern sense; they did not see it as an elevated creation, cut off from the mundane practicality of other objects; they did not have the modern concept of 'art for art's sake'; they did not even have a word for art, since the Latin *ars*, like the Greek *tekhne*, refers to all kinds of craft and skill. Roman 'artists' are perhaps often best equated with modern craftsmen, skilled workmen. These objections are largely (though not completely) valid.

There was a notion of something *like* high art in the Roman world. For example, we know that connoisseurs and collectors admired works of sculpture, painting, and gem engraving in much the same terms as modern art-lovers.[5] At times temples and public porticoes housed such works, almost like modern art galleries.[6] But at the same time there is no sharp distinction between these works and more functional, practical images. Indeed, as we shall see later, the works that educated Romans collected and valued were often originally intended to serve rather different purposes, particularly in connection with religion. Many other works were purely functional in one context or another. Nonetheless, one of the interests of a social history of Roman art is precisely to see how the objects that look to us like art related to those that do not; how the ancient aesthetic appreciation of works related to their functions within religion

[4] E.g. Scott 2003. Cf. Burke 2001: 16, insisting on 'images' rather than 'art' and Jordanova 2000: 89, 'Visual culture, like material culture, is a more *historical* category than "Art"'.
[5] Pollitt 1978 (on the 'connoisseur's attitude'); Bartman 1991. Tanner 2006 esp. 246–76 for the intellectual and sociological subtleties of Roman attitudes.
[6] Strong 1973; Pollitt 1978.

or other spheres; how finely made and attractive artefacts merge with those that are so simple, humble, or downright bad, that they normally do not earn the name of art. From the perspective of social history, 'high art' did not belong to a different material and visual world from 'low art' or craft products, any more than 'high literature' can be divorced from amateur verse, letter-writing, inscriptions on stone, and graffiti.

So as it is used here, the word 'art' has to be understood in the broadest sense and without our making unnecessary assumptions about the status, function, or aesthetic value of the works concerned.[7] Perhaps classical art history is well equipped for this approach, for it has traditionally been a sub-discipline of classical archaeology which, in theory at least, concerns itself with all kinds of artefacts and images regardless of merit. Similarly, the ancient historian's approach to ancient art as 'evidence' has the potential to circumvent artificial divisions between art and 'non-art'.

In any case, there is no very good alternative to 'art' as a label for describing the objects with which we are dealing. Some scholars prefer to write of 'material culture', which tends to play down the importance of imagery – of iconography – and its role as a sort of visual language in ancient society.[8] Conversely, to talk of 'visual culture' or 'visual history' is to disembody that visual imagery and to neglect the importance of individual works as material objects, operating in ancient society at particular places and times. Such terminological manoeuvres run the risk of throwing out the baby with the bathwater. They leave an art-shaped hole in the historical discourse. So as far as I am concerned, 'art' it is.[9]

And 'art history' this is – but of a particular kind. The intention of this book is not to tell a story of Roman art, to survey it, or to explain how it emerged and developed. It is not a history of art in that sense. Nor is it primarily about art as historical evidence. It is, rather, a discussion of art in its social context. It is intended both for those whose interest is historical – those who regard art as an unavoidable component of Roman society – and also for those who are interested in the art itself, but who do not accept that it can be understood outside society as an autonomous body of imagery. Few would disagree with the latter proposition. It would be wrong to claim that putting Roman art in its social context is an

[7] On this, and other issues addressed in this Introduction, see Kampen 1995 (p. 375 on the term 'art'). Cf. Smith 2002: 64 on 'art' as 'a convenient collective misnomer'.

[8] See e.g. Hedrick 2006: 144–65, though he caricatures art historians as seeking transcendent, non-contextual values in selected forms of material culture. Kampen 1995 writes of 'material production', but is sensitive to all the problems of terminology.

[9] Cf. Gell 1998: 5–7 for his defence of 'art' as a term in anthropological theory.

innovative or entirely modern idea. And yet, in practice, this has not actually been done as one might expect. A symptom of that neglect is the fact that many books on Roman art do little to explain what some important works were actually *for*: who made them, for whom, and why. For example, it is still generally supposed – and academic books persist in encouraging these notions – that Roman portraits were commissioned by the people they depicted, or that Roman emperors themselves erected the 'propagandistic' monuments that celebrated their regimes. Both ideas are wrong, and obliterate any sense of the networks of social interaction in which such works of art were implicated.

So one aim of this book is simply to explain something of what Roman art was intended to do, how it functioned, and how, in fact, it was perceived. The book also addresses some of the conceptual and methodological obstacles to understanding Roman art in this way. It should be read partly as a critical commentary on and complement to other studies of the subject, and it does not in itself provide a general introduction to the full range of material concerned. Finally, I have sought to emphasise and elucidate some of the current approaches of international authors who are concerned with contextualising Roman art. These are perhaps relatively modest objectives. But 'the social history of art' may imply something rather more than this. The title needs further explanation.

THE SOCIAL HISTORY OF ART

In 'mainstream' (non-classical) art history 'the social history of art' refers not simply to a general attempt to contextualise art, but specifically to a seismic shift in the discipline that began to take place in the 1960s and 1970s. At this time, certain scholars, particularly those influenced by Marxist concepts of society, became outspoken critics of the prevailing attitudes in art history. They attacked the limitations of scholarship that complacently focused on formalistic analysis of iconography or style, or on the dating of works and the biographies of artists, or simply on cataloguing and description – all without much regard to the social context of art or the values that it embodied. In reaction to these traditional interests, a 'New Art History' emerged, that focused, for example, on the social conditions for the production of art; on its circulation and reception by different audiences; on the ideological values – particularly those enshrining a class system – which it embodied and disguised. Similarly, feminist approaches were developed. Various authors sought to understand art in terms of the construction of gender and sexuality, while

others considered questions about social class and identity, or culture and ethnicity. Art, and art history, were no longer regarded as innocent or politically neutral. The parameters of study were no longer taken for granted. There was increasing experimentation with different kinds of social and critical theory.[10]

The various contextual approaches that come under the rubric of the 'New Art History' did not appear from nowhere, and it would be quite wrong to suppose that the social history of art was invented in the late 1960s. Indeed, T. J. Clark, one of the foremost advocates of a new approach to art history, expressed nostalgia for a 'golden age' of art history around the late nineteenth and early twentieth century, when art historians embraced big ideas and their works were at the forefront of all historical inquiry. (His heroes include Alois Riegl, who was among the first scholars to take Roman art seriously as a subject for research.) But according to Clarke, the intervening decades had seen art history become, 'Out of breath, in a state of genteel dissolution'.[11] Independently, a similar complaint had been made by certain classical archaeologists, notably the Marxist historian of Roman art, Ranuccio Bianchi Bandinelli.[12]

The 'New Art History' is no longer new. Broadly speaking, its emphasis on the social history of art has come to dominate the field over the last thirty years or so, to the extent that there is no longer anything very radical about studying art with factors like economics and social class, gender, or audience-reception in mind. This is true also of the specific study of Roman art, but perhaps to a lesser extent. For here the idea of concentrating on the social history of art continues to generate new perspectives. In other words, the social history of art is still a very current trend in Roman art history.[13] We can see this even in the titles of some of the books published in English since 2000: *Art and Society in Fourth-Century Britain*;[14] *I Claudia II: Women in Roman Art and Society*;[15] *The Roman House and Social Identity*;[16] *The Social Life of Painting in Ancient Rome and on the Bay of Naples*;[17] *Art in the Lives of Ordinary Romans*.[18]

As the titles themselves perhaps imply (and they are merely representative of many more books and articles in various languages), the social

[10] For a summary of the range of approaches encompassed by 'social histories of art' see Burke 2001: 178–89.
[11] Clarke 1974: 561, reproduced with commentary in Fernie 1995: 245–53.
[12] See e.g. Bianchi Bandinelli 1961a.
[13] Cf. Smith 2002: appeal for more rigorous historical and contextual study. [14] Scott 2000.
[15] Kleiner and Matheson 2000. [16] Hales 2003. [17] Leach 2004. [18] Clarke 2003.

history of Roman art is a broad church. It accommodates relatively traditional classical archaeologists with an interest in the manufacture and commissioning of art as easily as it does thoroughgoing theorists (and those whose critics accuse them of being theorists!) who are interested in visuality and reception. In a less obvious way, it also has the potential to embrace much more conventionally *historical* treatments of art than those who call themselves art historians would normally be prepared to engage in. For example, from this perspective a book about Roman houses, by an ancient historian, who constructs arguments based on a statistical survey of mosaics and mythological paintings, is most certainly about art even though it bears none of the hallmarks of traditional art history.[19] A book about Roman statues can exist which concentrates largely on their representation in literature and their place in ancient thought, rather than on the specific works themselves.[20] These particular studies and others like them will reappear from time to time in the chapters that follow.

This book is not and need not be dogmatic. Nor does it have a particular axe to grind. But some of the by now traditional concerns of the social history of art are here, including the consideration of status and class, gender and ideology, power and cultural identity. They are the background for some of the themes examined and can be ignored only at the cost of our understanding how Roman art worked.

Chapter One deals with the making of art. This is a rather neglected topic, but it is central to our perception of what Roman art is. Moreover, it is a source of tension in the social history of art between, on the one hand, a concern for the material circumstances of artistic production and, on the other hand, a tendency to subordinate the artist's or patron's contribution to broader cultural patterns. Chapter Two addresses the role of (domestic and funerary) art in reflecting, expressing, and constructing social status and identity; however, it also challenges the notion that Roman art does straightforwardly reflect such social distinctions. Chapter Three turns to portraiture, examining some of the problems that dog its interpretation. Portraiture receives special attention here partly because it demonstrates more clearly than any art form how works of art could perform an active role in the social relationships that Romans acted out in public. Portraits are also important for the values and assumptions about personal identity that they served spectacularly to parade. In addition this

[19] Wallace-Hadrill 1994. Cf. Clarke 1991, addressing many of the same issues, but from a more art-historical or archaeological angle, with more attention to specific works.
[20] Stewart 2003.

topic illustrates some of the marked differences in approach between art historians who tend to focus on specific images or imagery, and historians who may rely primarily on textual evidence to understand cultures or societies at large. Roman portraiture looks like a very different phenomenon when viewed from these discrepant standpoints. Does it also offer scope for a reconciliation of disciplines?

Chapter Four examines the increasingly popular theme of 'the power of images' both in the sphere of imperial, political representation and in religion. Here we are dealing again with the use of monuments to mediate particular kinds of social relationship, but also with public responses to these images. Finally, Chapter Five considers the Hellenic heritage of Roman imperial art but also alternative, non-classical traditions that tend to be marginalised in surveys of Roman art. A key question is whether these different traditions could be used to express different kinds of imperial identity. In the end how ought we to make sense of the art of an enormous empire which embraced such diversity?

These chapters are intended to offer different glimpses of the world of Roman art – the world of Roman art history – in its various dimensions: from production to reception, from private art to public art, from Rome to the provinces, from fine art to coarse art. But before we go any further, a disclaimer and a warning are due.

CAUTION

General or introductory books about Roman art are seriously deceptive, and probably ought to be avoided. But since they are a necessary evil, it is important at least to understand how they distort their subject.

A discussion like this one must be highly selective, highly synthetic, and can only pay even the slightest attention to a handful of examples. The critical perspective is personal and partial. The choice of which authors or approaches to follow, and which to ignore, is subjective, and not always explicit. I have tried to dip into topics and case-studies in the social history of Roman art that are representative of current interests, focusing mainly on the earlier imperial period, but a parallel text could have been contrived which pursued the same ends in an utterly different manner, and possibly without so much as mentioning any of the works of art discussed here. (The 'Bibliographical essay' at the end of the book will at least offer a glimpse of some alternative or complementary studies.) Furthermore, Roman art has its own, particular problems. What *is* Roman art? When does it start and end? What are its geographical limits?

Does it constitute a coherent cultural tradition? Some of these issues are examined further in the chapters that follow.

To an extent, however, these are all obvious problems of evidence and interpretation which are familiar in any branch of historical study. Other problems are insidious and lie unremarked in the methodological hinterland of books like this one. I have said that the use of examples must be highly selective. But behind any book on Roman art, there are processes of selection that are largely beyond the author's control. Most Roman art historians will never, in their lifetime, see more than a tiny percentage even of the more significant works that survive (which themselves represent only a fraction of what once existed). This is not simply because of the magnitude of this great body of material. It is also because most pieces are inaccessible. Many of the finest and most interesting Roman antiquities are in private collections, and many of these are unpublished, sometimes because of scholars' anxieties about the legality of their origins. However, works preserved in museums can be at least as difficult to access. Few museums are able to exhibit more than a small minority of the objects that they hold. It is not infrequent (or surprising) for some of the objects in storage to be, effectively, lost, and for other reasons it may be hard even for specialists to see material, particularly if it has been excavated recently. New discoveries may take many years to become familiar within the field, and even longer to filter into general, synoptic studies of Roman art.

So, for a variety of reasons, authors depend heavily on other people's publications of Roman art, where they exist, and on their illustrations. The photographs themselves are usually supplied by the museums that own the works concerned, or sometimes by commercial agencies. In many cases no photograph exists, and new photography may not be permitted. In other cases, the acquisition of photographs proves lengthy or impossible. Moreover, the photographs (especially colour images) and the permission to reproduce them in print can be extremely costly both for individual authors and for their publishers.[21]

All of these factors and others contribute to the distorting effect of any non-specialist treatment of Roman art. We tend continually to abstract examples, and perhaps ideas, from a familiar pool. They form an invisible canon of material. I offer these observations as a disclaimer and a sort of challenge. I hope that this book avoids some of the resulting problems,

[21] As an example of the practical consequences of these problems on an academic publication, note the disclaimer in Hallett 2005b: v.

and not only by admitting them. The book is not a survey or an overview. It sets out to discuss precisely some of those images and approaches which are already in circulation. Its agenda is therefore partly set by existing work in the social history of Roman art. It aims to explain some ways of thinking about art in Roman society, which can be applied far beyond the few examples offered here. In the end, however, while debating appropriate methodologies for the historical understanding of this material, it is important always to remember that even our basic knowledge of Roman art is still in its infancy.

Who made Roman art?

Roman art history is abnormal in a variety of respects, but one of the most striking is the relative absence of artists. The study of later periods of art may concern itself with the lives and personalities of individual artists, or it may prefer to marginalise them in favour of broader sketches of historical trends or phenomena. But the artists are usually there, somewhere in the account. We know their names, something of their lives, dates, and circumstances; their conditions and their motivations.

Artists existed (of course) in Roman antiquity, but we know very little about them and it is virtually impossible to give them prominent roles on the art-historical stage. This is partly because of an almost total lack of documentary evidence – virtually no contracts, no letters or memoirs, no artists' records, wills or account books survive. Ancient written evidence is fragmentary, and the actual surviving works of art themselves represent only a tiny fraction of the material that once existed, so there is great difficulty in trying to reconstruct an artist's oeuvre.[1] More importantly, however, Roman authors pay almost no regard to contemporary artists. They do take an interest in the names, biographies, and achievements of Greek artists of the past, particularly classical sculptors and painters of the fifth and fourth centuries BC.[2] Sometimes those figures are elevated as great innovators and outstanding creative personalities; but few of the artists of these writers' own period are deemed worthy of similar attention. They are usually left in anonymity, and when their names are in fact

[1] The attempt is usually possible only where there are large bodies of material that can be traced to a limited source; Richardson 2000 offers a rare attempt to do this at Pompeii, attributing Roman frescoes to anonymous artists in the manner of attributions of Renaissance paintings or Greek painted pottery; but the method and its application are highly questionable.

[2] References are widespread, but note esp. Pliny the Elder, *NH* 34–37. See also text and commentary on these sections in Jex-Blake and Sellers 1976 (original edition 1896).

known to us it is usually from unforthcoming inscriptions, notably the 'signatures' linked with certain extant works.[3]

Some scholars might suspect that this is a good thing: that the obsession with individuals and with such slippery concepts as artistic creativity or 'genius' has been the bane of art history in general; that artists and their works should be understood as manifestations of the values and relationships of the broader society in which they are embedded. After all, the thrust of the 'New Art History' has been towards a social history of art that insists on the explanation of art in its social context, rather than a narrow focus on more or less able and inventive individual artists creating autonomous masterpieces.

The nature of Roman evidence allows us – or rather forces us – to pursue such a social history of art, looking at bigger trends and forming generalisations about the makers, users, and viewers of Roman art. Yet even this kind of broad survey demands attention to artists: artists as a group no less than as individuals. What *can* we say about them? And what can we say *without* them? Therefore it is with artists that we must begin. We shall briefly consider practical matters: the processes of artistic production and the role of patrons or customers within it.[4] However, it is also necessary to ask who the Romans' artists were. And this immediately raises a bigger issue which is fundamental to the subject, namely, the so-called 'problem of Roman art'.[5]

GREEK ARTISTS AND ROMAN ART?

The problem of Roman art is that it does not appear to have a well-defined cultural identity of its own. It is very hard to determine just what is *Roman* about it. The artistic traditions of many cultures are distinctive. To a large extent they serve to define those cultures in the modern mind (think, for example, of ancient Egyptian art[6]). But it is difficult to find Roman art-forms, or artistic styles, or even types of imagery – of iconography – that do not owe something to the Greek tradition. In fact, many of the works with which Romans surrounded themselves seem to copy or closely imitate Greek models from previous centuries.

This is a rather unsettling fact. Consequently, in the past many scholars have tried to identify the Romans' distinctive contribution, arguing that

[3] For signatures and other inscriptions see Loewy 1885 (Greek and Roman sculptors); Giuliano 1953 (Roman painters); and generally: Calabi Limentani 1958; Becatti 1951; Burford 1972: 207–18.
[4] For a short introduction to these see Ling 2000.
[5] For full discussion of the problem and approaches to it see Brendel 1979. [6] Brendel 1979: 6.

this is obscured by the veneer of Hellenism that we so often encounter. They have looked, for example, at those kinds of Roman art, both in Italy and the imperial provinces, which do depart from Greek representational conventions such as naturalism.[7] Sometimes they have emphasised the formative influence of the neighbouring Etruscan culture or other Italic communities in the period of the Roman republic, although those cultures themselves owe much to the Greeks. Such attempts have usually met with little success, and more recently there has been a tendency to study Roman art on its own terms – to examine it in its own context without seeking to justify it by finding some original, creative essence. We shall return to some of these points later. For now we are concerned with the identity of the artists themselves. They are central to the debate, for one way of understanding the relative lack of originality in Roman art is to suppose that it is literally just a continuation of Greek traditions, passed on by Greek artists who were now working for Roman customers under Roman rule.[8]

In the course of the third to first centuries BC, the developing Roman state grew through military victories and alliances to control most of Greece and the Hellenised lands of the eastern Mediterranean. In the course of the empire's evolution, Romans embraced and adopted many elements of Greek culture, including aspects of Greek literature and art. Near the end of the first century BC the poet Horace (thinking specifically of poetry) referred to this cultural change in the famous lines,

Captive Greece took captive the savage conqueror and brought the arts into rustic Latium ...[9]

This period also saw an influx of free and enslaved Greeks into Roman Italy. The conventional view is that they included many craftsmen who could cater for the local taste for Greek art. Moreover, it has been supposed that artists from the Greek lands, or at least of Greek descent, continued to dominate 'Roman' artistic production throughout the period of Roman rule: that an indigenous Roman artistic tradition never truly developed and that the whole business of art was, broadly speaking, left to the Greeks.

The Greek *appearance* of Roman works of art in all periods seems to support this assumption. The Romans made extensive use of a range of

[7] I.e. the representation of objects and spaces in a manner that is true to nature. Cf. Chapter Five.
[8] See esp. Toynbee 1934 for an important statement of this position; the title refers to Hadrianic art as 'a chapter in the history of Greek art'.
[9] Horace, *Epistles* 2.1.156–7.

Fig. 1. The Ara Pacis Augustae in Rome, constructed 13–9 BC: view of north-west corner.

Greek styles originating in different periods. Even works of art which had a very public and political role, and which represented particularly Roman subjects, could follow Greek stylistic precedents. The Ara Pacis Augustae (Altar of August/Augustan Peace), which was built by the senate in Rome in honour of the emperor Augustus between 13 and 9 BC, has often been used as an example of the Hellenism of Roman art, especially in the early empire (Fig. 1). The altar, or rather the highly decorated marble enclosure around the altar, bears a wealth of very complex, ideologically charged imagery. Yet despite its contemporary political significance, it betrays a considerable debt to earlier Greek models. The outer walls are largely occupied by fantastic scrolls of vegetation which can be traced back to Hellenistic precedents.[10] Above them, the famous processions of the imperial family and Roman priests, magistrates, and attendants are executed in a style which recalls relief sculptures in fifth-century Greece. In particular the subtle depiction of processional movement, the figures' drapery, and the classicism of faces and bodies are frequently felt to show the influence of the frieze of the Parthenon in Athens (c. 440–432 BC).[11]

[10] See esp. Castriota 1995. [11] E.g. Neils 2001: 223–4, suggesting a direct and deliberate copy.

In fact all of the altar's sculptures employ styles first developed at some stage in the Greek world.

As we shall see, not all Roman public monuments are so straightforwardly indebted to the earlier Greek artistic tradition. The Ara Pacis tends to be singled out as an exceptional example of the (Augustan) Romans' willingness and ability to have Greek art adapted to their own purposes. But it is important to note that even the Ara Pacis can be regarded as a more difficult case than it first appears. It is, of course, reasonable to imagine that monuments that *look* Greek were made by Greek artists who had inherited the necessary skills, habits, and sensibilities to work in this manner and who were patronised by Romans who favoured such work. However, in her book *The Artists of the Ara Pacis* Diane Conlin argues, first, that the Greekness of the Ara Pacis reliefs has been exaggerated (for example she rightly casts doubt upon the Parthenon as a direct model); and, second, that a close examination of the tool-marks and evidence of techniques used in the friezes suggests that the monument is primarily the work of Italian, not Greek, sculptors, albeit influenced by Greek practices.[12] In other words, Conlin argues for the existence of a nascent indigenous school of Roman marble sculptors who were as skilled as any in producing a work that appeared to belong within the Greek artistic tradition. To an extent the same 'native' characteristics have been claimed for other late republican or early imperial sculptures in Italy, particularly for funerary reliefs from Rome, which broadly draw on Greek conventions of style and iconography, but preserve Italic tendencies in form and technique.[13]

Conlin's proposals are controversial and have not been generally accepted.[14] They appear too speculative to be entirely successful. As many assumptions are made in the attempt to reconstruct a workshop of Italian sculptors as in conventional arguments about the Greek origins of the artists. Yet her work has a broader importance, in that it reminds us to question the link between the cultural identity of artists and the appearance of the works that they produced.

Equally important for evaluating the Hellenism of Roman art is the evidence for the names of its artists. They too appear to suggest a strong debt to the Greek world, for those names that are known to us are overwhelmingly *Greek* in origin.[15] The evidence is not as extensive as it might be – and sadly no names can be attached to the Ara Pacis or to

[12] Conlin 1997. [13] Gazda 1973. [14] See e.g. critique by Claridge 1999.
[15] Toynbee 1934: esp. xviii–xix.

Fig. 2. Mosaic representing a scene from Greek comedy, from the so-called Villa of Cicero at Pompeii. The signature of the artist, Dioskourides the Samian, is written in Greek in the top-left corner. *c.* 100 BC.

most other public works – yet we do have dozens of artists' names inscribed on other works as 'signatures', preserved in epitaphs, or occasionally mentioned in literature. The names have the potential to tell us a lot about these artists, but they also need to be treated with caution.

Many of the names, particularly those on the works of art themselves, are unambiguously Greek and are inscribed in the Greek alphabet. In accordance with convention, they often name the artist's father or place of origin, or both. Obviously such inscriptions occur in the Greek-speaking parts of the empire, but they are also to be found in Italy and the west, on works which were either imported or manufactured there by Greek artists. For example:

Dioskourides of Samos made [this]
(on two fine mosaic panels from Pompeii, *c.* 100 BC (Fig. 2));[16]

[16] Bieber and Rodenwaldt 1911.

Zenas son of Alexander made [this]
(on a marble portrait bust from Rome, first half of second century AD);[17]

Glykon the Athenian made [this]
(on the support of the approximately early third-century Farnese Hercules, from the Baths of Caracalla in Rome);[18]

Apollonios son of Archias, the Athenian, made [this]
(on a first-century BC bronze bust in the Villa of the Papyri at Herculaneum copying Polyclitus's famous Doryphoros statue).[19]

It is not quite clear why some works are 'signed' in this way, for the majority are not.[20] In some specific cases the Greek inscription, and particularly the statement of the artist's geographical origins, probably served as a kind of mark of quality – in the most general sense – when the artist was working in the western empire or sending his products there (it is notable that Athens and Aphrodisias, both cities with long flourishing traditions of sculpture, are relatively frequently mentioned).[21] It is worth remembering that the inscriptions we do happen to have (and the information that they offer) are not necessarily representative of artists in general.

 Those who signed work in this way will have been freeborn members of Greek communities in the Roman empire, but they are unlikely to have possessed formal Roman citizenship. (In fact, most of the empire's inhabitants did not, at least before AD 212, when Roman citizenship was extended to the whole freeborn population.)[22] Nevertheless, many citizen artists and craftsmen are attested. They are recognisable when they are identified with the three Latin names (*tria nomina*) by which Roman citizens were officially distinguished, and their status may be obvious even when not all of the names are recorded:

Gaius Postumius Pollio, architect
(on a building fragment from Formiae);[23]

[17] Loewy 1885: 268–9, no. 383 (a second, accompanying bust is signed by Zenas II, perhaps his son).
[18] Loewy 1885: 245–6, no. 345. [19] Mattusch 2005: 276–82.
[20] But cf. Stewart 1979: 101–3. See also Smith et al. 2006: 27–8 on the issues.
[21] See e.g. Squarciapino 1943: 23 (on Aphrodisians abroad). For the equivalent situation in Renaissance Tuscany see Thomas 1995: 7. At the same time, names sometimes appeared on relatively humble artefacts such as pottery; in referring to 'signatures' there is a risk of exaggerating the prestige of the work and the claim to authorship (cf. Tanner 2006: 153–4).
[22] A famous exception is Pasiteles, the first-century BC sculptor from Magna Graecia (Greek southern Italy) whose whole community received citizenship in 89 BC: Pliny, *NH* 33.156; 35.156; 36.39–40.
[23] *CIL* X 6126; Calabi Limentani 1958: 175, no. 194; Donderer 1996: 248, A135; cf. 247, A134 (*CIL* X 6339).

Marcus Plautius Menecrates, painter
(on the travertine architrave from a second-century building at Rome);[24]

Marcus Epidius Eros
('signature' on a marble herm of Jupiter Ammon from Rome);[25]

...the [personified images of] fourteen nations that surround the Theatre of Pompeii were made by Coponius.[26]

While some such names appear to document the activities of 'indigenous' Italian artists and architects, many others are at least partly Greek – for example, Menecrates and Eros above – and so even they may imply that the artist has origins in the Greek, eastern parts of the empire. In fact, a few citizen names are written on works of art with Greek letters and spelling; so for example, 'Maarkos Kossoutios Kerdon [Marcus Cossutius Cerdo], the freedman of Maarkos' who signed two identical statues of Pan, executed in different marbles but both found near Rome, which are now in the British Museum.[27] But these names can be rather deceptive. Many Roman citizens were actually former slaves (freedmen/women or *liberti/libertae*) – as Cossutius certainly was – or else descendants of slaves. Freed slaves retained their slave name, adding it as a *cognomen* (the third name) to the names of their former owner. (Thus the above artist will have been a slave called Kerdon – the name roughly means 'Profitable' in Greek – in the ownership of a certain Marcus Cossutius.) The origin of the freedmen is frequently acknowledged in inscriptions, but even when it is not, Greek-sounding *cognomina* often imply the possibility of servile origins or descent. In the examples above, M. Plautius Menecrates and M. Epidius Eros are likely to have been freedmen whose slave names had been, respectively, Menecrates and Eros ('Eros' in particular was a common name for slaves).[28] Since it was common practice to give Greek names to slaves, whatever their actual place of origin, we cannot assume that such names always point to a Greek cultural background.[29] But the recognition of servile names in references to artists does undermine any impression that there was a well-established artistic tradition passed on through generations of freeborn Romans. Skilled slaves are well attested. Many artist-freedmen

[24] *CIL* VI 9790; Calabi Limentani 1958: 154, no. 15.
[25] *CIL* VI 29799; Calabi Limentani 1958: 160, no. 60.
[26] Pliny, *NH* 36.41. Cf. C. Vibius Rufus, whose name appears on one of the classical Athenian-style caryatids in the Forum of Augustus: Schmidt 1973: 11, figs. 4 and 5.
[27] Neudecker 1988: 162–3, nos. 21.12 and 21.18, with bibliography. For the various artists bearing the name Cossutius see Rawson 1975.
[28] On slave names and identities see Joshel 1992 (36 on typical and appropriate names).
[29] Toynbee 1934: xviii–xix admits this.

will have begun their careers as slaves owned by other craftsmen or
workshop-proprietors and, whatever their real origins, they evidently
played an important role in the transmission of the artistic tradition that
the Romans inherited from the Greek world.[30]

So what can we learn from this kind of evidence? It is true that artists
with Greek names or unambiguously Greek origins do dominate the
historical record. But it would be dangerous to base on this observation
any general statement about the identity of Roman art and its makers.
Greek names belie the more complex backgrounds of craftsmen in Roman
society. Freedmen artists were not all of Greek extraction. And in any
case, what does it really mean to talk of an artist being of 'Greek extra-
ction'? Greek ancestry may indeed imply possession of an inherited craft
tradition. Yet we shall see again shortly how the extensive use of slave
labour and the method of training reduce the degree to which the con-
tinuation of Hellenic artistic traditions under Roman rule can simply be
associated with the heritage of the empire's Greek population.

THE STATUS OF ARTISTS

When Roman authors do write specifically about artists of their own day,
which is not often, their attitude tends to be dismissive. Cicero, for
example, explicitly divorces workshop production from the 'liberal arts':
those skills which are respectable for some freeborn citizens.[31] Acknow-
ledging the general esteem for famous Greek artists of the past, he suggests
that the Romans also would have had their 'Polyclituses and Parrhasiuses'
if they had considered sculpture and painting respectable practices; for
'honour nourishes the arts'.[32]

The second-century author Lucian (a Greek writer from Roman Syria) is
frequently cited as one of the best witnesses to the low regard in which
artists of that period were held. He wrote a supposedly autobiographical
account of his own decision to pursue a life of literary, rhetorically based
education and culture – that is *paideia* – in preference to the family business
of sculpture. His decision follows a dream in which Hermoglyphike
(Sculpture or, more literally, 'Herm-Carving') and Paideia, in the guise of
female personifications, compete for his favour. Hermoglyphike offers him
prosperity and strength, success and admiration; but Paideia's retort that all

[30] On the role of slaves in production see Burford 1972: esp. 42–52. [31] Cicero, *De Officiis* 1.50.
[32] Polyclitus and Parrhasius being among the most famous classical Greek artists. Cicero, *Tusculan Disputations* 1.2.4.

sculptors remain *banausoi* – mere mechanics or manual workers – contributes to her ultimately winning Lucian's allegiance.[33] The slightly earlier Greek author Plutarch also questions the status even of those past masters whose works the Romans admire. Often, he suggests, we delight in the work but despise the workman, and 'no well-born young man ever longed to become Phidias because he had seen the Zeus at Pisa, or to become Polyclitus having seen the Hera at Argos'.[34]

Despite these rather rhetorical claims, many Roman writers do seem to admire ancient artists like Phidias and Polyclitus. Upper-class Romans sometimes betray attitudes analogous to those of the modern art world, even a connoisseurial attitude that involves a preoccupation with famous names and the antiquity of works of art (both of which could affect their market value).[35] At the same time we have to remember that neither in Greece nor in Rome was there a clear-cut distinction between 'art' and 'craft', or between 'artists' and 'craftsmen', and there is no reason to believe that the activities of most 'artists' in the Roman world would have been accorded particular respect as an elevated occupation. There was no intrinsic difference between Roman artists and, say, furniture-makers.

We can substantiate the very biased views of the Roman upper classes by examining the actual social and legal status of the Roman-period artists we encounter.[36] Once again their names and inscriptions are revealing. It is very hard to quantify differences in status accurately, since only a fraction of Roman artists *are* recorded and their social position often remains in doubt. But we can derive some impression from the artists' names that have been collected, particularly from the city of Rome.[37] Slaves form a significant proportion even of these artists who are fortunate enough to leave some record behind.[38] A high proportion of artists working in different media are freedmen. Others, as we have seen, are likely to be freedmen, even if the evidence is not conclusive. It was probably common for artists to begin their trade as trained slaves,

[33] Lucian, *Somnum* (*The Dream*). Toynbee 1951: 17–18. Cf. Romm 1990 on some of the difficulties of using this text as a source.
[34] Plutarch, *Perikles* 2.1. Cf. Lucian, *Somnum* 9. See also Cicero, *Brutus* 257 for the *relative* prestige of famous artists. In the Roman period Phidias and Polyclitus were recognised as two of the most famous artists of the Greek past. Phidias's colossal cult statue of Zeus at Olympia (often referred to as Pisa in later literature) was one of the Seven Wonders of the World.
[35] See e.g. Pollitt 1978 (on the 'connoisseur's attitude'); Bartman 1991. Amongst the abundant literary evidence note e.g. Phaedrus 5 *Prologus* on the effect of names on commercial value.
[36] On status of Roman artists in general see esp. Calabi Limentani 1958; Burford 1972; Coarelli 1980. For mosaicists: Donderer 1989.
[37] See esp. Calabi Limentani 1958 for texts, references, and analysis.
[38] On slave labour and related themes see, generally, Bradley 1994.

continuing it, perhaps even as owners of workshops, after they obtained their freedom.[39] Only a few artists can be demonstrated to have been born free, and of course freeborn status does not in any way imply that they enjoyed a high social standing. The evidence therefore points to the relatively humble status of all kinds of artists in Roman society. Yet status *is* relative, and even formal, legal distinctions between different social orders tell only part of the story. A more or less officially recognised status does not necessarily correlate with the perception of one's standing in a particular community; the terms of reference will vary from place to place, from situation to situation; and financial success was naturally an important, differentiating factor. Inasmuch as a 'workshop' owner was a tradesman or perhaps an entrepreneur, he had the same potential for attaining prosperity as anyone engaged in business.[40] In some parts of the empire we even find artists or workshop owners established within the local governing elites of provincial cities. Lucius Sossius Euthycles was a fresco figure-painter in second-century Cyrene who was perhaps not even born a citizen, but nevertheless ended up as a *decurio* – a town-councillor – a position to which a high property qualification was attached.[41] (Interestingly, however, his remarkable epitaph, written in Homeric-style verse, seems to exhibit some defensiveness about his origins.) At Perinthus on the Black Sea the mosaicist Publius Aelius Proclus was also a *decurio* and apparently a benefactor of the town.[42] At Aphrodisias a number of sculptors (or owners) from this successful 'school' were wealthy and socially prominent between the second and fourth centuries.[43] There are other indications that here at least the production of sculpture had a slightly more elevated place in civic culture. For example, we have an early third-century(?) inscribed statue-base that commemorates a victor in 'the competition of sculptors of divine statues (*agalmatopoion*)': this is not a competition to win a contract, but a festival event analogous to the contests of musicians or athletes held elsewhere. Admittedly it is a unique document.[44]

Much may have depended also on the kind of artistic production in which particular craftsmen were engaged. The hard, physical labour of

[39] Cf. Burford 1972: 52.

[40] See Stewart 1979: 101–14 on the wealth and status of Hellenistic sculptors. For different approaches to Greek artists' status and the attendant problems note Coarelli 1980; Tanner 1999; Tanner 2006: 141–204.

[41] Ling 1991: 213; full analysis in Reynolds and Bacchielli 1996.

[42] *CIG* 2024, 2025 (there is some lack of clarity about the identity of father and son, both mosaicists). See Burford 1972: 150, 181; Ling 2000: 106.

[43] Erim and Reynolds 1989; Squarciapino 1943. [44] Squarciapino 1943: 11, no. 1; *MAMA* VIII 519.

sculpture has always been looked down upon in comparison with the lighter and apparently more cerebral work of the painter (especially the panel-painter) or, as we shall see, the architect.[45] It is also likely that some kinds of sculptural production offered more hope of a prestigious reputation than others. Andrew Stewart has noted the relatively elevated position enjoyed by the makers of divine statues in Hellenistic Greece, as opposed to human images, and the same kind of distinction may well be true of the Roman world.[46] We can imagine that Lucian's proposed career in 'hermoglyphike' – manufacturing sculptural decorations like herms – brought less respect than the trade of the 'andriantopoios' (maker of portrait statues) or the 'agalmatapoios' (maker of divine images). Meanwhile, to judge from the emperor Diocletian's Edict on Maximum Prices of AD 301, different crafts commanded sometimes notably different levels of wages.[47]

All such discussions, however, ignore the attitudes of the social milieu to which artists themselves belonged. Indeed they are partly coloured by the perspective of the upper-class literary sources on which we rely, as well as our own prejudices about the status of 'artists' or 'craftsmen'. Some ancient artists may have shared these perspectives, but as we shall see, others had quite different aspirations and different images of themselves.

THE ARTISTS' PERSPECTIVE

Although they are helpful as historical sources, epitaphs and signatures hardly offer eloquent testimony to the artists' own attitudes, aspirations, or perceptions of themselves. Only rarely do we find texts that offer more than bare information, as when, for instance, Novius Blesamus, an early imperial sculptor in Rome, boasts on his grave altar that he has 'decorated the city and the world with statues'.[48] However, even much simpler artists' inscriptions allow us to extract some useful indications of how they viewed their activities or wanted them to be seen, and the efforts they made to enhance their status.

We should note, first of all, that in theory at least, and notwithstanding Plutarch's reservations, the renowned Greek artists of the past offered proof of the glory and prosperity that a mere craftsman could attain. This is made clear by the figure of Hermoglyphike in Lucian's fictional dream,

[45] Cf. Hall 1999: 19–34 for the image of the sculptor in all periods. [46] Stewart 1979: 113.
[47] Graser 1940, esp. 338–9. Elsner 1998b: 239–43 on the value of art and artists' work.
[48] *CIL* VI 23083 (inscription of Novius Blesamus; the text's interpretation is not certain, but it seems very likely from the boast that Novius was a sculptor); Stewart 2003: 146–7.

and there is no doubt that *in principle* Romans regarded the artists of their own day as essentially engaged in the same sort of activity as those old masters. Roman authors are prepared to mention recent artists in the same context as the ancients. The Elder Pliny, for example, though he largely disregards Roman artists, does mention a few of them alongside their illustrious predecessors.

Another interesting manifestation of the perceived connection between famous classical artists and Roman craftsmen is the fact that the latter seem occasionally to have born illustrious artists' names. When we encounter the inscriptions of Roman sculptors called Myron and Phidias, we have to suspect that the names are deliberately significant and not merely coincidental.[49] Such famous names were perhaps often given to skilled slaves, some of whom were later freed. (Were their masters trying to give them striking and appropriate names, or enjoying the pretentious irony?) One of these cases, however, may concern a family of freeborn sculptors who at some stage started using a prestigious name and subsequently passed it down through generations. The name is that of the most famous artist in classical antiquity: Phidias. It appears on a second-century AD, Egyptian-style, marble statue of the baboon-god Thoth which was found in Rome's Campus Martius in the Middle Ages.[50] It was originally an offering in the large sanctuary of the Egyptian deities Isis and Serapis which stood on the site. On the side of its base it bears their signature, written in Greek:

Phidias and Ammonios, both sons of Phidias, made [this].[51]

Effectively this is evidence of a firm of artists in imperial Rome which might be dubbed 'Phidias and sons'. It is easy to see why they might have stood out from the crowd of sculptors offering their services!

It is possible that the art of painting offered clearer avenues for self-promotion than the hard, manual labour of sculpture. Among the Roman artists whom Pliny the Elder does care to mention are a sequence of well-known painters extending from the fourth century BC to the early

[49] A freedman called Myro (i.e. Myron) from Verona: *AE* 1998, 591; Buonopane 1998; another Myron appears in the signature on an early imperial marble bust: *CIL* VI 29796; Loewy 1885: 319, no. 488a. There are various cases of workers with names of famous artists in *different* crafts, e.g. the freedman goldsmith Zeuxis (*CIL* VI 3927), and many more examples of freedmen with famous artists' names whose occupation is unknown.

[50] Botti and Romanelli 1951: 114–15, no. 181, pl. LXXVIII.

[51] *CIL* VI 857, dated by another inscription to AD 159; Loewy 1885: 267–8, no. 382. The name Ammonios has Egyptian associations, so the family may have originated in Roman Egypt and specialised in this sort of Egyptian-style work.

imperial period.[52] These appear to have a genuinely Italian origin, and they are of respectable, sometimes even aristocratic, birth. Some at least are muralists and perhaps they testify to the stronger indigenous tradition of wall-painting in Rome and Italy, no doubt influenced by, but not dependent upon, Greek craftsmen. At the same time, these are the exceptions that prove the rule, and Pliny seems to regard them as such. For other Roman painters whom he introduces here and a little later in the *Natural History* are implicitly presented as unusual, dubious, or plain eccentric cases, and he does stress that through history only panel-painting has offered a real path to 'gloria'.[53]

Pliny does seem to have slightly more respect for one of these individuals: an artist called Famulus who worked on the notorious Golden House (Domus Aurea) which the emperor Nero built in Rome between about AD 64 and 68. Famulus is a particularly interesting character, and Pliny's brief comment deserves attention:

Another recent painter was Famulus, who was serious and stern yet at the same time *floridus* and *umidus*. His was the Minerva whose eyes used to meet the viewer's regardless of the angle from which she was observed. He used to paint for a few hours each day, and that he did with great seriousness, because he was always dressed in a toga, even when he was on the scaffolding [or 'amidst his easels']. The Golden House was the prison of his work, and so other examples do not survive to any great extent.[54]

This is all we are told, though it is surprising how much mileage art historians have got from these few lines. Most scholars change Famulus's name to the more common Fabullus, though there is no reason at all to believe that our manuscripts of Pliny are mistaken here.[55] There have been many attempts to make sense of the vague term 'floridus umidus', particularly with reference to cognate terms in Greek art criticism and literary criticism, or to clarify the text by amending it.[56] Meanwhile it has been supposed that Famulus, as a major painter of his day, must have been directly or indirectly responsible for much of the decoration in the parts of the Golden House that still happen to survive today underneath the Esquiline Hill. Once that questionable assumption is made, the path is open to debate which *particular* portions of fresco can be attributed to the *floridus umidus* style of the great man.[57]

[52] Pliny, *NH* 35.19–23. [53] Pliny, *NH* 35.115–20 (118 on *gloria*).
[54] Pliny, *NH* 35.120. [55] Cichorius 1927; Croisille 1997: 227–9.
[56] For useful explanation of *floridus* and related terms see Pollitt 1974: 138–9, 373–5.
[57] See e.g. Dacos 1968; Segala and Sciortino 1999: 29–39.

Such efforts are bound to be fruitless.[58] They tell us more about the wishful thinking of art historians and the lure of a 'famous name' in a period that offers so little information about the lives of artists, than they do about Roman art. Yet we can extract a more modest and speculative conclusion from Pliny's anecdote. The name Famulus means 'servant' or 'slave' in Latin. It implies that the painter, like so many other Roman painters, was a freedman – that this was his former slave name. We can imagine that his excessive wearing of the toga, a badge of Roman citizenship, and his grave and severe demeanour, so appropriate for the traditional, respectable Roman, are the marks of someone trying to assert his new-found status and good reputation in Roman society. So too his eccentric working hours are unlikely to have an obvious practical motive (such as the limitations of fresco-painting on wet plaster or the need for good light) for Pliny himself finds them unusual. Perhaps they show that Famulus was presenting himself as a prosperous Roman gentleman, working formally only in the morning hours, enjoying the leisure that was denied to most craftsmen, who worked when they could to support themselves.[59]

Famulus's short appearance in Pliny's *Natural History* is one of the few examples of anything like the biography of a Roman artist. Some artists may have written about their own works and the art of others, just as some earlier Greek artists had done, but with the exception of the lost *Nobilia Opera in Toto Orbe* (*Famous Works Throughout the World*) written by the late-republican sculptor Pasiteles, no direct evidence of writings by painters or sculptors survives. On the other hand, we do have one very important treatise by the late first-century BC architect and military engineer Vitruvius. Vitruvius's *De Architectura* (*On Architecture*) has had a phenomenal influence in more recent centuries since it is the only extensive architectural text to survive from antiquity. But perhaps it also tells us a little about the place of artists in Roman society.

It is possible that Roman architects in general enjoyed a higher social status and greater financial rewards than most other artists.[60] However, as far as the sources allow us to judge, a similarly high proportion of them were freedmen and the profession was also dominated by Greeks. Vitruvius is evidently a Roman of respectable birth and education and

[58] Cf. Meyboom 1984.
[59] For an account of the notional working day in Rome cf. Martial, *Epigrams* 4.8.1–6 and Laurence 1994: 122–32 on varied experiences.
[60] On Roman architects and their position see Donderer 1996: esp. 68–76; Wilson-Jones 2000: 26–30; Taylor 2003: esp. 9–12 on architects and patrons.

he seems acutely aware of the need to distance himself from less distinguished architects. In the course of informing his readers (including the emperor Augustus, to whom the treatise is dedicated) about the practical concerns of architecture, he also manages to show off literary and philosophical erudition. Indeed he tells us that architects should know something of literature, drawing, geometry, history, philosophy, music, medicine, law, and astronomy.[61] The architect is a jack of all trades who need not surpass specialists in the various fields: 'not a painter like Apelles, but not without skill in drawing; not a sculptor like Myron or Polyclitus, yet not ignorant of the principles of sculpture'.[62] He is also rather disdainful of those common architects who seek commissions to earn money. Architects of his calibre are gentlemen performing services (*beneficia*) for their equals almost as a favour (for which, presumably, they receive favours in return).[63] Perhaps Vitruvius's image of the refined and highly educated expert, possessing practical skills but also theoretical vision, is the sort of paradigm that a few other artists, like Famulus, working in his toga for a few hours a day, aspired to imitate.

We find this ideal reproduced on an early second-century funerary altar from Rome. It was the memorial of a rather more humble kind of Roman architect – more of a surveyor and builder – called Titus Statilius Aper (Fig. 3).[64] Aper died at the age of 22 and his parents had the monument made for him and the whole family. On the front he is represented in high relief, elaborately dressed in the toga. His professional skills are amply indicated by a document case to his left, surmounted by a scroll or scroll-container. But the monument also uses a clever mythological allusion. The dead boar that lies by Aper's side in an outdoor setting is a visual pun, for 'aper' is the Latin for 'boar'. Monstrous or ordinary boars are the frequent victims of mythical figures like the hero Meleager, who is regularly used on funerary monuments as a model for the deceased. But here the dead man is associated with the animal itself. Beneath this scene three lines of skilful amateur verse lament the premature demise of 'Boar', not slain by Meleager or Diana the goddess of the hunt, but snatched away by a quiet death. In these different ways the image and the text present an altogether sophisticated and arresting memorial to a surveyor. We are left in no doubt about his or his family's view of their education, cultivation, and social status.

[61] Vitruvius 1.1.3. [62] Vitruvius 1.1.13. [63] Vitruvius 6.praef.5. See Wallace-Hadrill 1994: 10.
[64] Stuart-Jones 1912: 76–77, no. 8, pl. 15; Zimmer 1982: 197–8, no. 142. *CIL* VI 1975 for the text.

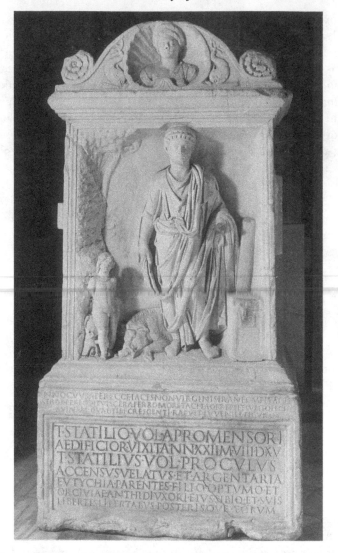

Fig. 3. Funerary altar of T. Statilius Aper and his wife. Rome, *c.* AD 120.

Once again, what allowed even humble architects to distinguish their trade from that of other artists and craftsmen was that their work was less obviously reliant on manual labour. Design and measurement are apparently more cognitive skills. It was much harder for other craftsmen to present themselves in such a genteel way if they were to make any explicit visual reference to their trade.

Fig. 4. Scene on a funerary altar representing a sculptor at work.
Rome, *c.* early second century AD.

On the other hand, many appeared to take pride in the work that had
supported them and given them an identifiable role in society. They
placed the emphasis on the nature and success of their work rather than
trying to exaggerate their social position. Figure 4 offers an instructive
contrast with the monument of Aper. It shows another, smaller funerary
altar of roughly the same date, also from Rome.[65] The most significant
decoration is on the front, where a relief shows a seated sculptor at work
in front of a seemingly well-dressed lady. He is chiselling at a tall pedestal
supporting a portrait medallion – a sculptural bust of a woman in a
circular frame. He is bearded and wears a practical short tunic – typical
working attire. His scrawny legs end in bare feet. In contrast, the lady next
to him, like the figure in the portrait, is respectably dressed in a long
tunic, which falls modestly to the ground, and a mantle draped around

[65] Lippold 1956: 317, no. 52; Zimmer 1982: 36, 157–8, no. 80; D'Ambra 1998: 94–5 with colour
photograph, Fig. 58; Varner 2006: 290–2.

her hip and over her shoulder and left arm. Both females are portrayed with elaborate coiffures such as were fashionable in this period (see Chapter Three). The standing woman holds a fruit-like object – probably actually a bag of money – and places her right hand on the edge of the medallion, at which she gazes intently.

Unfortunately this altar now lacks an inscription or other clues that would help us to interpret the main scene.[66] Is this the gravestone of a sculptor, depicted here with individual-looking features? Does it commemorate the woman in the bust, the sculptor and the standing lady perhaps being her parents? Are both females one and the same person? If we imagine it as the monument of a sculptor, he has represented his own work in a favourable light: it is apparently his efforts that keep alive the memory of the dead, while he works for elegant patrons. More likely, perhaps, this is the memorial of the woman in the bust, commissioned by her female relative whose very act of commissioning such monuments from the sculptor is an advertisement of her pious devotion. In any case, an essential fact remains: that the artist who made this altar represented himself or a generic sculptor realistically, as a humble manual worker, proud of his role in such transactions and content to share the widespread conception of his own relatively low social status.

In fact, this kind of non-aspirational self-representation is widespread. Gerhard Zimmer documents many images of craftsmen that depict them in humble clothing and working conditions.[67] The monuments of freedmen frequently allude to their trade, sometimes literally representing the tools of the trade.[68] While many other monuments will have excluded any explicit visual reference to professional attributes (and are harder to identify as a result), it should not be surprising that significant numbers of craftsmen were content to parade the roles constructed for them by Roman culture.

ARTISTIC PRODUCTION

We have paid enough attention to individual Roman artists. Perhaps in general the sources display a bias towards individuals that appeals to modern expectations. But in thinking about who made Roman art, we

[66] Sculpture on the other sides, including an unfinished portrait on the rear of the stone, offers little help.

[67] Zimmer 1982: esp. 66–7. Cf. examples in Clarke 2003: 118–23.

[68] See Chapter Two. Cf. Joshel 1992: esp. 46–53 on slaves' inscriptions.

need to give proper recognition to collective production. Ultimately we also need to reconsider the role – some would say the paramount role – that customers or 'patrons' played in the creation of Roman art.

On a basic level, most artistic production, even relatively small-scale production, depended on collaborations of craftsmen that are loosely labelled as 'workshops'.[69] The 'workshop' can probably usually be conceived of as a kind of firm, with or without permanent premises, under the ownership or direction of one person. The Latin term is *officina* and that word occasionally appears even in the 'signatures' on works of art such as those inscribed within mosaics in Italy, Spain, and North Africa (but notably also on a range of very humble products).[70] The premises of some artists have been excavated in different parts of the empire. The third- to fourth-century sculptors' 'workshop' at Aphrodisias has attracted a lot of interest because of the quality and evident prestige of works from that city (though this small series of rooms is perhaps better regarded as a city-centre show-room more than a primary place of work).[71]

'Workshops' probably involved a division of labour between artists with different areas of expertise, or levels of skill and experience, or both. For instance, figure-painters (*pictores imaginarii*) were distinguished (at least in the Edict of Maximum Prices) from the much less well-remunerated painters of ordinary fresco who would have worked alongside them on specific jobs.[72] The potential for (rather surprising) specialisation, perhaps within larger workforces, is illustrated by the inscriptions of two *oculariarii* – makers of eyes for statues – in imperial Rome.[73] But a sense of how different craftsmen of various levels of proficiency could operate together in the same establishment is more eloquently conveyed by a rather crude Roman relief from Ephesus (probably second century in date and perhaps from a sarcophagus), which includes a representation of five sculptors or assistants working side by side.[74] All wear tunics at most, and all appear to be beardless save one, who may be the 'master' of the workshop. He sits on a stool and chisels at a frontally facing statue with a *himation* (mantle), while his colleagues work at different tasks: one seems to trace a design on

[69] For critique of the term and concept see e.g. Allison 1995.
[70] E.g. on mosaics at Carranque and Emerita in Spain (Dunbabin 1999: 158, 272). Sculpture: e.g. 'ex officina Sextili Clementis' (*CIL* X 1896) on the base of a statue from Puteoli.
[71] Rockwell 1991; Van Voorhis 1998. On the Aphrodisian 'school' see Squarciapino 1943; Erim and Reynolds 1989.
[72] Ling 1991: 213; Clarke 1991: 57–61 on their division of labour.
[73] *CIL* VI 9402, 9403; Calabi Limentani 1958: 173.
[74] Mendel 1912: 78–80, no. 13; Conlin 1997: 31–2 with figs. 2a–d (somewhat misleading drawings after Mendel).

a panel; another polishes a small sculptural element placed on a table; another chisels at a bust on another table with the help of a small figure – perhaps a boy – who holds the bow of a drill. Conlin has used this ambiguous but informative relief to comment on the hierarchy of tasks in a sculptor's workshop assigned to craftsmen of different ages and abilities.[75]

Despite such evidence, however, Roman artists, like those of other periods, are likely to have been quite versatile in the work they performed. There may also have been a certain fluidity in the composition of workshops, with individual artists or groups combining, or individual artists joining or leaving the group, as the work required. Such behaviour is attested in other periods, and is detected in the wall-paintings of Pompeii by those who claim to be able to identify the artists' hands by connoisseurship.[76] On a much larger scale, there is good evidence for a certain kind of collaboration across massive distances, whereby some marble sarcophagi quarried and partially carved in Asia Minor were finished off or completed with the addition of lids at their ultimate destination in Italy. This is surely a phenomenon that could be imagined only in a huge, Mediterranean-based empire, but it is not clear whether it represents an organic response to market forces or whether it was a more tightly organised, orchestrated, trans-imperial production process.

It is a characteristic of many societies that particular trades, including arts and crafts, tend to be passed down through families. This is certainly true of the production of Greek and Roman art. There was security in the maintenance of a family business. Children could learn the trade without unnecessary expense. They did not need the money to invest in their own training or materials. They could capitalise on the resources and the reputation of a business established by their father, and his father before him.[77] It appears that some families of artists carried on the trade not only over several generations but even across centuries (which can be confusing for the art historian, given that the same personal names tended to recur within a family). The descendants of the famous fourth-century BC Athenian sculptor Praxiteles were seemingly still making sculptures some three centuries later.[78] There is no reason to believe that such dynasties of

[75] Conlin 1997: 31–2.
[76] Richardson 2000: esp. 7–22. Richardson (ibid. 15–16) considers that Campanian wall-painters were hired individually and did not belong to permanent workshop-groups. Contrast Ling 1991: 214–17. Note also Goodlett 1991 on Hellenistic sculptors on Rhodes. Cf. Thomas 1995: 1–4 on the flexibility of the Florentine Renaissance workshop.
[77] For the exceptional cases of women inheriting a craft see Pliny, *NH* 35.147–8.
[78] Stewart 1979: 102 and passim on other artists; table of sources at 157–74. Cf. Ling 2000: 91–2.

Greek craftsmen did not continue to pass on the family trade in the period of the Roman empire. This is one reason why it is tempting to emphasise the continuity of Greek artistic traditions under Roman rule, though we have already seen some of the problems with that view.

However, even among freeborn Greeks of the Roman empire, craft traditions were not exclusively passed down within families. Both slaves and freeborn boys and girls learned crafts through apprenticeship. For a variety of reasons a parent might choose to apprentice his or her own child to a craftsman outside the family to learn a trade. We do not have any ancient documents of 'artist'-apprenticeships as such, but a number of papyri from Roman Egypt preserve contracts agreeing the terms by which children in their early teens would become apprentice weavers, bronze-smiths, nail-manufacturers, bricklayers, and so on.[79] The contracts typically specified the length of the apprenticeship, what the apprentice would learn, which party would be responsible for feeding and clothing him or her, what work would be required and for how much remuneration, and what penalties would be due from the respective parties if the apprentice did not do as required or was not properly taught. The content of these contracts is analogous to those for apprentice craftsmen or artists in the Middle Ages and Renaissance; apprenticeship was a highly effective system.

So we can be confident that similar contracts governed the apprenticeships of prospective Roman sculptors, painters, engravers, and so on. In any case the relationship between teacher and former apprentice is more generally documented in literary and epigraphic sources.[80] It is a further reminder – if such is needed – that the Graeco-Roman arts were acquired and learned, and that they have an existence that is not dependent on the origins of the craftsmen themselves.

Such a system of artistic education might seem partially to explain the conservatism of Roman art: the tendency to rely on pre-existing models and types; the retrospective character of artists' styles and broad continuity of technique. Yet that impression may be deceptive. Similar conditions prevailed in other periods of more conspicuous artistic development and innovation, including classical Greece and Renaissance Italy. In these cases the cultural, institutional, and economic setting in

[79] Generally, see Bergamasco 1995 (including 42 examples of apprentice contracts, 20 of which are from the Oxyrhynchus papyri).

[80] E.g. Pliny, *NH* 35.146–7; Pausanias 6.4–5; *AE* 1909, 157. Burford 1972: 87–91 with further references.

which art was produced and received provided the conditions for change. The traditions of artists are not in themselves a determining factor.[81]

Creative artists do not dictate the development of art in Rome. At every period it is the patron, whether he be a private citizen or an official of the imperial government, who plays the leading role.

So Donald Strong articulates a widely held view of Roman creativity.[82] Many have shared this opinion, though they do not always acknowledge it explicitly.[83] The relative absence of information about individual crafts-men and the highly traditional or backward-looking character of a lot of Roman art often discourage us from attributing to the artists any major creative input into the conception or design of their own works. The evidence reviewed above for the status and role of Roman artists largely prevents us from seeing them in the same light as their modern coun-terparts who tend to work independently, experimenting with ideas, or seeking self-expression.

There are exceptions, it is true. For instance, there is a general con-sensus that a single, highly skilled and imaginative artist was responsible for designing the extraordinary narrative frieze that spirals round Trajan's Column in Rome (Fig. 26; see Chapter Four). The same might be said of other complex monuments, and occasionally Roman art historians have indeed celebrated the talents of anonymous 'masters'.[84] But in general the Roman artist's contribution, whatever exactly it may have been, is con-sidered subordinate to the intentions of the patron or, in the case of more run-of-the-mill works, the pressures and demands of the market. It is necessary to re-examine these assumptions by considering the role of patrons and customers before returning to the most general questions about the identity of Roman art.

[81] Note Baxandall 1980 (a landmark in a certain kind of social history of art) for the reconciliation of these various factors in Renaissance Germany. On apprenticeship and continuity in the Graeco-Roman context see Conlin 1997: 30–4.

[82] Strong 1988: 11. He goes on to argue that the Greekness of Roman art is due to the needs and preferences of those who commissioned works, and not to the nationality of the artists involved. Contrast Smith 2002: 70–1 on the need to consider the role of artists, buyers, and public in artistic production.

[83] Note objections in Toynbee 1951: 6–7.

[84] See e.g. Bianchi Bandinelli 1950 on 'The Master of Trajan's Works', identified by some as the famous architect Apollodorus of Damascus.

To begin with we need to consider the mechanisms of Roman artistic patronage. Unfortunately relevant historical evidence is thin on the ground. Conlin's book on the Ara Pacis attempts to understand how such a major monument might have been commissioned in the early Roman empire, but she relies heavily on comparative material from other cultures and periods.[85] In particular, Hellenistic Greece offers interesting and detailed documents for the creation of public architecture: they suggest a process of sometimes close scrutiny and active involvement on the part of overseers and committees.[86]

The best evidence we have for the Roman world also concerns contracting (*locatio*) for building projects. We know a little of the types of contract that governed such commissions, and in fact two contracts survive.[87] One of these, the so-called Lex Puteolana of 105 BC, was inscribed on blocks of marble at Puteoli (Pozzuoli).[88] It records the commission for the construction of walls at the local sanctuary of Serapis by the chief governing magistrates (*duumviri*) of the town. The Lex Puteolana is extensive and detailed. It even stipulates measurements. But it is essentially a unique survival and we cannot determine whether it is typical of Roman architectural and building contracts in this period or later, let alone artists' contracts in general.[89] Other evidence suggests that contracts agreed not only fees payable but also the respective responsibilities of the patron and the contractor (*redemptor* or *conductor*) in providing materials.[90] We know that the patron, unsurprisingly, kept an eye on progress, and that building works ended with *probatio* – formal approval by the customer. In 54 BC, for example, Cicero was watching over projects on properties belonging to his brother Quintus (who was away taking part in Caesar's invasion of Britain), and expressed annoyance with the builder Diphilus's slow progress.[91]

In the case of civic building projects and public monuments it was apparently individual magistrates who normally bore responsibility for overseeing the commission and ensuring that it was properly completed.[92]

[85] Conlin 1997: 27–44.
[86] Conlin 1997: 38–9. See also Coulton 1977: 15–29. Cf. also the very precise specifications for mosaic designs in the 'Zenon papyrus' contract, an Egyptian document of the mid-third century BC: P. Cairo Zenon 59665 (overview in Dunbabin 1999: 278).
[87] See Anderson 1997: esp. 68–75.
[88] *ILS* 5317. Wiegand 1894. Cf. the similarly early contract for repairs to the Via Caecilia: *ILS* 5799.
[89] Anderson 1997: 74. [90] Ibid. 68–75. [91] Cicero, *Ad Quintum Fratrem* 3.1.
[92] Cf. explicit statements on inscribed statue bases (e.g. in Aphrodisias) about the individuals who 'took care of' the setting up of honorific statues – in this case apparently supportive volunteers rather than office-holders: Smith et al. 2006: 26–7.

For example, the Small Theatre in Pompeii, which was built around the 70s BC, bears an inscription recording that the *duumviri* performed this task.[93] However, even with such building works the surviving documents do not help us to determine the role of the patrons or their representatives in the planning or design.

Unlike classical and Hellenistic Greece, the Roman world presents no evidence of detailed involvement by the patrons, which is not to say it did not occur. Inscribed bronze tablets found in Spain record the decision of the senate in AD 19 about how to commemorate the beloved prince Germanicus, who had perished that year.[94] Like other honorific decrees all over the empire, it is quite specific about the types of honorific monument that are to be constructed in significant places and, in the case of one commemorative arch, about the inscription that is to be set up; but it remains vague about details of design. For example, a cenotaph is to be erected for Germanicus at a particular site next to the River Rhine, and on it he is to be represented (presumably in relief sculpture) 'receiving supplications from the Germans and especially the Gauls and the Germans who [live] on this side of the Rhine'. Such a decree is not the place for any more precise specifications. We cannot tell whether the choice of how to meet this request would have been left to the artists favoured with the commission, or whether, say, individual senators would have been deputed to develop the proposal in more detail. One suspects the latter on account of the complexity and subtlety of some of the imagery on public monuments, but that is merely an assumption.[95]

In other cases we can assume that the patron may have taken a close interest in the design and iconography (visual content) of a commission, but once again the evidence is very limited. One extraordinary document, the will of a provincial aristocrat in second-century Andemantunnum (in eastern France) which happens to be partly preserved in a medieval copy, goes to great lengths to explain in exceptional detail exactly what the man's funerary plot and tomb are to look like, how they are to be designed and decorated, and what his family and servants must do to look after them.[96] Similarly, the grotesque millionaire freedman Trimalchio, in

[93] *CIL* X 844. It is likely that major public commissions generally involved competitive tendering; see e.g. Plutarch, *Moralia* 498E ('public buildings or colossal statues'); Cornell 1987: 28; Anderson 1997: 85. Note also Cicero, *Philippics* 9.16 urging the senate to erect a statue for Servius Sulpicius Rufus, the contract for base and statue to be let out by the quaestors.

[94] Tabula Siarensis esp. 26–30. For English text and further discussion see Sherk 1988: 63–72 (including text of the related Tabula Hebana, with references); González 1984; Rose 1997a: 108–10.

[95] Note Lepper and Frere 1988: 16–19 on possible designing of Trajan's Column by committee.

[96] *CIL* XIII 5708 – the so-called 'Testament of the Lingon'.

Petronius's first-century novel the *Satyricon*, declares his intention that his own grand tomb should be decorated with his portrait-statue, at the feet of which should be images of his dog, wreaths and perfume jars, and gladiatorial fights; the dimensions and planting of the plot are specified.[97] There should also be reliefs of sailing ships; of Trimalchio on a tribunal distributing largesse (wearing the appropriate kind of toga and five gold rings); and of a dining-room full of happy diners. Then Trimalchio asks for a statue of his wife next to his own: she should appear holding a dove and leading a small dog dressed in a girdle. There should be images of his pet boy; of large amphoras sealed with gypsum; of a boy crying over a broken urn. Finally, there is to be a sundial and an epitaph dictated by Trimalchio. The fact that Trimalchio's instructions find remarkable resonances in real tombs from Pompeii and elsewhere gives weight to a text that might otherwise be dismissed as satirical fantasy,[98] though it also suggests that some of this iconography was more common (in every sense) than this pompous 'commission' assumes. We shall return to Trimalchio in Chapter Two. In any case, it is at least possible that such precise and legalistic instructions were in wider use among patrons of art, though they still do not involve the sort of detail about iconography that can be found in artistic contracts of the Renaissance.[99]

It may, however, be appropriate to talk about artistic patronage only in relatively few cases (indeed some would prefer 'buyer' as a more neutral alternative to the word 'patron'[100]). For much of the time the preferences of customers were apparently satisfied by the ability to choose from the supply of art that was readily available rather than through bespoke commissions. The wall-paintings that survive in great numbers from houses in Pompeii, Herculaneum, and the other sites destroyed by Vesuvius in AD 79 are revealing in this respect. The decorative schemes on these walls tended to display similar traits in particular periods, to the extent that Pompeian painting is generally classified into four 'styles', originally identified by August Mau during the 1870s.[101] Yet virtually no two rooms out of all these buildings are exactly alike. It is unlikely that the variety of paintings was dictated by the specific demands of patrons, and

[97] Petronius, *Satyricon* 71. [98] See Chapter Two.

[99] There is a general lack of evidence for the details of commissions and contracts. A papyrus of AD 357 (P.Oxy. 1.66) is a tantalisingly fragmentary correspondence concerning the commissioning of a statue of the Egyptian praefect Pomponius Metrodorus. For papyri relating to payments to painters see Doxiadis 1995: 89.

[100] E.g. Johns 2003a: 16, 19. Cf. Cornell 1987: 26 for challenge to the term 'patronage'.

[101] Mau 1882. See also Chapter Two.

there is repetition of specific motifs; but clearly painters were practised in adapting the conventions for each new customer.[102]

At the same time, many of the figured scenes which appear in the centre of frescoed walls, especially mythological scenes, appear to be derived from a popular repertoire of subjects and compositions. They do occasionally resemble each other closely, and they may represent choices from a 'pattern-book' of images on offer.[103] Such a repertoire would have provided the patron with enough scope to assemble significant programmatic combinations of the kind that have occasionally been detected (in the House of the Vettii at Pompeii, for instance (cf. Figs. 9 and 10)[104]). However, once again, we cannot prove that the selection was not left to the artists, working to approximate instructions. In fact, the one thing we are told by ancient writers about the patron's contribution to wall-painting is simply that he is expected to make additional payments above the contracted price for use of the most expense pigments.[105]

In some areas of artistic production, such as the supply of garden sculptures, votive dedications, or funerary altars and sarcophagi (see Chapters Two and Five), there is such a consistent range of subjects and iconographical types that one can rarely detect any trace of distinctively personalised commissions. We have good evidence for Cicero's attempts to decorate his villas in an appropriate manner, for some of his letters to Atticus deal with the ordering of sculptures from Greece. But his demands are generic: he is not interested in the specifics of iconography, for example, since these are predictable. What does concern him are the materials, themes, and prices of the sculptures, all of which seem to have been made already (if they are not, in fact, antiques).[106]

Even such a personalised art-form as portraiture may have depended less on individual commissions than one might imagine. Most portraits probably were based on the real features of the person depicted – and so there was a 'sitter' – but as we shall see again in Chapter Three, personalised portrait faces were usually inserted into conventional, perhaps ready-made, bodies or busts. Indeed, given the length of time it would

[102] Cf. Dunbabin 1999: 313–23 on the limited evidence for patrons' specific requirements in the production of mosaics.

[103] Ling 1991: 128–34, 217–20. There is, however, little firm direct evidence of copy-books or pattern-books.

[104] See Chapter Two. [105] Pliny, *NH* 35.44. Cf. Wallace-Hadrill 1994: 31.

[106] Cicero *Ad Atticum* 1.1.5; 1.4.3; 1.5.7; 1.6.2; 1.8.2; 1.9.2; 1.10.3. Cf. Leen 1991; Marvin 1993. Cf. Pliny the Younger, *Epistles* 9.39, vaguely asking Mustius to purchase materials and have a cult statue made for the renovation of a temple of Ceres, though some have taken his lack of precision to imply revision of the letters: Bell 1989: 462–3.

have taken to design and carve or cast a new statue from scratch (possibly up to a year or more), it was practical to choose even portrait-bodies from a familiar (and perhaps prefabricated) repertoire.

Finally, sarcophagi seem at first sight to present a conspicuous example of 'mass-production' in Roman sculpture and the purchasing of sizeable works of art 'off the shelf' (cf. Figs. 15 and 16). While some of the grander and more unusual sarcophagi may be responses to the particular demands of individual patrons, the majority bear highly repetitive imagery – mythological or otherwise – and there is concomitant reliance on typological, that is to say paradigmatic, images: standard scenes with a broad symbolic relevance that transcends the specifics of their narrative context (see Chapter Two). Given the tendency to standardised iconography there would rarely have been any necessity for special commissions (even for those who could afford the time or money). Something suitable could normally be obtained when a sarcophagus was needed, though the choice might not be ideal (as when the imagery lent itself to the commemoration of someone of the wrong gender[107]). On the other hand, the notion of Roman mass-production has been questioned, and it is also possible that the supply of works like sarcophagi did not only involve 'off the shelf' purchases, but also 'manufacture on demand'. In other words, repetitive imagery was relatively quick and easy to supply when required, even perhaps to supply from long distances.[108]

We should also remember that many works of art in the Roman world were not subject to any very specific demands by the buyer. Many artists' workshops produced objects that were made to be sold to any customer they might attract, with sometimes minimal correspondence between iconography and function. This is frequently the case with the so-called minor arts, which include, for example, engraved gems and the figured decoration of mould-made pottery.

The examples surveyed above illustrate the importance of the patron or customer in different ways. In a few cases we can imagine that the patron had his or her own, personal intentions and made an individual contribution to the creation of the art-work. In many other cases we are not dealing with the precise requirements of one patron but the tastes and

[107] See Walker 1990: 38, no. 43, pl. 16 for a sarcophagus in the British Museum on which the image of Ariadne has been converted to Endymion, presumably to suit a male occupant.

[108] For speculation about the long-distance trade see e.g. Waelkens 1982: 124–7. Cf. Dodge and Ward-Perkins 1992.

requirements of a broader clientele whose attention and favour the artist seeks to attract.

This chapter has sketched just some of the circumstances in which Roman art was made: the identity of the artists, so often either taken for granted or ignored; their standing in society and their self-representation; the organisation of their work and the market for which they catered. Very occasionally written sources and the works of art themselves allow an insight into the particular relationships and creative processes that bring them into existence. But more often we are left to speculate about the answer to the broader question implied here: about the factors that informed Roman art and about who or what determined its development. It is our relative ignorance that invites a particular attention to the contribution of patrons or customers. There has been a tendency to use patronage as an explanation both for fundamental changes in Roman art (such as the 'decline' of classical naturalism in Late Antiquity) and for its general continuity and conservatism (the dependence on Greek styles and models).

My focus on artists is intended as a partial antidote to that approach. In the end, however, the problems of evidence limit the extent to which we can concentrate either on artists or on patrons. Moreover, although the analysis and demystification of production is an important part of any social history of art, modern approaches to art in antiquity as in other periods have tended to play down the significance of the artist's or patron's intentions as a matter of principle. The influence of post-structuralist thinking has led to a particular focus on the reception of art and on its non-intended meanings: on its viewers, rather than its makers; on what it says about the *society* that produced it. These themes will re-emerge in the chapters that follow.[109]

[109] For an introduction to post-structuralist and other treatments of the artist and the social production of art see Wolff 1993: esp. 117–36; Tanner 2003: 69–103 (readings with introduction). For post-structuralist tendencies in Roman art history, with emphasis on the viewer, note e.g. Elsner 1995.

Identity and status

The concerns of the modern world often have a conspicuous impact on the fashions and vocabulary of academic research. Perhaps that is why work on Roman art shows an increasing interest in concepts such as 'identity' and – a popular term in German scholarship – 'self-representation' (*Selbstdarstellung*). Within classical studies generally, and classical art and archaeology in particular, there has been an exponential growth in the number of books and articles published since 1990 that explicitly deal with social identity, including two books of notable relevance here: *Art and Identity in the Roman World*[1] and *The Roman House and Social Identity*.[2] This chapter therefore focuses on works of art that in some sense reflect or project Romans' notions of their own identity and place in society. The emphasis here is on personal identity and the representation of social status. In Chapter Five we shall return to the theme in considering questions about collective identity and ethnicity.

However, the concepts of identity and social status need to be treated with care. A term like 'identity' is both difficult to define and burdened with anachronistic associations. There is a temptation to use it as if it naturally accounts for the phenomena that we seek to explain: to say, 'this work of art expresses identity' without much further clarification.[3] The idea of social status – which is often taken to mean social class – can be similarly deceptive. It implies, for example, a rigidly defined hierarchy in society, within which an individual can be placed unproblematically. Indeed the nature of Roman society itself encourages us to think in this way, for to a very large extent the Romans had formal, legally recognised distinctions between classes or 'orders' which underpinned their ideology of a social pyramid: they separated senatorial families, 'equestrians', the municipal aristocracy of *decuriones* (town councillors), humbler freeborn

[1] D'Ambra 1998.　　[2] Hales 2003.
[3] For general critiques of the term see e.g. Gleason 1983 and esp. Brubaker and Cooper 2000.

citizens, freedmen and slaves, as well as distinguishing different kinds of citizenship. But beneath this theoretical hierarchy was a much more complex and fluid society, and formal distinctions can sometimes become almost meaningless.[4] 'Freedman status', for instance, encompasses a spectrum from wealthy and influential imperial freedmen – including some of the richest men in classical antiquity – to those who continued to live their lives in virtual servitude. It is precisely because of this tension between formal rank and actual social positions that self-representation through art is important. As we shall see, art could be used variously as an assertion of one's position, as a claim to superior status, or as an expression of aspirations. Art did not merely reflect the 'reality' of Roman society.

These qualifications should be kept in mind when considering the examples that follow. Nevertheless, no one would deny that Roman art did serve the expression of identity and status in certain ways. Artistic 'self-representation' is easiest to perceive and interpret in the spheres of artistic production on which this chapter concentrates: the art of the house and the art of the tomb. Both areas require a few words of introduction.

There was nothing very obviously intimate or 'domestic' about Roman houses. Nearly all houses and villas, even those that were comparatively small, could be places of semi-public display, as the prominence of art-works at excavated domestic sites implies. Because they are durable and tend to survive in the buried foundations of houses, mosaics attest most powerfully to the pervasive presence of 'decorative art' in the home. They are surprisingly prominent not only in countless villa remains, but also at numerous large urban sites excavated right across the empire including, for example, Italica in Spain, Agrigentum in Sicily, Paphos on Cyprus, Antioch on the Orontes in modern Turkey, and perhaps most spectacularly, the cities of Roman north Africa. It is also clear that figural wall-paintings in fresco were employed to a remarkable extent in a range of houses. They too are central to the artistic culture of the Roman empire, and very fine examples survive intact from sites across Italy and the provinces, including the important discoveries at Ephesus (the so-called Hanghäuser), those of Ostia at the mouth of the Tiber, and of course the best survivals of all: the late republican and early imperial frescoes from

[4] Alföldy 1985b: esp. 94–156; Saller 2000. For overview of issues in relation to art see also introduction to D'Ambra and Métraux 2006: viii–xviii. For a basic introduction see Garnsey and Saller 1987: 107–25.

buildings at Pompeii, Herculaneum, and neighbouring settlements buried by the eruption of the volcano Vesuvius in AD 79. We shall concentrate on these Campanian examples, although it is important not to see them as straightforwardly representative of Roman art in general.

It is somewhat harder to contextualise less durable and more portable works of domestic art, though many were made and used, and some of these do survive well from certain sites like Pompeii. We shall look briefly here and in Chapter Five at some domestic sculptures and the luxury items that were involved in affluent Romans' presentation of themselves.

Roman tombs belong to a different sphere of Roman life, and by law they had to be sited outside the confines of towns. Nevertheless, they were physically not far removed from houses and in some places, including the city of Rome itself, they clearly jostled with entrances to grand suburban villas. Moreover, the tomb buildings that accommodated the dead have sometimes been likened to houses. The metaphor itself was common in antiquity; as one inscription from Rome declares: 'haec est domus aeterna' – 'this is our house for eternity'.[5]

The Romans used sculptures and paintings in many ways to commemorate the dead or adorn funerary spaces. Tomb buildings themselves might be elaborate and were sometimes decorated with figurative stuccoes and paintings. There were funerary statues and busts. At different times and different places there was a great variety of marble cinerary urns, sarcophagi, and gravestones, many of them bearing appropriate imagery selected to convey messages about the status and identity of the dead and their relation to the living. More than domestic art, funerary art in general seems to make strong, sometimes conspicuously ideological, assertions about the identity of the deceased. In the discussion of funerary art below we shall examine just a few examples of the messages – deliberate, unconscious, or incidental – that are communicated by the funerary art of differing groups in Roman society: the socially mobile and insecure as well as the wealthy and well established.

THE ART OF THE HOUSE

'No marker of identity was more profound, in the world inhabited by the Roman elite, than the "private" house.'[6] Indeed, Roman literature presents a lucid vision of how, ideally, houses, villas, and the works of art they contained might both display and help to inform the social 'personae' of their owners.[7]

[5] *CIL* VI 9583. [6] Elsner 1998b: 44. [7] See esp. Hales 2003: e.g. 3.

The role of art is most conspicuous in descriptions of aristocratic villa retreats, and perhaps most of all in the work of the late first-century AD poet Statius. Statius devotes two poems to the praise of his admirable friends' luxurious villas at Tibur (Tivoli) near Rome and on the Bay of Naples.[8] He applies his florid verse to evocations of landscape and architecture, exotic woods and marbles, and precious antique works of art:

I beheld the arts and crafts of the ancients, and metals that lived in various forms. It is a labour to tell of the figures in gold, or the ivory, or the gems worthy of gracing fingers . . .[9]

Why should I tell of ancient forms of wax or bronze, of anything that the colours of Apelles rejoice to animate, or of anything carved by Phidias's hands . . . ? Or what was conjured into life by Myron's art or the chisel of Polyclitus?[10]

Statius is here conjuring up a world of leisure appropriate for an adherent of Epicurean philosophy.[11] The general word for the aristocrat's retreat into the cultivated delights of villa life is *otium* – as opposed to *negotium* (public life and business). The sphere of *otium* was dominated by Hellenising pleasures such as the reading and writing of literature (it is to this literary world that Statius's poetry itself chiefly belongs), philo-sophical discussion, and admiration of antique sculptures and paintings.[12] The appropriate artistic furniture for this environment was considered to include Greek-style mythological sculptures, and particularly those that related to the wine-god Dionysus/Bacchus and his companions – especially satyrs, nymphs, and maenads – or associated figures like the uncouth Hercules, playful cupids, or demigods of the ocean. Insofar as provenanced Roman villa sculptures survive, they are dominated by this theme (cf. Figs. 5 and 34).[13] Their garden settings were works of art (or artifice) in themselves: elaborate and carefully planted spaces with water-features and contrived views.[14] They constructed an escapist fantasy for the very wealthy owners of villas.

Even in such pleasurable surroundings, however, art was conceived as having a more serious, active role in the intellectual and cultural

[8] Statius, *Silvae* 1.3; 2.2. On his descriptions note Leach 2004: 173–5. [9] Statius, *Silvae* 1.3.47–9.
[10] Ibid. 2.2.63–7. On these proverbially famous classical Greek artists cf. Chapter One.
[11] Ibid. 1.3.90–110; 2.2.113.
[12] Ibid. 1.3.90–110 (using the phrase 'docta ... otia' – 'learned leisures'); 2.2.112–120; 4.6 esp. lines 20–31 (on art appreciation). On art collecting etc. see Bartman 1991, with references.
[13] Once again cf. the imagery of Statius's poetry itself: *Silvae* 2.2.99–109. On the thematic preferences in surviving sculptures see Neudecker 1988: esp. 31–64.
[14] On views particularly in Statius see Bergmann 1991.

formation of the patron. Suitable artistic ornaments do not only *reflect* the cultivation and sophistication of their owner; they also *make* the man. Alongside the art treasures in Pollius Felix's villa are:

the faces of chiefs and bards and wise men of the past, whom you take pains to follow, whose example you take completely to heart, free from cares, composed in your calm virtue and always in control of yourself.[15]

The allusion here is to galleries of portrait sculptures representing famous and worthy figures from (mainly Greek) history. The archaeological evidence shows that such portraits really were common in wealthy houses and villas, and while we might be inclined to see them simply as the trappings of an affluent and sophisticated lifestyle, these images are repeatedly explained in Roman texts as positive influences on people's lives, reminding a house's cultivated residents of their moral bearings.[16] In this way they complement more traditionally 'Roman' portraits such as images of ancestors which had been displayed in the home since republican times, or indeed the portraits of the emperor and his family which were also loyally exhibited in private settings.[17]

This phenomenon is spectacularly demonstrated in the famous Villa of the Papyri at Herculaneum.[18] At the time of its destruction by Vesuvius in AD 79, the villa contained a huge collection of bronze and marble sculptures acquired at indeterminate times during the previous century and a half. Unearthed from 1750 on, this collection of over 85 works represents one of the biggest Roman sculptural assemblages ever found. The sculptures were originally displayed in and around an atrium (a central hall), a square peristyle (colonnaded court), and a second, very large, rectangular peristyle. In the latter were found many of the typical ornaments of the luxurious villa garden: statues of satyrs and of Dionysus (Fig. 5); figurines of 'putti', animals, and even a lascivious Pan coupling with a goat (typical characters and theme, even if the particular rendering is unique). There were also numerous works of ideal sculpture in classical styles, including athletes and gods. But almost literally alongside these were small portrait heads, herms and statues portraying famous figures

[15] Statius, *Silvae* 2.2.69–72.

[16] See also Cicero, *Orator* 110; Seneca, *Epistles* 64.9–10. On such galleries see Neudecker 1988: 64–74; Zanker 1995, esp. 203–210.

[17] On these various portraits in the domestic setting see Neudecker 1988: 74–91. On ancestor images: Flower 1996.

[18] The key work in English is now Mattusch 2005. See also important documentation by Wojcik 1986 and Neudecker 1988: 105–8, 148–55.

Fig. 5 Bronze statue of a drunken satyr from the Villa of the Papyri, Herculaneum.
First century BC/AD (before AD 79).

from different spheres of Greek history and culture. Their identifications
are fraught with difficulty, but they certainly include Philetairos of Pergamon
and other Hellenistic rulers and political figures; Epicurus, Zeno, and
other philosophers (Fig. 6); and possibly some portraits of poets. In other
words, 'the faces of chiefs and bards and wise men of the past'. Close by
we find an assortment of contemporary Roman portraits which perhaps
ties all of this to the family histories of the villa's owners.

Attempts have been made to reconstruct elaborate, intellectual pro-
grammes of meaning from the collection of sculptures, and especially
thematic statements about the concept of *otium* and *negotium*.[19] That such
theories command no general approval suggests either that the pro-
grammes were too subtle for the modern viewer to retrieve from partial
evidence or, more likely, that they did not exist. The 'collection' may be
due to a more haphazard acquisition of generally appropriate sculptures.
But there is no doubt at all that they combine the typical, 'suitable' decor

[19] See e.g. Pandermalis 1971; Warden and Romano 1994. See also critical discussion in Stewart 2003:
252–9.

Fig. 6 Miniature bronze bust of Epicurus from the Villa of the Papyri, Herculaneum. First century BC/AD (before AD 79).

for Roman gardens and spaces of domestic leisure, with Greek and Roman portrait subjects carrying a clear moral, exemplary value. And although the strong emphasis on philosophers, especially Epicurus, may point to the particular proclivities of the owners, who had also assembled the villa's now famous philosophical library, it is well attested elsewhere in archaeology and literature. This is Statius's world.

The town houses of the rich might also be places of leisure and luxury, but in Roman literature they appear above all to be implicated in an ideology of proper public conduct, of political and social responsibilities and *negotium*. That is to say, Roman houses and their decorations are presented as reflecting, facilitating, and shaping the public persona of the master of the household, the *dominus*, as a figure who necessarily engaged in public life of some kind or other.[20] Cicero reveals the rules of the game as he sees them, warning also of the negative consequences of ill-judged

[20] Generally, see Wallace-Hadrill 1994 (on whom see further below); Hales 2003; Leach 2004: esp. 19–20.

domestic self-representation.[21] This ideal is expressed in a much-discussed passage by the Augustan architectural writer Vitruvius. Having distinguished between the parts of the (upper-class) house which are 'private' in the modern sense, and those spaces like vestibules and peristyles which are effectively open to uninvited guests, Vitruvius proceeds to explain which sorts of domestic architecture befit men of different stations in society. He argues that, in principle, houses should reflect the hierarchy of social relationships and the Roman patronage system. In theory, Roman citizens with any degree of wealth and status were 'patrons' who had a following of 'clients'; these clients were dependants of lower social status and included the patron's former slaves.[22] The patron could offer financial assistance and other kinds of support and favour. In return, clients collectively contributed prestige and represented the patron's power and standing. According to convention, clients paid their daily respects (*salutatio*) to the patron by greeting him in his bustling home each morning.[23] Thus the expectation is that 'ordinary' Romans – those with 'a common fortune' – visit the houses of others as clients, rather than accepting visitors in their own homes as patrons. Consequently, according to Vitruvius, they have no need of grand architecture. Other ranks and professions bring their own particular requirements, and towards the top of the social ladder:

for men of nobility, who hold offices and magistracies and whose duty it is to serve the people, there should be provided regal vestibules, lofty halls (*atria*), and spacious peristyles, planted areas, and broad avenues, refined for the embellishment of their dignity (*ad decorem maiestatis perfectae*).[24]

The spaces described by Vitruvius are functional and are therefore indicative of their owners' social activities. By implication, therefore, they serve to reflect status. Yet they are also required to exhibit the dignity of the magistrate in suitably majestic style, and so ultimately they serve as symbols of an elevated social position. They do not simply reflect it, they subtly help to *make* it.

What can these sources tell us about real Roman art and architecture? As historical evidence they pose problems.[25] They obviously relate to the perspective of not only the Roman 'elite', but often the very apex of

[21] Cicero, *De Officiis* 1.39.
[22] For an introduction to the system, with references, see Garnsey and Saller 1987: 148–59.
[23] For relevance to houses in Rome and Pompeii see Leach 2004: 21–8.
[24] Vitruvius, *De Architectura* 6.5 (quotation 6.5.2).
[25] For excellent analysis of the many literary sources relating to houses see Leach 2004.

Roman society: the senators and equestrians based in Rome, and the fabulously rich. Leaving aside the remains of imperial palaces, we have virtually no extant, physical evidence for the urban residences of such elevated Romans, and relatively little of their villa retreats. The historical texts are ideological in that they presuppose and reinforce the values and interests of these groups, and they are imbued with the moral assumptions of these classes. They are also sometimes complex works of literature, involving subtle self-representation by the authors themselves, as much as do the works of art and architecture they describe.

Most surviving Roman domestic architecture is considerably humbler in scale and decoration than the sumptuous properties evoked by ancient writers. Even on the Bay of Naples, where the Vesuvian eruption has impressively preserved several very large villas reminiscent of those in Statius's poems, the extant works of domestic art are, arguably, comparatively modest reflections of the wealthiest complexes of the late republic and early empire. The huge villa at ancient Oplontis (Torre Annunziata) near Pompeii, which may ultimately have belonged to the family of Nero's wife Poppaea, is one of the largest so far discovered in the region. Yet although it has extensive frescoes and the traces of beautiful gardens populated by statues, there are none of the luxuries like marble columns and revetments that characterised the grandest of residences close to Rome.[26] Sites such as Oplontis probably therefore represent a rather lower level in the Roman social hierarchy than that portrayed in classical literature. For what such a term is worth, we can perhaps imagine them as the property of the local 'gentry'.[27]

However, wall-paintings and other domestic decoration do not offer straightforward indications of social or economic standing. The choice of decoration at Oplontis might theoretically be explained by self-conscious modesty, for the condemnation of domestic *luxuria* is a recurring motif in Roman literature. Not everyone, in all periods, rejoiced in such display as Statius did (and even Statius feels obliged to claim, rather weakly, that his friend's villa contains 'pleasures without luxury'[28]). The scale of the villa at Oplontis (the excavated building alone ranges across nearly 120 metres) bespeaks an enormous investment of wealth even in the earlier phases of

[26] Ibid. esp. 75–85, 90–1. For the social status of villa-owners in the region see D'Arms 1981: 72–96. Generally on Oplontis see Clarke 1991: 112–23, 126–40, 166–70; Fergola and Pagano 1998; Mazzoleni and Pappalardo 2004: 126–64 (esp. for photographs).

[27] Leach 2004: 91.

[28] Statius, *Silvae* 1.3.92–3. Cf. Leach 2004: 167–76 for arguments about the evolving rhetoric of luxury in Roman literature.

Fig. 7 Wall-painting in the atrium of the so-called Villa of the
Poppaei at Oplontis. *c.* 40s BC.

its development, but its artistic decoration, extensive and beautiful though
it is, appears somewhat humbler. What is most striking is the reliance on
particular styles of wall-painting to create an *impression* of luxury.

The most extraordinary illustration of this evocation of luxury is
provided by several rooms at the centre of the villa, which preserve early
wall-paintings. These are so-called 'Second-Style' frescoes from around
the 40s BC. Paintings of this kind, in this period, rely on virtuoso illu-
sionism to create a sense of space beyond the surface of the wall, and in
these particular rooms we find some of the most impressive trompe-l'oeil
evocations of late republican, aristocratic luxury. In the surviving paint-
ings of the enormous atrium the viewer is confronted by illusionistic
columns of coloured foreign marble of the kind described in the houses of
Rome's richest aristocrats (Fig. 7). They flank fictive doors seemingly
inlaid with ivory and tortoiseshell and decorated with relief figures of
Nike (winged Victories). The imaginary walls are further adorned with
objects such as grand candelabra and shields suspended from the columns;
there are also 'shield-portraits' – portrait busts on shield-like discs – which
are connected in literature with Roman aristocratic families.[29] Several

[29] Leach 2004: 83–4. Columns: Pliny, *NH* 36.1–8. Shields: Pliny *NH* 35.12–14.

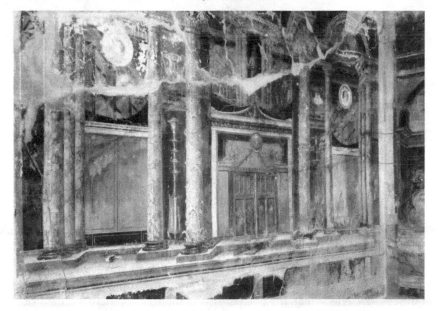

Fig. 8 Wall-painting in Cubiculum 14 of the so-called Villa of the
Poppaei at Oplontis. *c.* 40s B C.

smaller rooms with intact Second-Style paintings use different, fussier but
less ponderous scenes that were no doubt more appropriate to their
functions, and which are typical of contemporary paintings found in
other Campanian villas (Fig. 8).[30] Their illusionistic vistas skilfully
employ images of receding architecture to evoke a somewhat mysterious
open space beyond the wall. It is debatable whether this is supposed to
resemble a religious sanctuary or whether in its own way it too alludes to the
architectural extravagances of the most luxurious aristocratic properties.[31]

What is important here is that these are self-conscious illusions of
luxury, rather than the genuine luxury that is described, and often criti-
cised, in literature. Such paintings conjure up the impression of the
grandest of decor, but inasmuch as they show off the illusionistic skills of
the artists, inviting the viewer to marvel at them and to think about how
the illusion works, they must also necessarily be boasting of their own
unreality. It may therefore be that they amount to more than just ersatz

[30] The proximity of a kitchen suggests that room 15 probably served as a grand dining room; Leach
2004: 84–5.
[31] Ibid. 85–92.

luxury for the owner with limited wealth. In evoking luxury they avoid
not only the financial but also the *moral* cost of actually possessing it.[32]

Conspicuous modesty may therefore be one reason why Roman wall-
painting in general, in different styles, in different places and periods,
tends to be highly allusive: it alludes to grander settings and to imagined
spaces beyond the real confines of the room. Evocations of elaborate
architecture are common, both in the convincing illusionism of the
Second Style and in the later, more fantastical constructions of so-called
Third- and Fourth-Style painting.[33] But another reason for the tendency
to fantasise is the role that wall-painting plays in expressing the aspirations
of those whose potential for living in luxury was strictly limited.

Once it was established that wealthy houses were decorated in par-
ticular styles of wall-painting, it naturally became possible for much more
humble property-owners to imitate them and to harness some of the
positive associations of these grander houses. Wall-painting was com-
paratively inexpensive in the Roman world and it permitted a superficial
levelling out of social distinctions at least in the internal decoration of
houses – an effect that may have driven the development of new dec-
orative styles as patrons higher up the social scale sought to preserve those
differences.[34] What house-owners lacked in real capital, they might
compensate for with symbolic investment in their decor. The process by
which even relatively small houses could be assimilated to richer ones
through the use of painting can be charted in properties at Pompeii and
Herculaneum. Here Andrew Wallace-Hadrill's statistical survey of
selected houses demonstrates three tendencies.[35] First, there is an unsur-
prising correlation between the size of houses and the lavishness of their
decoration (he focuses on wall-paintings and mosaics, and more specif-
ically on mythological paintings with their connotations of education,
cultivation, and high status). Second, however, some wall-paintings, even
mythological paintings, and occasionally mosaics, do exist in the smaller
houses.[36] This means that 'the same status markers' are found to different
degrees throughout the spectrum of houses. Finally, Wallace-Hadrill
notes that the successive styles of wall-painting are increasingly wide-
spread across the range of house sizes; in other words, humbler houses
benefit from fresco decoration more and more as time goes on, and

[32] Cf. (with differing emphasis) ibid. 89.
[33] On the allusive qualities of the different styles see Wallace-Hadrill 1994: esp. 28–31.
[34] Ibid. 145–7. [35] Ibid. 143–74.
[36] In fact these can be found in the very smallest architectural units acknowledged in Wallace-Hadrill's
survey, which are mostly considered to be shops or workshops rather than 'houses' as such.

particularly in the period of the early empire. The 'luxury' of such domestic art trickles down through society. The availability of wall-painting compared with works of art that rely on valuable materials or rare skills ultimately allows those further down the social scale in a community like Pompeii to bridge the gap between themselves and their social superiors. Or at least it helps them to try, for this is still the imagery of aspiration, not of real social advancement.[37] There are other signs of this phenomenon in Pompeii, notably in some property-owners' disproportionate investment of space in gardens, rather than in 'useful' rooms. The result is the creation of some extraordinary 'miniature villas' in parts of the town.[38]

The phrase 'statistical survey' is not very common in books about art, and it may not be very welcome here. It is significant that Andrew Wallace-Hadrill is an ancient historian rather than a classical archaeologist or art historian; he asks broader questions about the social context and significance of art than are usual in Roman art history as such. But the success of the social history of Roman art depends on such broad questions, and in general more recent scholarship on Roman domestic art, in Pompeii and beyond, has tended to consider the kinds of issues surveyed above.[39] There has been a methodological shift away from a focus on classification, dating, and iconographical interpretation of isolated works, towards a social-historical approach. For instance, Roman painting is almost invariably classified using the chronological sequence of 'Four Styles' devised by August Mau on the basis of his research at Pompeii in the 1870s.[40] In the past a great deal of work on wall-painting has been devoted to refining the definition of these four styles and applying them to paintings all over the Roman world. In contrast, various recent studies have sought not merely to 'label' paintings in this sometimes rather abstract and over-simple manner, but to explain how they worked in context.

This approach is not only applicable to whole communities or groups of houses like those at Herculaneum. It is also useful in explaining the decoration of individual buildings. Wallace-Hadrill's work on the fundamental principles underlying the structure of the Roman house has

[37] Cf. Wallace-Hadrill 1994: 164–9. [38] Zanker 1998: esp. 145–56.

[39] Clarke 1991, Wallace-Hadrill 1994, and Leach 2004 typify the new approach in general works (and make references to numerous specific studies). Note the fierce debate on changing approaches, between Yerkes, Tybout, Bergmann, and Hallett in *JRA* vols. 13–15 (2000–2002). For a comparable shift in the study of domestic mosaics note Kondoleon 1995; Muth 1998 (note e.g. 25–7); Muth 1999.

[40] Mau 1882. For a recent English overview see Ling 1991. Critical overview and introductory bibliography in Stewart 2004: 74–84.

been particularly influential.[41] He takes Latin literature as his starting point, arguing that houses at the Vesuvian sites reflect more or less the same assumptions expressed by writers like Vitruvius in reference to the homes of the metropolitan elite. For example, in simple terms, as we have seen, large Pompeian houses are designed to facilitate the activities of wealthy citizens and advertise their status in appropriate terms. Lofty atria lie at the heart of such houses, providing a semi-public space for receiving clients and visitors. The *tablinum* – an open room conventionally giving onto the back of the atrium – is regarded as the traditional focal point where the *dominus* might wait to greet these visitors.[42] Other parts of the house could also be used as reception rooms but, on the whole, rooms separated from the central atrium are regarded as more secluded, more exclusive places. Dining rooms, bed chambers (*cubicula*), and some other rooms in these areas perhaps tended to be reserved for more privileged guests or friends, or for the house-owner and his family, though this is a matter of degrees: there is no sharp distinction between the public and private parts of the house. A substantial house will also have had more humble rooms and passage-ways intended for the accommodation or work of slaves, or for commercial and industrial activities. These too would have differed in their degree of privacy or accessibility.

In this way the parts of the Roman house are measured against sliding scales ('axes of differentiation') according to whether they are more public or private, grander or more humble. The hypothetical pattern of activities associated with these different spaces (and mentioned by Vitruvius and others) can indeed be traced approximately in the scale, position, and extent of rooms in real Pompeian houses, while various evocative architectural features amplify the functional differences between rooms. For instance, the architecture of grand, 'public' spaces like atria and peristyles, with features such as classical columns, recall real public buildings and create an appropriate setting for the house-holder's business affairs.[43]

Wallace-Hadrill argues, moreover, that functional differences between domestic spaces are also articulated in their artistic decoration, and most straightforwardly by the wall-paintings that survive. Within the same house different uses of colours, detail, and figurative imagery might be

[41] Wallace-Hadrill 1994. Cf. Leach 2004: esp. 18–54.

[42] Note Wallace-Hadrill 1994: 51–2 on the atrium and tablinum, and their gradual disappearance. For critical reconsideration cf. Leach 2004: 20–6; Trimble 2002, which is also an interesting attempt to relate the *salutatio* to mythological display and considerations of gender.

[43] For architectural features in such spaces that evoke public buildings see Wallace-Hadrill 1994: esp. 17–37.

employed to set up contrasts between the rooms. The repertoire of Roman wall-painting with its complex allusions to various kinds of public architecture offered a sort of language through which grander rooms could be contrasted with one another according to their importance, function, or prominence. Similarly, humbler spaces were distinguished by being less carefully painted (if they were painted at all); they were sometimes de-emphasised by simple, repetitive decoration, often merely space-filling zigzag stripes.[44]

According to this view of the Roman house, its art is bound to provide an index of the status of the owner. More importantly, domestic art emphasises the messages that the architecture is *meant* to communicate about the proprietor's role in society, and it effectively demarcates the different spheres of activity in the house, reflecting the Roman social hierarchy as it does so:

the dominant concern in articulating domestic space was to provide a suitable context for the differentiation of public activities from those of a more private nature, and for the activities of persons from the full social spectrum: from members of a public figure's peer group and his circle, through lesser *amici* (friends), to humbler dependants, tradesmen, and slaves.[45]

This approach concentrates on the social functions of works of art such as wall-paintings, and this helps to explain their appearance. It moves beyond mere categorisation and description, or isolated analysis of individual works. And although it can be still be criticised for being excessively schematic or artificial, it does, broadly, appear to work. At Oplontis, for example, we can detect dramatic differences in the character of wall-paintings that were made at the same time (compare Figs. 7 and 8). If such differences are meaningful at all, they can be explained only within a social, rather than a purely chronological framework.

LOOKING FOR TRIMALCHIO

The quality of artistic and documentary evidence at Pompeii and Herculaneum is so high that there has always been a temptation to 'read'

[44] The description of these 'rules' in the 'language' of Roman domestic architecture and decoration inevitably involves simplification of a messier reality, and of course most people did not have the opportunity to design and decorate their houses just as they required – the art of Pompeian houses represents generations of changing tastes. Note also extensive critique of Wallace-Hadrill and other text-based approaches in Allison 2001.

[45] Wallace-Hadrill 1994: 12.

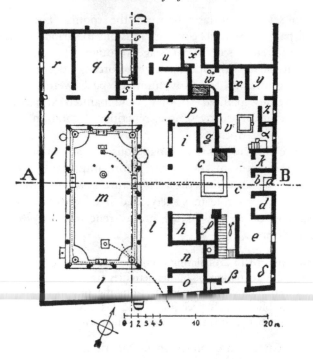

Fig. 9 Plan of the House of the Vettii in Pompeii.

houses for even more specific messages about the status, identity, and even the personality of their owners.[46] The interpretation of the House of the Vettii, one of the most beautiful and best preserved large houses in Pompeii, is typical of this tendency to reconstruct Roman lives from archaeological remains (Figs. 9 and 10).[47] The house occupies a quarter of a block near the forum of Pompeii. In its surviving form it dates to the first century AD, though there were probably houses on the site in the second century BC or earlier. Virtually all of its surviving paintings seem to date from around the 60s AD (after the earthquake of AD 62). It is a rather unusual shape – broader than it is long – and it lacks a *tablinum*, so it does not quite conform to the 'typical', traditional configuration of the Roman house described by Vitruvius and frequently attested at Pompeii. Nevertheless, like other Pompeian houses it centres on a large atrium,

[46] Ibid. 66, 118–142 on past attempts to pinpoint the social status of house-owners and for critique. For Amedeo Maiuri's tendency to read houses as reflections of class see Maiuri 1929: e.g. 69.
[47] On the House of the Vettii in general and in detail see Mau 1896; Sogliano 1898; Clarke 1991: 208–35.

Fig. 10 Wall-painting panel from *oecus* n, House of the Vettii: the infant Hercules strangling snakes. *c.* 60s AD.

behind which is a substantial peristyle garden. There are very rich and lavish paintings in the 'public' atrium and, particularly, in the more secluded dining or 'reception' rooms (*oeci*) off the peristyle. Paintings in more marginal or less important rooms are cruder or simpler, the decor once again being a function of their status and purpose; they include elegant but sketchy sex scenes in a 'cook's room' off the kitchen and bold, frontal images of household deities in a shrine (the *lararium*).

The paintings of the House of the Vettii are all executed in Mau's 'Fourth Style', which was favoured in the last 30 years of Pompeii's existence. (This 'style' really consists of a varied repertoire of forms that recall earlier fashions in decoration: the fictive architecture and illusionistic vistas of the 'Second Style' and the more flimsy, fantastical, decorative details of the 'Third Style'.) The finer walls include numerous elements that refer to educated Romans' shared heritage of Greek mythology. Most notably – and typically for Fourth-Style decoration – several rooms (e, n, p, q, and t) had mythological scenes in panels in the

centre of the walls. Fresco panels of this kind possibly alluded to much grander picture galleries (*pinacothecae*) with real, antique portable panels, which are attested in literature.[48]

Those in rooms n and p are extremely well preserved. The example illustrated here from the left-hand wall of room n (Fig. 10) shows the moment when the infant Hercules demonstrates his future potential by killing serpents sent by Juno to kill him. This is a classicising scene that corresponds to Pliny's description of a work by the famous Greek painter Zeuxis, and that masterpiece is conceivably its ultimate source.[49] This does not necessarily mean that the scene in the House of the Vettii was consciously intended as a copy, though it is possible that the source was recognised. At the very least such paintings imply an educated familiarity with literary and artistic renderings of Greek myths, which cannot but be a comment on the patron's social status. The other myths depicted in this room, and, in a similar arrangement, in room p, have much in common, and there have been more or less plausible attempts to argue that their arrangement is programmatic – that all the paintings complement each other in conveying certain themes. One must be cautious about such claims, for no doubt shared themes could be identified in any combination of Greek myths. But whether or not the subjects of the panels were deliberately linked, it is easy to imagine that the owner of the house and his guests could engage in erudite discussion of these stories that were probably familiar mainly from literary versions.[50]

The Hellenising character of the decor extended to the peristyle garden, which was furnished with two double herms and a dozen statuettes. Most were of painted marble, but two were bronze. Some of them served as fountains. The largest of these was an unusual image of the ithyphallic god Priapus (who was associated with Dionysus and with fertility); he served as a fountain, with water spouting from his erect penis. The other sculptures were generally more closely connected with Dionysus and included cupids, satyrs, maenads, and images of the god himself.[51] There were other furnishings carved in a variety of white marbles.

[48] Zanker 1998: 190–2; Leach 2004: 132–52. [49] Pliny, *NH* 35.62–3.

[50] On the possibly programmatic use of the paintings see Thompson 1960–1961; Brilliant 1984: 53–89. On this example see esp. Wirth 1983; Brilliant 1984: 71–3; Clarke 1991: 223–7, 233–4 for critical comments on the thematic unity of the decorations. The subjects are as follows. Room n: the infant Hercules; the death of Pentheus; the punishment of Dirce. Room p: Pasiphaë and Daedalus; the punishment of Ixion; Dionysus finding Ariadne.

[51] On the sculptures see Mau 1896: 36–43; Clarke 1991: 211–14 (with updated identifications) and interpretation.

Faced by such a rich assemblage of pristine artistic finds, scholars cannot resist asking: what sort of person lived in a house like this? From the general impression given by the art and architecture alone we might answer: someone wealthy, who has and wants to display cultivated tastes; someone who has a significant staff of slaves to maintain such a place; someone who receives visitors through an impressive atrium. The excavator's full publication of the house in 1898 describes it as an important dwelling of well-to-do people; he refers to 'the fortunate inhabitant of this rich and splendid house'.[52]

Since then, however, a century of more detailed speculation has crystallised into firm assumptions about the inhabitants and their taste in art. In fact, it appears that we really do know a little bit about who these people were. Many of the modern names given to houses in Pompeii are based on more or less spurious guesses about the identity of their occupants, but the House of the Vettii is so called after bronze seals bearing names which were discovered in the house itself. One of these admittedly belongs to a certain P. Crusius Faustus, but he has been explained away as, perhaps, an upstairs tenant. Two further seals discovered in the atrium name individuals called Vettius: Aulus Vettius Restitutus and Aulus Vettius Conviva. The latter name seems to figure as a monogram on a fourth seal and possibly also in a fragmentary painted inscription on the exterior of the house.[53] So there is strong evidence to suggest that these Vettii were closely associated with the property. Were they its owners, or did they work there? Were they members of the family of Vettii attested as significant figures in Pompeian public life? An A. Vettius Conviva – surely the same Conviva – features as a high-ranking witness on a financial document found in the so-called House of Caecilius Iucundus. This, together with the painted inscription on the house, suggests that he was an *augustalis*.[54] The augustales were wealthy members of local institutions that were involved in the imperial cult and in public benefactions. It appears that the great majority of them were freedmen (it was the closest a freedman could come to having the rank and prestige enjoyed by freeborn magistrates).[55] From this chain of inferences it is a reasonable guess that Conviva was indeed an important freedman owner of the House of the Vettii at the time of its destruction. This notion is reinforced by the

[52] Sogliano 1898: 234, 388.
[53] External inscription: *CIL* IV 3509. On the identification generally note (the controversial) Della Corte 1965: 67–71, here relatively cautious.
[54] See e.g. Andreau 1974: 172, 266.
[55] Duthoy 1978 for general discussion of different kinds of augustalis.

symbols of prosperity – notably attributes of Mercury – that appear in the paintings of the house, and which seem to have been popular with freedmen, for whom trades and commerce might offer advancement. We cannot truthfully say much more than this.

Nevertheless, further assumptions are frequently made: that both Vettii were freedmen and joint owners of the house (plausible but not demonstrable); that they were brothers (very unlikely, if by this we mean natural brothers);[56] that they themselves commissioned the sculptures and paintings that survive in the house (not certain, even if they were indeed the owners); that their business activities are alluded to by an intricate painted frieze of industrious cupids in room q (pure speculation); and, especially, that their social status is reflected by the tone of the works of art throughout the house – that this is characteristically the art of freedmen. John Clarke argues these points particularly strongly:

> ... the two freedmen brothers who owned the House of the Vettii, had done very well for themselves indeed... Their house, not the largest at Pompeii but perhaps the finest in the quality of its Fourth-Style decoration, expresses in several fashions their nouveau-riche mentality.[57]

For those who follow this line, two things particularly suggest the vulgarity of newly rich freedmen. On the one hand, there is the colourful extravagance of artistic display in what is a large but relatively confined house. To some this looks like a desperate attempt to ape the decoration of aristocratic homes. On the other hand, there are particular elements which seem to betray bad taste or an unrefined preoccupation with financial gain. These include the allusions to Mercury, the cupids frieze and, most spectacularly, the imagery of Priapus, for besides the spurting statuette in the peristyle, there is a large painting of the god weighing his gargantuan phallus against a bag of coins right at the entrance to the house, inside the vestibule – to the perpetual delight of modern tourists.[58]

But this dismissive reading of the House of the Vettii is not based on art or archaeology alone. Behind it is the fictional literary figure of Trimalchio. Trimalchio is an exaggerated caricature of an ostentatious, nouveau-riche freedman and augustalis, who hosts a grotesquely lavish,

[56] The myth of the Vettii brothers is almost universally accepted, even in the latest, highly sceptical treatment of the subject (Petersen 2006: 5–6). If they were ex-slaves of the same household they could be considered 'brothers' in that sense, now enfranchised as Vettii. But then their shared name would be adopted from their former master – one Aulus Vettius – and would not imply any natural blood relationship, as is always at least implied.
[57] Clarke 1991: 208. [58] On the use of this 'evidence' see Petersen 2006: 5–6.

bad-taste banquet in Petronius's first-century novel, the *Satyricon* (or
Satyrica). He has wealth, and influence, and art, and luxury, but he can
never acquire the true currency of education and cultivation which is
implicitly shared by the (apparently) senatorial author and his aristocratic
readers, and the freedman makes crude mistakes in his attempts to show
off.[59] Thus his house contains Homeric paintings, but they are boorishly
juxtaposed with a scene of gladiatorial games;[60] he has a sculpture in the
rare 'Corinthian bronze' that was much prized by connoisseurs, but it is
merely a sculpture of an ass that he uses as an olive-holder;[61] he shows off
his possession of silver vessels, but overdoes it when he has them swept up
with the rubbish;[62] he displays his education with allusions to Homer and
Greek mythology, and boasts of the mythological scenes on his silverware,
but gets the stories hopelessly confused and places more value on the
weight of the metal than on the vessels' artistic quality.[63]

Time and again scholars compare the Vettii 'brothers' to Trimalchio,
often quite emphatically.[64] A similar attitude is adopted towards other
Pompeian houses as well.[65] These sorts of assumptions are not neces-
sarily mistaken, and they are not wholly without foundation, yet they
represent an unsound approach to the social contextualising of art.
It is a kind of 'social history of art' that is a world away from the
historical analysis of scholars like Wallace-Hadrill (the divergent meth-
ods remind us that 'the social history of art' can mean very different
things). Interpretations of sites like the House of the Vettii are unsound
for several reasons. First, they depend to an extent on our imposition of
modern (middle-class western academics') taste onto Roman usage of
art. It is becoming increasingly clear, for instance, that our aversion to
dense juxtapositions of differing decoration, or to objects like lamp-
stands fashioned from Polyclitan statuettes (as in the 'freedman' House
of the Ephebe at Pompeii (Fig. 35); see Chapter Five), is an anachron-
istic response that would have made less sense to Romans.[66] Second, as
we have seen, scholars have relied heavily on Petronius's *Satyricon* as a
key to understanding the class-specificity of Roman art, despite the fact

[59] Clarke 1991: 220, 234. [60] Petronius, *Satyricon* 29. [61] Ibid. 31; cf. 50–51.
[62] Ibid. 31, 34. [63] Ibid. 52; cf. 48, 50, 59.
[64] E.g. Clarke 1991: 220, 234, 368. Butterworth and Laurence 2005: 229 – 'The slightly ludicrous air of
self-promotion that pervades this house points to its owner being very much the kind of man one
might imagine Petronius's Trimalchio to be: ostentatiously proud of his achievements and rather
vulgar in how he chose to demonstrate his wealth.'
[65] Note the retreat from this position in Zanker 1998: 192–203 with 240 n. 165. See now also Petersen
2006: 123–62 for extensive discussion of the problem, with other examples.
[66] Zanker 1998: 178. Cf. Marvin 1997.

that Trimalchio is a fictional caricature.[67] Even assuming that we have
properly understood the (aristocratic) author's snobbery, does it help us
to adopt the same point of view in explaining Roman art? Third, we
have little opportunity to test the assumption that the art of houses
linked to freedmen is 'typically vulgar', for we do not have sufficiently
comparable 'respectable houses'. Or do we? How would we recognise
them if we did?[68]

Yet, despite these necessary methodological cautions, it is true to say
that the art of Trimalchio repeatedly recalls real works of domestic art
found in Pompeii and elsewhere in the Roman world. Trimalchio's house
is guarded by a realistic painting of a hound with the inscription 'Cave
canem!' (beware of the dog); mosaics and paintings of this kind do survive
at Pompeii, most famously the inscribed guard-dog mosaic at the entrance
of the House of the Tragic Poet.[69] A painting in his house depicts
Trimalchio in the guise of Mercury, the god of commerce; similar 'dei-
fying' portraits of freedmen were indeed used in funerary sculpture.[70]
Trimalchio has a statuette of Priapus at his banquet; his is a fake fruit
holder made from pastry, but reminiscent nevertheless of the fountain in
the House of the Vettii.[71] Trimalchio commissions his own tomb, which
is to be decorated with reliefs of sailing ships, gladiatorial fights, and his
distribution of largesse to the public; such themes are well attested on real
monuments (including the tomb of Vestorius Priscus, below).[72] Most
interestingly perhaps, there are some extraordinary parallels for one par-
ticular incident in Trimalchio's banquet, when the host embarks on a
banal lamentation about the brevity of life:

as we were drinking and admiring the luxuries with the utmost care, a slave
brought a silver skeleton made in such a way that its joints and vertebrae could be
flexed and bent in every direction. He threw this down on the table repeatedly
and its articulated structure fell into several poses. Then Trimalchio declared:
'Alas, how wretched we are! The whole of man is nothing! So we shall all be when
Death carries us off. So let us live while things may go well for us!'[73]

[67] For critique of 'Trimalchio vision' in general see Petersen 2003: 238–40 and Petersen 2006: passim.
Cf. Leach 2004: 309 n. 117. Cf. also D'Arms 1981: 97–120.
[68] See Wallace-Hadrill 1994: esp. 65–90 on limitations on making such judgements and for objective
criteria (however, the fact that the House of the Vettii falls into his top quartile – of richest houses
in his sample – demonstrates the problems with more subtle distinctions, e.g. between houses of
aristocrats and freedmen).
[69] Petronius, *Satyricon* 29.
[70] Ibid. Cf. Wrede 1981: 273–83, and esp. 68, 98–9 for Mercury's associations for freedmen.
[71] Petronius, *Satyricon* 60. [72] Ibid. 71. [73] Ibid. 34.

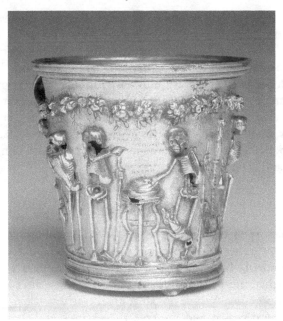

Fig. 11 One of the skeleton cups from the Boscoreale Treasure.
Early or mid-first century AD.

A number of model skeletons do survive, including just such an articu-
lated silver skeleton, found at Pompeii.[74] But Trimalchio's display is also
reminiscent of two famous cups discovered in a hoard of silver at a villa
near Boscoreale, just outside Pompeii (Fig. 11).[75] These matching silver
cups bear relief figures of skeletons who ironically enjoy the pleasures of
feasting and music. Some of the skeletons are identified with Greek
inscriptions; they include famous philosophers (Epicurus, Zeno) and
playwrights (Sophocles, Euripides). And there are also appropriate texts
which refer to the figures and, like Trimalchio, make conventional
comments about the lot of mankind: 'life is a stage'; 'enjoy yourself while
you live'.

The Boscoreale Treasure includes some of the finest silver plate to
survive from antiquity, so the hint that it might represent the tastes of
some kind of real-life Trimalchio is disconcerting. Do all the parallels

[74] Guzzo 2006: 89, no. 41. On these figures and other skeletal imagery see Dunbabin 1986; Dunbabin
2003: 133–6.
[75] Héron de Villefosse *c.* 1895; Dunbabin 1986: 224–31. Guzzo 2006: 186–8, no. 272 for one of the cups.

with Trimalchio's world suggest, in fact, that the domestic art that
dominates the surviving archaeological record, that to a large extent
encapsulates Roman art for us, is the art of the 'middle orders' in Roman
society: the norm rather than a rather laughable exception? Perhaps that
the snobbish perspective of Petronius's *Satyricon* is peculiar merely to the
small aristocratic minority? And from this perspective, does it make much
sense to bracket a broad segment of Roman art and society under the
heading of a 'middle class'? With this mention of skeletons, let us turn our
attention to the funerary monuments that expose the complexities of
Roman art and society in rather different ways.

THE ART OF THE TOMB

Most inhabitants of the Roman world have left no monument behind
them. In many cases this is because they were too poor to afford any
durable memorial. Nevertheless, it is clear from literary sources and
inscriptions that the preservation of one's memory after death was of
enormous importance. Where possible, great care was taken to protect the
remains of the deceased and preserve their name, and many took steps
while they were alive to secure their place in posterity.[76]

In the late republic and early empire the prevailing custom was to
cremate the dead. Their ashes were deposited in containers, which were
then preserved either buried in funerary plots or placed within tomb
buildings or other forms of monument. In Italy the finest containers and
markers for cremated remains included elaborately carved marble cinerary
urns and altars that often had recesses (Figs. 3 and 4). Alternatively, if the
ashes were buried in the ground, the spot could be marked with a *stela* or
gravestone. Inscribed and sculpted gravestones were very widely used
across the empire in the first and second centuries AD and later (Figs. 38
and 39). During the second century AD inhumation grew in popularity
(if popularity is the right word) and began slowly to replace cremation as
the preferred means of disposing of remains. The reasons for this change
are obscure.[77] It did not make much difference to most aspects of funerary
practice, nor to the basic forms of tomb-buildings, but it did result in the
widespread use of stone sarcophagi which lent themselves to extensive
decoration with sculpted relief (see below).

[76] On Roman death, burial, and commemoration in general see Toynbee 1971; Carroll 2006; and
articles in Hesberg and Zanker 1987.
[77] Cf. Morris 1992: 31–69.

The imperative to preserve memory as effectively as possible meant that the more substantial tombs, in which many members of a household and its dependants might be buried, were often prominently sited along the roads around towns. Some adopted striking designs, such as miniature pyramids, or cylinders, or gigantic altars; some used inscriptions to address passers-by and invoke their attention and sympathy.[78] They were self-evidently intended to celebrate the lives and the identities of the people who were buried there. They were also monuments for the living, not only because they advertised particular families, but also because family members themselves continued to visit the site regularly, commemorating their dead relatives with feasts, offerings, and sacrifices on particular anniversaries and festivals.[79]

Striking architectural forms were obviously intended to attract attention and imply the wealth and importance of the families and individuals involved, and indeed some of the largest and most remarkable tombs that survive clearly belong to the imperial family and the senatorial elite. For example, famous among the surviving monuments of Rome are the mausolea of Augustus and Hadrian in Rome (both originally over 40 metres high); the gigantic cylinder-tomb of Caecilia Metella on the Via Appia (almost as tall); and the exotic pyramid of Gaius Cestius. However, the implicit claims to status made by the tombs themselves can be deceptive. It is significant that the very grandest senatorial tombs mostly belong to the late republic and very early principate (imperial period). Thereafter aristocratic taste or perhaps the comparatively precarious position of senatorial families under imperial rule seems to have favoured a more circumspect approach to funerary display, and it may be, for example, that the largest and most conspicuous remains of monuments in imperial Italy disproportionately represent rather lower social classes, including wealthy freedmen.[80]

There is certainly some evidence from the city of Rome and smaller towns to suggest that these wealthy *liberti* particularly favoured expenditure on impressive funerary monuments. The fictional Trimalchio once again provides a seductive paradigm for scholars trying to understand such 'middle-class' tombs.[81] For, as we have seen, elements of his monument, as he prescribes it in the *Satyricon*, are echoed by real tombs,

[78] For the various forms see Hesberg 1992. See Eisner 1986 for examples around Rome. On the appeal to passing viewers see e.g. Clarke 2003: 182–4.

[79] Toynbee 1971: 61–4. [80] See Hesberg 1992: esp. 26–42, 239–40.

[81] Petronius, *Satyricon* 71. Petersen 2003; Petersen 2006: 84–120.

Fig. 12 Tomb of M. Vergilius Eurysaces and Atistia, Rome.
Second half of first century BC.

if not its phenomenal scale (with a frontage of 100 Roman feet it is many
times greater than the average for attested freedman tombs), then at least
its sculptural imagery.[82] The most commonly cited real-life analogue for
Trimalchio's fictional tomb is the bizarre monument of the baking
contractor Marcus Vergilius Eurysaces and his wife Atistia, which was
constructed on a very prominent site on the Via Labicana just outside
Rome in the second half of the first century BC (Fig. 12).[83] With a height
of around 10 metres, it is one of the most spectacular tombs to survive
around the capital, but circumstantial evidence supports the (virtually
universal) assumption that Eurysaces was a freedman, and the monument
has been taken to reflect the vulgar tastes of this real-life 'Trimalchio'. The
monument incorporates cylinders, which perhaps imitate kneading

[82] For parallels with real tombs: Whitehead 1993; Clarke 2003: 185–7. For comparisons of scale see
Eck 1996: 256.
[83] For full documentation of the tomb see Ciancio Rossetto 1973. Generally: Petersen 2003; Petersen
2006: 84–120.

machines or grain-measuring vessels (not a bread oven, as has sometimes been claimed). An inscription implies that Atistia's ashes may have been deposited in an urn shaped like a bread-basket. Near the top of the tomb runs a relief frieze representing stages in the process of bread production. Is this just the sort of bathos we might expect from a nouveau-riche parvenu?

Lauren Hackworth Petersen has presented a strong critique of this sort of interpretation of Eurysaces' tomb through the model of Trimalchio, and by contextualising the tomb she shows that its decoration owes more to the need to perpetuate memory than a desire to show off.[84] But even if it is viewed in a positive light, the monument does suggest that funerary art and architecture could be particularly important for a minority of freedmen who managed to attain wealth and relative status in society, but to whom other avenues for self-promotion such as the holding of magistracies were closed. In fact, through the slice of funerary architecture excavated at Pompeii we can see how a few freedmen – as it seems – who attained some kind of prestige as augustales are actually very prominent in the prestigious cemetery areas immediately outside the town walls.[85]

In general it is the funerary art of freedmen that makes the most clear and explicit claims to social status and public identity. It would be easy to assume that their monuments represent an attempt to imitate the status-display of higher strata in society. But there is actually nothing to show that this is the case. They may adopt aspects of upper-class funerary imagery, as we shall see, but they do not attempt to disguise their actual status. It is evident from the epitaphs and iconography of freedmen that they often are, if anything, proud of their position in society and make no attempt to hide it.[86] They are, after all, the lucky few who have made it. Not only have they acquired their own freedom, usually citizenship, and the promise of even greater respectability for their descendants, but they have also become sufficiently prosperous to leave behind them a truly durable record.

Some of the ambiguities of this position are well illustrated by perhaps the best-known body of freedman art from Italy. These are the numerous funerary reliefs that were once built into tombs shared by groups of freedmen and their relatives.[87] Many of them survive along the Via Appia outside Rome, though they are not in their original settings. Figure 13 has typical characteristics of these 'freedman reliefs'.[88] It shows a family

[84] Petersen 2006: 84–120. [85] See Kockel 1983 for many of the tombs; Petersen 2006: 60–80.
[86] Cf. George 2006. [87] See esp. Zanker 1975; Kleiner 1977; Kleiner 1992: 78–81.
[88] Zanker 1975: 293–4; Kleiner 1992: 79.

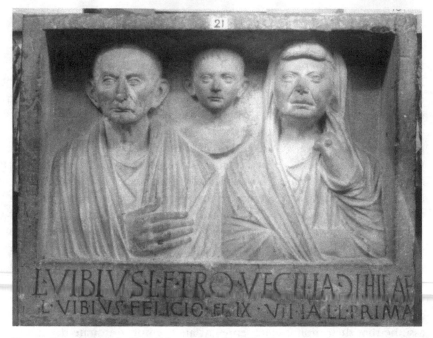

Fig. 13 Funerary relief of L. Vibius and Vecilia Hila. Rome. *c.* end of first century BC.

group. Husband and wife are respectably dressed, the man in the toga of a
Roman citizen, the woman with her head covered by her mantle. Her left
hand is raised in a conventionally modest gesture, which also happens to
display her wedding ring. Both of their faces are individualistic portraits,
but while we particularly notice the wife's so-called *nodus* hairstyle, which
recalls the contemporary fashion familiar in female portraits of the
imperial family, what is most obvious in the man's facial features are the
conspicuous signs of age. He has sunken cheeks, an overbite, balding
head, and sagging and wrinkled skin. The combination of fashionable
female figures with aged men is common in freedman reliefs. 'Signs of
age' is the right phrase, however, for they need not merely be a response to
the actual features of the man depicted. In fact, most scholars believe that
the sort of stark realism seen on such reliefs, which is often, rather con-
fusingly, termed 'verism', is an imitation of traditional features in the
portraits of late republican aristocrats and elder statesmen. If this is true
(and in fact there is only limited comparative evidence), then the freed-
men's use of 'verism' may be seen as an attempt to appear as highly
respectable, established Roman citizens.

On this relief, there is a hint at the present and future respectability of the family in the portrait bust between the couple. This is the kind of family bust that might have graced both grander tombs and upper-class houses, but it is not the image of an ancestor, but rather of the couple's son. The relief may have been made while the parents lived but after the child's death. Yet the promise that he offered is expressed in his hairstyle and face, which imitate those of the imperial princes, Lucius and Gaius (perhaps the sculpture dates to after their own premature deaths in AD 2 and 4 respectively). Such hints at the promise of further, future respectability are common.

Sculptures of this kind are sometimes considered aspirational, but that term is misleading, for it implies that they allude to something that has not been attained. In fact, on the contrary, images like these are images of the success that has already been accomplished.[89] Occasionally they incorporate the markers of a particular profession or tools of the trade that has brought prosperity.[90] Where the inscriptions survive, they quite clearly indicate the freedman status of those represented. As for the portraits themselves with their veristic features: the more we see of these, the less they appear to be imitations of upper-class self-representation; rather, they begin to form an impression of collective identity, inadvertently signalling membership of a whole class of the socially mobile. If the imagery in fact constitutes a collective expression of identity, then no doubt this owes much to the relative disdain in which the freedmen of the period were held, but it does not mean that the freedmen were pretending to be something that they were not.[91]

It should be noted, however, that the example shown above is by no means a straightforward 'freedman relief'. While typical of such monuments, it actually commemorates a couple of mixed origins. While Vecilia is indeed a freedwoman, her husband is freeborn. There is plenty of evidence in these reliefs and other sources for intermarriage between freed and freeborn men and women who can be regarded as belonging to the same social milieu. Many of those sculptures that now lack inscriptions may have commemorated freeborn citizens. Consequently, although this body of monuments was particularly popular among *liberti*, it is perhaps misleading to describe it as freedman art, rather than defining it in hazier terms as the art of a certain kind of 'middle class'.

[89] Zanker 1975: 284–5. Stewart 2003: 102.
[90] Zanker 1975: 300. Cf. Clarke 2003: 118–123. Zimmer 1982: passim.
[91] For the position of freedmen see e.g. Treggiari 1969. For disdain: Zanker 1975: 282–4; cf. Horace, *Satires* 1.6.7–8.

As we have seen, however, it is even problematic to use a term like 'middle-class', which is at best an approximate description of such a Roman social grouping, and at worst entirely anachronistic. The difficulty of applying labels like 'middle-class art' or 'freedman art' to any of the works that we have examined is clearly something of an obstacle to describing them and analysing them. Nevertheless, it is also helpful in reminding us of two important facts: first, the sharp distinctions of class and status – which the Romans themselves employed – apply only loosely to 'real life', and to an extent one's social status was malleable; second, artistic self-representation played an active role in the construction of social identity, so that we cannot straightforwardly divorce image from reality. Art, once again, was not a mere reflection of status but a component in the process of status-construction. Of course we, as historians, are the audience for this image-making as much as the ancient viewers, and we are more easily misled.

One particularly splendid and intriguing funerary monument at Pompeii helps to illuminate these various issues. The tomb of Vestorius Priscus was built by his mother on a prestigious plot of land, donated by the town council, just outside the Vesuvian Gate of Pompeii.[92] Vestorius himself was a junior magistrate, who died at the age of 22 around AD 71, just eight years before the eruption of Vesuvius. The monument is not atypical in design. It consists of an elevated cinerary 'altar' surrounded by an enclosing wall. The outside of the wall is plain and the altar is simply decorated in stucco. The interior of the wall, however, is richly painted with a variety of scenes in fresco which may all have had funerary significance, though this is debated. They include a beautiful table laden with silver drinking vessels, landscape and garden elements, a pomegranate tree, a Nilotic scene with pygmies, views of a banquet and Vestorius in his atrium. Other paintings probably related more explicitly to the ideal activities of a magistrate: a scene of gladiators alludes to the games that a magistrate might sponsor; a tribunal scene seems to represent Vestorius dispensing justice, or largesse, in the presence of citizens and attendants (Fig. 14). These are clearly statements about the status of the deceased as magistrate and member of the town council. Interestingly, however, these subjects correspond to those celebrated on the tombs of freedmen who had become augustales – for example, that of Lusius Storax at Chieti – besides the fictional tomb of Trimalchio.[93]

[92] See Mols and Moormann 1993–4; Clarke 2003: 187–203.
[93] For this comparison see Clarke 2003: 145–52 (on Storax), 185–7, with Fig. 101.

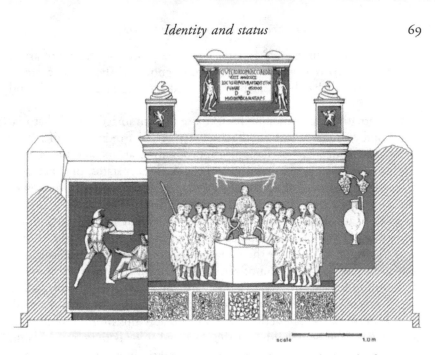

Fig. 14 Paintings of gladiators and a tribunal scene in the Tomb of
Vestorius Priscus, Pompeii. *c.* AD 70–1.

So why is there such an overlap between the iconography of freedmen
and the iconography of the petty aristocracy? Some would argue that the
Vestorii were of relatively low social status, part of a new, upwardly
mobile elite that supposedly came to dominate Pompeian political life
after a devastating earthquake in AD 62.[94] John Clarke includes this tomb
in his study of the art of 'ordinary Romans'. If this is true, then a young,
junior magistrate from such a family might effectively be of a similar
social status – in fact if not in law – to the wealthy freedmen who were
also prominent in towns like Pompeii (and whose tombs literally loom
large around the walls of the town). Such freedmen, as augustales, might
behave like magistrates in all but name.[95] Like freeborn town councillors,
they might be major benefactors of the community. From this perspec-
tive, then, art serves to express the essential shared culture of men like
Vestorius and their freedmen counterparts, which is belied by the formal

[94] Clarke 2003: 189. On arguments about social change in Pompeii and elsewhere see Mouritsen
1997.
[95] D'Arms 1981: 146–8. Note also Petersen 2006: 59–83, who is nevertheless critical of sweeping
assumptions about the freedman status or distinctive artistic culture of augustales.

distinctions between them.[96] It is the opposite process to the use of art in Petronius's *Satyricon*, where Trimalchio's ignorance shows up a social inferiority which has been all but obscured by his extreme wealth and power.

An alternative explanation is that the use of such imagery as gladiatorial games and tribunal scenes in the funerary art of freedmen marks their attempt to claim high social status, appropriating aristocratic imagery in order to efface their legal inferiority and claim a higher status. In either case, we have to understand the art itself as a dynamic agent in the construction of a social persona, and once again it becomes inadequate to talk inflexibly about the 'status' of individuals or the role of art in 'reflecting' that status.

There is one more important observation to make here – an observation of great importance for the social history of art, which concerns itself with audiences and reception of art. The beautiful paintings in the tomb of Vestorius Priscus are virtually invisible, or at least unviewable. Only those who entered the tomb enclosure through a tiny door in its rear wall could observe the pictures effectively. Presumably this means members of the *familia* – the household – of the deceased. Nor is there much room within the enclosure to enjoy the view. Unlike some funerary precincts which have room for visitors to dine in the presence of the dead, this tomb leaves only about a metre's space in which to edge around the interior of the wall. The corollary of this is that the paintings, despite their apparently bold claims to social status and importance on behalf of the deceased and his family, are not actually aimed at a wide public – at least not in any rational way. Their messages – whether aspirational, proud, or consoling – are aimed at the makers of the tomb themselves or at notional viewers. This is an important reminder that we should not regard funerary art in unduly instrumental terms. It is not merely status symbolism and display – personal propaganda for an external audience. That lesson can no doubt be applied to many further examples of ancient art.

SARCOPHAGI

We shall return to the theme of 'audience' in Chapter Four when we consider the political use of art. For now, let us finish the discussion of funerary art with some observations about the carved sarcophagi that became widespread within a few decades of Vestorius's death. The majority of these works, particularly in Italy, were intended to be displayed inside

[96] Lawn 2001 (I am grateful to Nicholas Lawn for discussion of these issues).

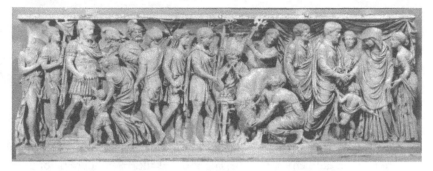

Fig. 15 'Biographical' sarcophagus. Rome. *c.* AD 170.

tomb-buildings and must have been experienced by a similarly restricted audience.[97]

Inhumation – the burial of intact bodies – began gradually to replace cremation as the normal Roman way to dispose of human remains from around the start of the second century AD. From this period on, decorated stone coffins were increasingly commissioned by those who could afford them. Something resembling 12,000 to 15,000 marble sarcophagi survive (almost half of them found in the vicinity of Rome) as well as innumerable fragments.[98] These are among the most numerous and conspicuous of all Roman sculptures. They were manufactured in different marble-producing parts of the empire, and as we briefly noted in Chapter One they testify to the extent and complexity of marble- and sculpture-trades in the empire. Many marble sarcophagi were quite plainly adorned, for example with carved garlands or other decorative motifs, but hundreds were elaborately sculpted, particularly with idealised scenes from the life of the deceased or mythological narratives. Portraits were often integrated into these scenes. Whether commissioned and executed in the lifetime of the deceased (as was probably often the case), or hastily procured after his or her death, the sculpted sarcophagi speak eloquently about their intended occupants and convey a particular view of their role in life. That is not to say that they or their imagery are easy to read, nor that they simply reflect either social status or individual beliefs. Two examples will serve to illustrate how the sarcophagi, particularly those in Italy, work.

The first example (Fig. 15) is a 'biographical sarcophagus'. Various types of idealised biographical scene appear on these reliefs between the

[97] Generally on sarcophagi see Koch and Sichtermann 1982; Koch 1993.
[98] Koch 1993: 1 for the estimate.

middle of the second century and the fourth century AD. There are battle and hunting scenes in which the deceased appears as heroic protagonist, rather like the emperor in some public monuments, emerging from a mêlée of virtuoso carving. There are more peaceful evocations of *paideia* (Greek-style education and cultivation), in which the deceased is a refined philosopher, often accompanied by the Muses. Sometimes the marriage of a couple provides the focus; such an image would have been appropriate for the commemoration of either a man or a woman (or both). There are various other types which focus on different aspects of the idealised lives of men, women, and children. The sarcophagus illustrated here belongs to a group of reliefs that combine different episodes from the life and career of an adult male.[99] On the left side of the front relief he appears as a general, his features reminiscent of the emperor Marcus Aurelius, standing on a low podium to accept the submission of a barbarian family. This group merges with the central image of sacrifice before a temple of Jupiter; the protagonist is a beardless young man and we are probably expected to identify him as the deceased in his youth. Next, on the right, comes the man's wedding ceremony. In each incident we see an assortment of human and divine attendants and onlookers.

The biographical scenes on sarcophagi like this constitute a sort of curriculum vitae, but they are highly formulaic and conventional. There are minimal signs of the reliefs' being tailored to the particularities of the recipients' experiences. It has long been held, in fact, that key incidents in the life-cycle represented on sarcophagi really stand as emblems of fundamental Roman qualities. The man's appearance in battle, when it is shown, suggests his *virtus* – his courage and manly virtue; receiving submissive barbarian prisoners, he demonstrates his *clementia* (clemency); sacrificing to the gods he becomes the very model of *pietas* (piety and sense of duty); finally, the married couple, clasping each other's right hands, refer to *concordia* (harmony).[100] Biographical reliefs on sarcophagi probably have their origin in more complex visual narratives of the earlier empire, as well as being related to literary biography and to the eulogies that were traditionally pronounced at funerals. But the scenes on sarcophagi have become stereotyped and abstract, apparently disregarding any coherent sense of a biological narrative.[101] This is also a characteristic of mythological sarcophagi.

[99] Levi 1931: 86–8, no. 186, pls. XCV–XCIX; Kampen 1981a: 51, figs. 12–13.
[100] The idea originates with Rodenwaldt 1935 and has been followed by many authors since: see e.g. Kampen 1981a.
[101] On the origins and development of biographical narration see Kampen 1981a.

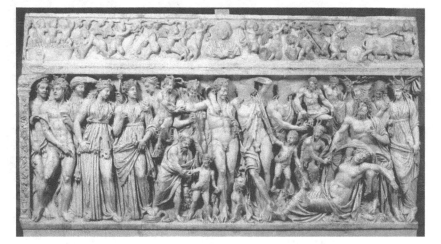

Fig. 16 Sarcophagus with representation of Ariadne and Dionysus. Rome. *c.* AD 200–10.

Reliefs containing mythological narratives, which appear most extensively on those pieces carved in Athens and in Italy, make more allusive comments on the life and death of the deceased.[102] Frequently, Greek heroes are used as ideal models for the dead person. The labours of Hercules are popular: he had come to represent heroic perseverance and enduring virtue on account of his travels through the mythological world, vanquishing monsters.[103] It is not uncommon to add portrait features to the figures of gods and heroes – a practice which was also applied to sculpture in the round, as we shall see. The idealising effect of such imagery is fairly obvious. But sometimes the use of myth is more obscure. A number of subjects seem to emphasise the tragedy of death, appropriating figures famous from literature and drama like Creusa (murdered by the witch Medea) or Actaeon (torn to pieces by his own dogs for accidentally observing Diana's nude bathing). More frequently the choice of myth alludes gently to death and possibly to hopes for happiness or peace beyond death.[104] The second sarcophagus illustrated here (Fig. 16) represents the popular figure of Ariadne.[105] Here the sleeping princess, who has been abandoned by her lover Theseus after his defeat of the

[102] For critical discussion see Koortbojian 1995.
[103] See e.g. Seneca, *De Constantia Sapientis* 2.1–2; Cornutus, *De Natura Deorum* 1.
[104] On mythological sarcophagi note esp. Zanker and Ewald 2004, adopting a sceptical attitude to the notion that the imagery refers to the afterlife; also Nock 1946.
[105] Lehmann-Hartleben and Olsen 1942: 14–16, 72–77, figs. 9–10, 12–13.

minotaur, is discovered by Dionysus and his companions. Sleep, of course, stands for death, but Dionysus' arrival represents a reassuring image of deliverance: he will discover her and make her his wife.

This allegorical use of myth can be explained in various ways. For a start it displays education. Detailed knowledge of myth was an index of cultivation and education, and therefore of wealth and social status.[106] We have already encountered its sophisticated use in the tombstone of Statilius Aper (Fig. 3). More generally, by the end of the second century AD it is possible to see the regular use of myth in funerary art as a symptom of a nebulous cultural phenomenon in the Roman empire which is usually called (in a phrase first used by the ancient writer Philostratus), 'the Second Sophistic'.[107] The period of the so-called Second Sophistic – approximately the second and third centuries AD – was one of Greek cultural revival particularly in literature and rhetoric. It was an era of more conspicuous nostalgia for the glorious past and traditions on the part of Greeks within the Roman empire, and as such it can perhaps be seen as a reflection of or reaction to the political subordination of Greek cities. On the other hand, this was also a period in which the Greek lands were fully assimilated in the empire, when an increasing number of senators and even consuls were Greeks, and when emperors (Hadrian and his successors) overtly admired and emulated Greek culture.

Like other retrospectively constructed cultural phenomena (the Renaissance; the Enlightenment) one can question the nature of the Second Sophistic, its causes and duration, and whether it quite existed at all. But sarcophagi have been regarded as perhaps its most conspicuous artistic manifestation, and there are good, specific reasons for the connection. It has been noted that more than ever before Greek mythology, and indeed the exemplary qualities of myth, were paraded in the rhetorical literature that was a hallmark of the period. For example, there is good evidence that myths were advocated as consolatory analogies for the dead in eulogistic speeches. And correspondingly, we find the development of an extensive repertoire of myths in the sarcophagi not only of Roman Greece but of Rome and Italy during the second and third centuries.[108]

We should beware of treating 'Greek myth' as a straightforward body of stories or knowledge in imperial Rome. There was evidently some

[106] Müller 1994: 150–1. For the application of the term to art see e.g. Elsner 1998b: 170–86.
[107] For an overview of the literary phenomenon see Whitmarsh 2005.
[108] Müller 1994: esp. 139–50; Zanker and Ewald 2004: 110–115.

concept of mythology as a repertoire of stories,[109] but in funerary art the stories themselves need not be of primary importance; rather, they provided a versatile visual language for talking, in erudite terms, about the lives and deaths of the real people commemorated in sarcophagi. Although the sarcophagi are important examples of narrative in Roman art, their use of narrative has become almost entirely abstract. The figures from myth, the incidents in the apparently familiar stories, have become important as paradigms – as types – adapted for the sculptures' funerary and commemorative functions. We shall encounter this treatment of narrative again in Christian art of roughly the same period. It is also important not to *over*-emphasise the role of such imagery in 'self-representation' or the exhibition of social status. These are explicit concerns for us, but not necessarily always for those who made and viewed the sculptures in antiquity. Paul Zanker has stressed the function of sarcophagus imagery in appealing to the emotions and providing consoling commentaries on the vicissitudes of life.[110]

The splendid Ariadne sarcophagus now in Baltimore was found together with ten others in one of three neighbouring chambers on the edge of Rome.[111] Dating between about AD 130 and AD 330, their reliefs represent a variety of subjects: a Dionysiac *thiasos* (the wine-god's company of companions, including satyrs and maenads); cupids and Victories holding garlands, interspersed with a mask and portrait busts; griffins and candelabra; the infancy of Dionysus; the divine heroes Castor and Pollux abducting the daughters of Leucippus; Victories and cupids flanking a gorgon's head; and the triumph of Dionysus, returning victorious from the east. Finally there are three children's sarcophagi, one showing little cupids chariot-racing (a common and appropriate theme for children), the second with two large cupids holding a shield that might have been intended to bear an inscription, and the third decorated once again with cupids holding garlands and theatrical masks. Collectively the sculptures provide excellent evidence for the funerary tastes of wealthy metropolitan Romans throughout that period and probably also for the ways in which imagery could be selected according to the gender and age of those commemorated.

Nevertheless it is generally difficult to pin down the social position or identity of their owners. Unlike other funerary monuments, sarcophagi

[109] See e.g. Petronius, *Satyricon* 48. [110] Zanker and Ewald 2004; cf. Hallett 2005a.
[111] The context is highly controversial, but there is evidence to suggest that the majority of them belonged to the same tomb: Kragelund et al. 2003: esp. 55–65.

generally lack carved inscriptions. They were perhaps sometimes painted on and were probably visible elsewhere in the tombs and grave plots to which the sarcophagi belonged. The result is that controversy remains over what sort of people commissioned or purchased them. They must have been very expensive objects, even when the carving is simple or poor in quality. Many, however, were very elaborately carved. Some are of huge proportions and were shipped across long distances. So most will have been made for the wealthy. But as we have seen, the wealthy included a very wide social range.

It is likely that the practice of using highly decorated marble sarcophagi originated with the senatorial aristocracy.[112] Certain surviving pieces from the second to the fourth centuries were demonstrably used by senatorial families, and even perhaps the imperial family.[113] Some sarcophagi can also be linked to the aristocratic equestrian order. But others again seem to have been used by wealthy freedmen, and Diana Kleiner has argued that freedmen possibly constituted a significant part of the clientele for early production of mythological sarcophagi.[114] The profile of use is further distorted because through the period concerned even the senatorial elite changed dramatically in its (increasing) size and social composition.[115] We are therefore dealing with a complex picture of social mobility of different kinds. What is interesting is that sculpted sarcophagi remained for almost three centuries, and with a certain amount of iconographical consistency, the predominant, prestigious funerary artform for all affluent social groups. The appearance of consistency may be the consequence of our ignorance, but it also offers yet another suggestion of the role of art in manipulating and obscuring social and cultural differences, as well as illuminating them.

[112] Müller 1994: 158–9.
[113] See Wrede 2001 for arguments about senatorial sarcophagi and their transformation.
[114] Kleiner 1988: 117–119. [115] Wrede 2001.

CHAPTER 3

Portraits in society

Of all Roman art-forms portraiture is perhaps the most immediately familiar and it offers important insights into the working of art in Roman society. Yet it has often been misunderstood. It therefore deserves special attention here.

Portraits as we tend to understand them today – as more or less individualised representations of particular people – were a largely Greek invention. Their earliest development can be traced to the fifth century BC and they flourished during the Hellenistic period.[1] Rome probably adopted portraiture from the Greek world. At any rate, the Romans of the republican period were heavily influenced by contemporary Hellenistic practices, and marble and bronze images in this period may have been made by Greek artists.[2] In both cultures portraiture served essentially the same range of functions: commemorating the dead or notable people of the past; honouring the living for their achievements and benefactions; providing permanent votive memorials in sanctuaries; and communicating authority and power, not least through the images struck on coins.

The republican nobility used portraits to preserve the images of their revered ancestors, and there is relatively early literary evidence for the parading of supposedly faithful portrait-masks at aristocratic funerals.[3] They also set up public, honorific statues to each other, particularly by the institutional authority of the senate, but no doubt also in independent attempts at self-promotion.[4] In the unstable politics of the late republic, portrait images in sculpture and on coins seem to have offered a useful way of celebrating and promoting the virtues of living, or recently

[1] For Greek portraits generally see Richter 1965; Tanner 1992; Tanner 2006: 97–140; Dillon 2006. On portraits in Hellenistic society see also Stewart 1979: esp. 115–32.
[2] On Roman republican portraits and statues, and Greek precedents, see e.g. Wallace-Hadrill 1990; Tanner 2000; Gruen 1992: 131–82. On the role of the Greek artists see Smith 1981: 28–9.
[3] Polybius 6.53–4; cf. Pliny the Elder, *NH* 35.6. Flower 1996.
[4] Wallace-Hadrill 1990; Tanner 2000: esp. 28–30. Generally, see also Sehlmeyer 1999.

77

deceased, competing dynasts such as Pompey the Great, Julius Caesar, and of course, Octavian – the first Roman emperor, Augustus – whose portraits have been subjected to intensive study.[5]

The portraits themselves survive only from around the later second century BC onwards, and the limited historical evidence has led to much academic debate and many questionable assertions. For example: is the uncompromisingly realistic appearance of some late republican portraits derived from the use of death-masks? (Probably not.[6]) Was the preservation of family portraits the preserve of the senatorial aristocracy, covered by a *ius imaginum* – a legal 'right to own images'? (The evidence is very doubtful.[7])

Portraits came to be used by a broader social range in the imperial period. Indeed, we have seen that they are used on many late republican tombs of freedmen.[8] The funerary sphere continued to afford opportunities for impressive portrait-representations, which one could commission while still living (the case of Trimalchio in Chapter Two is fictional, but reflects the reality). Portraits of all kinds also continued to be used as dedications in sanctuaries.[9] But the most prestigious portraits were those set up in prominent public places, above all the slightly over-lifesize statues in bronze or marble that filled areas like the forum or agora: the most important public space in any town of the Roman empire. Only the rich and important received portraits of this kind. The statues were often set up in recognition of their patronage of whole communities, the benefactions or services that they performed, the buildings they had constructed, and so on. Above all, however, it was the imperial family that received honorific portraits.[10] These were signs – and objects – of devotion. Indeed imperial portraits were used in all kinds of contexts for the actual worship of dead and deified rulers and their relatives, and in many parts of the empire, especially in the eastern provinces, for the worship of the living ruler himself.[11]

[5] On dynasts' images see e.g. Giuliani 1986; Zanker 1988b: 5–18, 33–77. On portraits of Octavian/Augustus: e.g. Zanker 1988b, passim.

[6] For a critical assessment of this claim, with references, see e.g. Gruen 1992: 152–82; Flower 1996: 38; Stewart 2004: 7–8.

[7] For a critical overview see Flower 1996: 53–9.

[8] On freedman portraits from Rome: Zanker 1975; Kleiner 1977.

[9] Stewart 2003: 85–6, with some references (note e.g. the portraits in the 'votive room' in the sanctuary of Diana at Nemi).

[10] On honorific portraits in general see Lahusen 1983; Stewart 2003: passim. On portraits for the imperial family see esp. Pekáry 1985 (surveying written sources).

[11] See esp. Price 1984: 170–206.

Let us be clear: little of this history could be constructed on the basis of the portraits themselves. Many thousands of them survive, to be sure, especially sculptures in bronze, marble, or limestone. A whole tradition of painted portraits is virtually lost, attested mainly by paintings on mummies from Roman Egypt,[12] but we have innumerable examples in other media, including profiles engraved in gems or struck on coins. Some of these images, with their often realistic features, have an impressive immediacy. In the popular presentation of ancient history – in general books, documentaries, and websites – they put a face to historical names and bring the past to life. But Roman portraits do not speak for themselves, or at least if they do, their claims to be authentic and psychologically penetrating are highly deceptive. It can be difficult to answer even the most fundamental questions about an individual Roman portrait. When was it made? Whom does it represent? And what relation does it bear to other portraits, or to the traditions of Roman art? We shall examine aspects of these questions, which dominate most of the literature of the subject.

Yet these are questions about specific, isolated objects, often heads and faces. The Romans might have appreciated this bias, because it is clear that they invested the head or face with great significance, associating them with individual identity.[13] But although busts and herms were popular in Roman art, many of the portraits that survive today as isolated heads were once attached to or inserted into full statues. Heads and bodies have often become separated. Only occasionally have they been reunited (and sometimes with dubious results). A more serious problem of evidence is presented by the general separation of sculptures from their original physical contexts (sometimes in antiquity but often in the modern era of haphazard excavation and collecting), and especially from the inscriptions which would once have identified them and explained their circumstances.

In short, we are left with discrete bodies of historical evidence: the components of the portraits themselves; the archaeological remains; and the inscribed texts. To these we must add literary evidence, for Roman literature contains innumerable, casually informative references to portraits and their usage.[14] There is a tendency for different specialists to

[12] Doxiadis 1995; Walker 1997.

[13] See e.g. Stewart 2003: 47–59, 79. Pekáry 1985: 101–3; Hallett 2005b: 289–95.

[14] For literary sources see e.g. Lahusen 1984 (a sourcebook of texts in Latin and Greek); Pekáry 1985; more generally, Stewart 2003.

study these varieties of evidence independently. Their interests are tailored
to the character of the material with which they are dealing. For example,
an epigraphist, examining inscribed texts and their occurrence on statue-
bases across a particular site or region will have a very different perspective
from the art historian who (rather anachronistically) considers 'portrait-
ure' as an artistic category.[15] These specialists do not communicate with
each other as effectively as they might do, although that situation is
perhaps changing.[16] One obstacle they face is the failure of the various
sources to connect. It is rare for a monument to survive together with
information about its provenance *and* ancient literary or epigraphic tes-
timonies. However, taken together the different bodies of evidence do
contribute to a rounded – or rather, a multifaceted – picture of the whole
phenomenon of portraiture in Roman society. Consequently, we shall
have to return to the broader, historical context that the textual evidence
evokes. But first we shall focus on the works of art themselves and the
ways in which they have been studied.

TYPOLOGY

Unsurprisingly, the identification of subjects has been a major preoccu-
pation of those researching Roman portraits, but this task is not easy, and
the difficulties involved tell us something about the very nature of the
portraits.

Broadly speaking, for an individual's portraits to be convincingly
identified, at least one of them must be accompanied by an inscription.
The task is therefore hampered by the separation of sculptural portraits
from their inscribed bases or architectural settings. There are some
examples for which the evidence is preserved intact or which have a name
written on the portrait itself. The most important source, however, is
coinage. The legends that accompany profile portraits on coins are often
essential for the identification of images of emperors and their relatives
(less elevated individuals were only rarely depicted on coins).

Yet even this source would be of limited value were it not for the
consistency in the portrait-types employed. This consistency contrasts,
for example, with the earlier images of Hellenistic monarchs, which are

[15] Contrast, for example, the regional surveys of statue-bases by G. Alföldy (1985a; 1979) – excellent of
 their type – with a very art-historical handbook such as Kleiner 1992, which elucidates the works
 themselves but marginalises inscriptions as a source.
[16] For recent attempts to relate inscriptions to images note e.g. work at Aphrodisias: Smith 1999;
 Smith et al. 2006: 21–26. See also e.g. Tanner 2000.

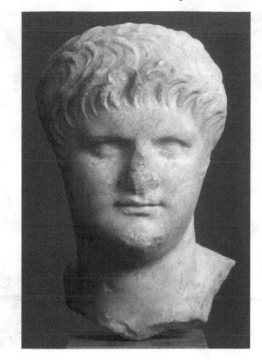

Fig. 17. Marble bust of Nero. AD 64–8.

frequently difficult to identify even though a significant number of examples survive, either originals or reliable copies. Despite an obvious similarity among images of particular Greek rulers, which may presumably reflect their actual appearance, there is nevertheless a great deal of diversity among them.[17] In contrast, there is much greater consistency in the features given to individual Romans in their portraits. Most imperial portraits can usually be sorted into just a few 'types' which appear to be closely adhered to on coins as well as in other media.[18] The portrait of the emperor Nero in Figure 17 is one of five types that are attested for him. Although this portrait corresponds roughly to an ancient description of Nero's 'hair arranged into tiers', the identification really depends on the fact that a very similar image is used on the emperor's coins (Fig. 18).[19] The other portrait-types of Nero have significant differences from this

[17] Pfanner 1989: 177; Price 1984: 172–3. Cf. Smith 1988a.
[18] On the use of typology see Smith 1996.
[19] Suetonius, *Nero* 51 on the hair. Generally on Nero's portrait types see Sydenham 1920 (coins); Hiesinger 1975; Kleiner 1992: 135–9.

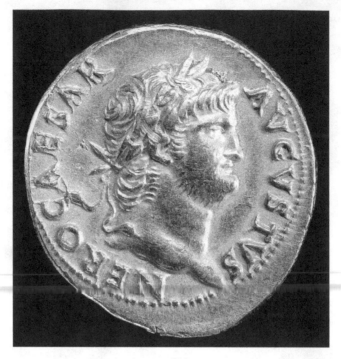

Fig. 18. Aureus of Nero, AD 64–8.

one, particularly in their simpler hairstyles. They too are identified by comparison with corresponding numismatic images.

Nero came to power as a 17-year-old in AD 54 and committed suicide in AD 68. During his reign the young man's image developed from that of a Julio-Claudian youth, resembling earlier successors of Augustus in his facial features and hair, to the fleshy and distinctively styled portrait depicted here. Most emperors' portraits demonstrate little or no ageing of this kind (indeed Augustus's hardly changed during the 44 years in which he ruled Rome), and so coinage also offers evidence for the chronology of the various portrait-types which is not necessarily obvious from the images themselves. Coins can usually be dated much more precisely than other works of art, and they seem to show how new portrait-types were introduced at particular stages in an emperor's reign, probably celebrating important imperial or dynastic events like adoption, accession, or ten-year jubilees (*decennalia*). Nero's last (and, in a sense, most flamboyant) portrait-type, illustrated here, first appears on coinage from the year AD 64 – the ten-year anniversary of his rule.

It is unlikely that coinage actually provided the model from which other portraits were copied. In all probability the portraits on coins and in other media reflect the creation at different times of officially sanctioned or commissioned portraits, which were then imitated by various kinds of artist throughout the empire.[20] In principle all of the above applies to empresses and imperial children as well, though their portraits are rather less numerous.[21]

Classical archaeologists and art historians favour and indeed depend upon typology – the definition and analysis of artistic types – in many areas of study. It is always harder to interpret ancient objects in isolation. Comparison with other material allows the creation of some kind of context. It permits classification. But this process of analogy has to be regarded with caution. In the case of Roman imperial portraiture, the recognition of regular portrait-types need not reflect ancient attitudes.[22] There is a risk that we oversimplify the material, either artificially forcing particular portraits into invented types, or ignoring and misinterpreting aberrant examples. There is no reason to assume that the sequence of types used on coins is *neatly* matched by other kinds of commissions. Old types could have remained in use till late in the emperor's reign and even after his death. Such uncertainties mean that there is still considerable debate (and probably should be even *more* debate) about the identification and dating of portraits linked even to significant and well-studied rulers.

Figure 19 is a good example of how the untidy reality of art in use through the empire can challenge our methods.[23] This is an over-lifesize bronze portrait head from Roman Britain. It was certainly removed (apparently with violence) from an important statue – perhaps an equestrian statue – in a province which never had many works of this kind. The head was found in a river some 30 miles from Colchester (Camulodunum), which was the main town in Britain between the Roman conquest of AD 43 and its destruction by the rebel queen Boudicca in AD 61. Science can tell us little about it, though analysis suggests that a fragment from a bronze horse-leg discovered about 30 miles to the northwest might belong to the same sculpture.[24]

The typological method demands first that we ask what other works the piece resembles. In the shape of the head and the arrangement of the hair it is reminiscent of portraits of the Julio-Claudian period (both of

[20] Smith 1996: esp. 37 for summary. [21] See e.g. Bartman 1999; Wood 1999.
[22] Note e.g. critique in Vout 2005.
[23] Rendham head: see Toynbee 1964: 46–8, pl. IV; Huskinson 1994: 13, no. 23, pl. II.
[24] Huskinson 1994: 13 n. 2, 22, 35; Lawson et al. 1986.

Fig. 19. Bronze portrait head from a statue, found in the River Alde, Suffolk. *c.* 50s A D.

imperial family members and private individuals), and more specifically of mid-first century portraits. It is most likely to have stood in Colchester and so it was probably broken and removed from there before the town's destruction. Who would have received such a statue in Colchester in the earliest years of the Roman occupation of Britain? Conceivably a compliant local leader, portrayed here in Roman style;[25] but there are no plausible candidates. Perhaps a Roman governor such as C. Suetonius Paullinus; but the man appears to be too young to be such an official. In fact this is almost certain to be a dynamic, youthful member of the imperial family; yet comparison with known portrait-types fails to turn up an exact match. And so by default, and perhaps with a certain amount of wishful thinking, the head is almost invariably identified as the Roman conqueror himself, the emperor Claudius (ruled A D 41–54). This identification represents the breakdown of the typological method. The problem is that the head only very vaguely resembles the much older-looking

[25] Poulsen 1951: 128–9 (I owe the observation initially to John Creighton).

portraits of Claudius that have been securely identified (Fig. 36 is closer than most), and scholars have to resort to the suggestion that this is a non-standard provincial portrait by a craftsman from Gaul.[26]

The identification is implausible. This is much more likely to be a portrait of Nero, who succeeded Claudius and was emperor just before Colchester's destruction. The hairstyle closely matches that of Nero's earlier portrait-types, though the physiognomy differs from most extant examples.[27] Yet even if this is the true identification, it still forces us to question the rigidity of classificatory structures in the study of portraits (and all Roman art-forms). This 'Nero' differs radically from the emperor's later images; it is not identical to any of the known earlier types. Its identification still depends on recognising some flexibility in the mass reproduction of portrait-types, and it raises questions that we shall touch on again about the effect of 'provincialism' on the diffusion of Roman art.[28]

THE DISTRIBUTED PORTRAIT

The problems raised above apply all the more acutely to portraits of imperial relatives, whose known images are usually far fewer. But one striking characteristic of many images of imperial children and empresses is that they sometimes tend to be assimilated to portraiture of the emperor himself. The likeness is often most noticeable in hairstyles, but also in the physical features of the face. The suggestion of resemblance crosses gender and can even defy the actual genetic connection (or rather the lack of connection) between those portrayed. Thus at the start of the principate (imperial period), Tiberius was given classicising, idealised features and hair that recalled the portraits of his stepfather Augustus, though interestingly, there is a yet closer visual association with his powerful mother Livia, Augustus's wife and widow.[29] Augustus's grandchildren, Gaius and Lucius Caesar, who were groomed to succeed him before their untimely deaths, are made to appear as younger, more idealised versions of Augustus himself, with virtually the same arrangement of hair.[30] A similar manipulation can be perceived in other Julio-Claudian images, including the bronze head from Suffolk. Such visual associations are encountered

[26] See e.g. Toynbee 1964:47–8.
[27] For identification as Nero see e.g. Poulsen 1951: 128–9, no. 15; Hiesinger 1975: 116.
[28] See Zanker 1983, Smith 1996, Riccardi 2000 for further discussion of the problems.
[29] Kleiner 1992: 123–6. Bartman 1999: 107–8 for his resemblance to her (and passim on such visual associations in dynastic imagery of the period).
[30] See Pollini 1987.

again and again through the history of Roman portraiture. Their effect would often have been emphasised by the juxtaposition of these portraits in prominently displayed groups of statues and busts which declared the ideal image of the emperors and their relatives as a united family, full of dynastic promise.[31]

On the other hand, these visual echoes among imperial portraits can be associated with a broader pattern in Roman portraiture – the phenomenon of the *Zeitgesicht* or 'period-face'.[32] It is observed that the portraits of many private individuals imitate features of imperial images. Sometimes this may be due to common fashions in self-presentation, embraced by the emperor as much as by his subjects; but in other cases it is clear that the prestigious image of the ruler has provided the model for private individuals or the artists whom they employ.

All of this further complicates the identification of portraits. Many of the portrait sculptures labelled as particular emperors, empresses, princes, or princesses in museum collections today probably are not only wrongly identified, but should not even be assigned to imperial family members at all. At the same time, the observation of period-features in unidentified portraits provides a useful, if approximate, dating tool. Many private images can be fairly reliably dated by their correspondence to no doubt more or less contemporary traits in imperial portraiture.[33]

I have emphasised some of the methodological issues arising from the typological interpretation of portraits partly because they are so central to our basic understanding of the images. And yet they also have wider implications for the social history of Roman art. The 'period-face' is not simply an index of chronology. It betrays something about the impact that imperial imagery had on its audience and the charismatic appeal of the ruling family. More fundamentally, the recognition of portrait-types ought to draw attention to the collective character of imperial portraiture. For the portrait-types are not simply scholarly abstractions. Despite the qualifications expressed above, the fact remains that there *is* remarkable consistency among many images, even in far distant regions of the empire. Intensive research on these portraits often depends on painstakingly finding correlations of details, especially in the disposition of locks of hair (sometimes misleadingly called 'lock-counting') in order to establish their

[31] Generally see Rose 1997a; cf. also Boschung 2002: 194.
[32] On the Zeitgesicht see e.g. Zanker 1982.
[33] A comparison of Aper (Fig. 3) with the much earlier portrait of Nero (Figs. 17 and 18) as well as the contemporary Hadrian (Fig. 20) shows how approximate this dating can be.

Fig 20. Bronze head of the emperor Hadrian, found in the River Thames,
London. AD 117–38.

genealogy and relation to posited prototypes. Maybe that tells us some-
thing about the personality of classical archaeologists, but the fact that it
can be done at all also tells us about Roman art itself.[34] It helps us to
construct the following picture.

Imperial portraits were produced in large quantities to conform to
prototypes apparently made in the city of Rome itself.[35] It has been
observed that many provincial sculptures are less detailed and subtle than
those found closer to Rome; they sometimes 'misinterpret' or modify
their models; and at the same time they often betray characteristics of
local artistic idioms or exaggerate certain traits (Fig. 20, if not Fig. 19, may
exemplify this).[36] Yet the degree of correspondence is high, even in the
particulars of the hairstyle. Evidently there was a will or a practical need to
follow the prototypes employed quite faithfully. The mechanisms
involved in the diffusion of these portrait-types remain obscure. In many

[34] Cf. Stewart 2006. [35] On the process in general see Stuart 1939; Pfanner 1989.
[36] Zanker 1983; Smith et al. 2006: 44–8.

cases images may have been copied from other, existing portraits in a particular area, some of them no doubt imported from Rome or other major centres. But it is assumed that portable models, perhaps in plaster, must have played a role: that these were dispatched from Rome to provincial centres and were copied indirectly by local workshops. This was not mass distribution in the modern sense; it involved localised craft-production. Yet the copying process that developed was relatively quick and its products were, selectively, very accurate.[37] The result was the distribution of a recognisable portrait image that appeared with minor variations in every province, conveying what we can assume was an approved imperial image to all the inhabitants of the empire.

As far as the quantities are concerned, Michael Pfanner's guess is as good as any. He suggests, for instance, that Augustus had perhaps 25,000–50,000 (sculptural) portraits, averaging about 500–1,000 for each year of his long reign, around 250 of which survive.[38] Consequently, imperial portraits were everywhere in public places. For example, statues will have been prominently displayed in porticoes and sanctuaries, fora and basilicas, on the stage facades of theatres. But the features of the imperial family were also conspicuous in less prominent places. Some impression of the sheer proliferation of imperial images is conveyed by an important comment by the second-century writer Fronto. He is writing with affection to his former pupil, the emperor Marcus Aurelius (AD 121–80; ruled AD 161–80), and comments on the ubiquity of portraits of the emperor, exhibited by a devoted population:

You know how in all the money-changers' bureaux, stalls, shops, booths, porches, windows, in every place that your portraits are publicly displayed, badly painted for the most part it's true and modelled or sculpted in a coarse, not to say sloppy, fashion, nevertheless whenever I'm out and your image meets my eyes it has never been so unlike you that it did not put a smile on my face.[39]

The quotation requires a cautious reading. It probably relates partly to more humble images than those that tend to survive, especially to paintings, and it suggests diversity as much as it implies the consistent diffusion of an official image.[40] The text is probably also intended to stress that its important author is intimately familiar with the *real* appearance of Marcus Aurelius. Nevertheless, it does give us a good indication of the place such portraits held in *most* people's experience.

[37] On speed, accuracy, and technique see Pfanner 1989. Cf. Stuart 1939.

[38] Pfanner 1989: 178–9 (he stresses the speculative nature of the figure). Some production was posthumous.

[39] Fronto, *Ad M. Caesarem* 4.12.4 (Naber p. 72). [40] Cf. Riccardi 2000: 116.

Ubiquitous images provided a focus for expressions of loyalty and reverence towards the Roman ruler and his family. Indeed they were proxies for emperors whom most people would never see or deal with directly.[41] Collectively they stood in for the emperor in the lives of his subjects. In a sense, they were more real – certainly more present – than the ruler himself. It is hardly surprising that they were often effectively treated as divine images, even outside the sphere of formal imperial cult. This is an issue to which we shall return in the next chapter.

All of this evidence tempts us to see imperial portraiture as an impressive form of propaganda: officially devised, centralised, inserting a favourable image of the ruler into people's lives (and their pockets). To a limited extent this is correct. It is safe to assume that imperial portraits were ideologically informed and we can speculate about their particular political values. In general, however, the 'propaganda' account is profoundly misleading, for the imperial family do not appear either to have orchestrated or even overtly to have approved of the widespread replication of their portraits.[42] The thousands of portraits that existed were not imposed by the centre but willingly purchased and commissioned by the imperial populace. We shall return to this important point shortly.

FACE VALUES

One surprising aspect of the discussion so far may be that it has hardly mentioned the subject of likeness, though for most people (and most dictionaries) likeness is the defining feature of portraiture. Indeed, that was the Romans' perception also, as countless ancient texts, including the extract from Fronto, make clear. This sense was also conveyed by the most common words for a portrait, in Latin and Greek respectively: *imago* and *eikon*.[43] Yet it will already be obvious that Roman portraits were highly artificial constructions. They purport to relay the real appearance of an individual, but under the cover of this inherent claim to veracity they convey tendentious messages about the sitters' social position, alleged virtues and qualities, public persona, and personality.

[41] See Stewart 2006.

[42] Generally note Price 1984: 170–206; Rose 1997b. See also Chapter Four for further discussion of 'propaganda', with references. For the posture of reluctance to allow erection of images see e.g. Augustus, *Res Gestae* 24; Suetonius, *Claudius* 26.1; Claudius's letter to the Alexandrians (Papyrus London 1912), in e.g. Bell 1924: 1–37; Pliny, *Panegyric* 52; statute of Marcus Aurelius and Lucius Verus, see Johnson et al. 1961: 214, no. 259.

[43] Pekáry 1985: 101–3.

We do not, of course, have any reliable corroborative evidence about the real appearance of individuals. Literary descriptions are rare and should be distrusted even when they appear to be telling the unadorned truth. For example, Suetonius's famous claim that, besides many handsome features, Augustus possessed bad skin and teeth, was short and had a slight limp, need not be any more reliable than the emperor's manifestly idealised, youthful portraits that were reproduced throughout his long reign.[44] Conversely, portraits that appear to be highly realistic need not be accurate. Even the creased, 'veristic' faces of late republican freedmen (Fig. 13) show signs of stylisation and perhaps a deliberate emphasis on the qualities associated with venerable old-age.

At times the very idea of a portrait, with all its prestigious connotations, appears to take precedence over its notional function of conveying a likeness.[45] In parts of the Greek provinces of the empire there is evidence for the rededication of public honorific statues – without making any physical changes to the portraits themselves – so that redundant images of Greeks were economically converted into new rewards for Roman notables. The practice does, admittedly, receive fierce condemnation from the orator Dio Chrysostom who says that people were calling the statues 'actors' (*hypokritai*).[46]

The physiognomy of the portraits themselves was a significant bearer of messages about what *sort* of person was depicted there. As we saw above, many portraits seem intended to harness some of the positive associations of a current or previous ruler's portraiture. As used in the representation of the imperial family, this strategy emphasises blood ties and genealogical stability, sometimes in defiance of the historical reality. But in time the array of past rulers, many of whose portraits continued to be displayed and viewed, came to offer a repertoire of positive role-models. Some scholars believe that the classicising image of Augustus was evoked repeatedly, not only in the portraits of his immediate successors and relatives, but in those of much later rulers, including Trajan at the start of the second century AD and Constantine in the fourth century.[47] Certainly there are specific cases of emulation of (or reaction against) the portraits of earlier rulers.

The images of Nero offer an interesting case of changing self-representation, with the earlier, Julio-Claudian style portrait-types

[44] Suetonius, *Augustus* 79. [45] Stewart 2003: esp. 79–117.
[46] Dio Chrysostom, *Oration* 31.155 (*Rhodian Oration*) Cf. Pausanias 1.2.4; 1.18.3; 2.9.8; 2.17.3.
[47] See e.g. Kleiner 1992: 208, 438.

superseded in the 60s AD by the more famous, bulging face and elaborate hairstyle illustrated in Figure 17. One should not deny that Nero probably looked like this and that the hair was consciously cultivated in life as in art, but the appearance propagated in these later portraits seems to recall some of the luxurious images of Hellenistic kings, and it seems likely that Nero – or whoever designed his portraits – was attempting to exploit those regal associations (with which previous emperors, including Augustus, had flirted).[48] The intention must have been positive, but after Nero's death, and probably by some sections of aristocratic society in his lifetime, this kind of self-presentation was considered to typify his shameless proclivities and excesses.[49] The portraits of the emperor Vespasian (ruled AD 69–79), who ultimately succeeded Nero after a period of civil war, could hardly be more different, for his creased and strained visage recalls, if anything, the gerontocratic images of the late republican elite.[50]

Even today, and even by art historians, Nero's portraits are presented as if somehow they provide a window into his corrupt soul. For example, one scholar sees in them 'a corpulent and debauched megalomaniac... The vicissitudes of Nero's life,' she claims, 'are ... mirrored in his portraits'.[51] Similar judgements are often made concerning the portraits of other emperors who have gone down in history, rightly or wrongly – for history is written by the political victors – as fallen tyrants. This approach to portraits is methodologically unreliable, for physical features do not reflect personality in this way; nor would any sane imperial artist or patron have deliberately presented the emperor in a negative light, even if they had wanted to. In any case, modern judgements are arbitrary and inconsistent. Yet the Romans may also have viewed portraits in a similar manner. In the ancient science of physiognomics, about which we unfortunately know relatively little, physical features were associated with particular moral qualities and character traits and may have been 'read' in this way, at least by educated observers.[52] It is possible that physiognomic theories influenced the design of some Roman portraits. They certainly seem sometimes to have influenced Greek portraits of notable men – generals, kings, philosophers, poets – which, copied in the form of busts and herms, became popular decorations for Roman villas, gardens, and public buildings (see Chapter Two).

[48] Nero and Hellenistic kings: L'Orange 1947: 57–63. Not all would agree: e.g. Hiesinger 1975: 122–3.
[49] Suetonius, *Nero* 51. Cf. Elsner 1994 on the representation of Nero's building activities.
[50] See e.g. Brilliant 1974: 212. [51] Kleiner 1992: 139.
[52] On various aspects of Roman physiognomics and representation see Evans 1969; Giuliani 1986; Barton 1994: 95–131; Gleason 1995.

The manipulation of physiognomic features was not simply the preserve of portrait artists. Real faces were (and are) also artificial constructions to a greater or lesser degree. The cultivation of different styles of hair (on head and face) was the most obvious means by which a portrait head could help to communicate the individual's place in society. Perhaps the most famous male examplar is the emperor Hadrian (ruled AD 117–38) (a friend of an expert on physiognomy, the sophist Polemo), who was the first Roman emperor to sport a full beard (Fig. 20).[53] It is probably wrong to suppose that Hadrian's beard represented a conscious attempt to assimilate him to Greek intellectuals or statesmen of the classical past.[54] But it does seem to demonstrate an adherence to a more generally Hellenic style of personal grooming, well established in the Greek parts of the Roman empire and, from Hadrian's time onwards, increasingly popular among Latin-speakers of the west.[55]

Hadrian's beard set a precedent for the progressively hirsute representations of his successors during the second century, and the style is attested in portraits of numerous private individuals in this period. It is, however, in the representation of women that we find the greatest care lavished on the elaboration of sometimes audacious and highly complex hairstyles. Unlike male hairstyles, which in reality must have involved some careful preparation but which present themselves as natural,[56] the female coiffures are to be perceived as highly artificial creations. There is some doubt about whether they are all possible to achieve using a real woman's hair; but that doubt is reinforced, even deliberately emphasised, by the portraits themselves, which often include elements that resemble wigs, hairpieces, or synthetic extensions.[57] This sort of visual play with female hair, in representation and in reality, conveys messages beyond a mere claim to beauty, elegance, or ideal femininity. In the memorialised hairdos of women's portraits we can see a hint of the sitter's wealth and status. She must have the resources to own specialist slaves and the leisure to spend hours submitting to their attentions (this is not to mention the expense of artificial hairpieces and wigs[58]). The choice of hairstyle, like any fashion-statement, is also a claim (whether successful or not) to cultural capital, cultural know-how: to proficiency in the language of elite female self-representation.[59]

[53] Hadrian and Polemo: Gleason 1995; Strong 1988: 171. On Hadrian's portraits: Evers 1994; Zanker 1995: esp. 217–24.
[54] See Zanker 1995: 218–20; Smith 1998: 60–1.
[55] Note Smith 1998: esp. 59–62 on some of the complexities; Zanker 1995: esp. 217–26.
[56] See Bartman 2001: 2–3. [57] For a full discussion of these issues see Bartman 2001.
[58] See Ibid. 14. [59] Cf. Ibid. 3–4.

As Elizabeth Bartman shows, the difficulty and expense involved in the production of delicate coiffures are not only represented by works of art, but also to an extent *replicated* in their own production.[60] Any sculptural representation of hair, for example, requires a compromise between the rendering of realistic details and the limitations of the media of carved stone or cast metal. In the Flavian and Trajanic periods (from about the 70s AD into the early second century) there developed a fashion of arranging women's hair in impressive heaped ringlets above the forehead. For many sculptors the rapid use of the drill to riddle the stone with holes afforded an easy method of creating the sponge-like impression of tightly-packed curls (Fig. 23). But those works which pay more individualistic attention to the arrangement of locks represent a sort of virtuoso display of skill as admirable in their own art and medium as the creations of the hairdressers themselves (Fig. 21). Both prototype and artistic representation make an impressive show and demonstrate the financial and cultural resources of those who had them made.

At the same time it goes without saying that art, costly though it might be in its own right, offered the potential for claims to wealth and status that could barely be realised in a woman's genuine personal adornment. It also allowed manifestations of wealth and status (such as complex and fashionable hairstyles) to be appropriated in different contexts for their symbolic value. Thus in some of the later paintings of Pompeii we find deities and mythological characters represented with contemporary, luxurious Flavian hairstyles (as is perfectly appropriate).[61] At Pompeii and elsewhere we also find explicitly erotic scenes in which prostitutes (or at least abnormally active female lovers) are similarly represented: an important reminder that the individual visual markers of status and identity cannot be read in isolation.[62]

Our sensitivity to details of physical appearance, personal grooming, and adornment in images, not only in the contemporary world but also to some degree in recent historical periods, must serve as a reminder of how crude our readings of Roman portraits must remain. The subtle varieties of female hairstyles alone are little understood and have only recently received serious study.[63] Still less do we understand all the connotations of full statuary iconography. But all such details must ultimately be

[60] Ibid. 8.

[61] E.g. the famous painting of Mars and Venus from the House of Mars and Venus (Pompeii VII 9, 47).

[62] Clarke 1998: e.g. 166–7, fig. 60 (a mirror cover); 257–9, figs. 99–100. Naturally these examples are not unrelated to erotic mythological scenes.

[63] See e.g. Borg 1996: 27–67; Bartman 1999: 32–9; Bartman 2001.

Fig 21. Marble bust of a lady (the 'Fonseca Bust'). Italy, *c.* early second century AD.

accommodated at least in any history of Roman art which aims beyond questions of chronology, identification, and type. The consideration of portrait-bodies presents especially interesting challenges.

BODIES OF EVIDENCE

Heads were of primary importance in Roman portraiture, as the fondness for busts or portraits set into herm-shafts attests. It was the more or less realistic face that established the identity of the sitter. But portrait

heads – even busts, which included part of the torso – had limited potential for displaying their subject fully engaged in the world and playing out a social role. The anatomy, poses, gestures, dress, and attributes of full statues were surely more effective in inserting the individual into her or his notional public role.[64]

The modern viewer is desensitised to the effect of much Roman statuary iconography. We are not attuned to the formal hierarchies and subtler connotations of different types and styles of drapery, shoes, rings, and jewels. This is largely due to the loss of the paint that originally made marble statues lifelike and arresting. It is perhaps also due to the repetitive character of many Roman works. For conventional body-types with conventional costumes were reproduced in their thousands in all parts of the empire, with very little variation on very few themes.[65] Nevertheless, these statues purported to represent the bodies of individuals, and the form of their dress (or undress) said much about how the portrait-subject was to be perceived, and in which social role.

Certain kinds of civilian dress predominate in Roman portrait statuary.[66] The standard formal dress for female statues is a long tunic, falling in folds to the ground and covered by a kind of woollen(?) mantle – a *palla* in Latin – which could be wrapped around the body more or less restrictively (Fig. 22). In early imperial sculpture, an intermediate dress called the *stola*, fastened by distinctive straps at the shoulders, is a regular feature. The long *stola* is frequently mentioned in contemporary literature and was clearly a badge of the ideally modest Roman matron.[67]

The *palla* was not unlike the Greek *himation*, the traditional Greek mantle that continued to be worn over a tunic on most male portrait statues in the eastern parts of the empire. Consequently, when statues in the eastern cities are draped in the Roman toga, we can take this as a marked statement about the subject's *Roman* citizenship.[68] The toga itself became, at least by the early principate, a particular attribute of Roman men: that is to say, both the badge of the mature citizen male (*toga virilis* or 'toga of manhood' was formally assumed during adolescence),[69] and the mark of 'Romanness' in general: Virgil, for example, famously refers to the Romans as the 'gens togata' – people of the toga. Romans imagined it as ethnically distinctive: it separated them from the Greeks in their

[64] See e.g. Lahusen 1983: 45–65; Smith 1998: 63–70; Stewart 2003: 47–59; Smith 2006: 35–8. Cf. Dio Chrysostom *Oration* 31.155–6 (*Rhodian Oration*).

[65] But note e.g. Trimble 2000 for how the repetition of formulaic statuary may be significant in itself.

[66] See Smith 2006: 35–8 for the Greek East (Aphrodisias) and general comments.

[67] See Scholtz 1992, esp. for *stola*. [68] Smith 1998: 65. [69] See Davies 2005.

mantles and from the trousered barbarians.[70] This was very much an ideal perception of cultural contrast, and it is interesting to note that the Greeks did not have a word for the toga and seem to mention it as if it is merely a particular type of *himation*.[71] Indeed, although the imperial toga was large and voluminous, and generally shaped so as to produce a huge arc – a *sinus* – curving in front of the body, the Greek and Roman garments were used in somewhat similar ways, and the sculptural conventions for representing clothed males in the eastern and western traditions are at least superficially similar (for examples of togas note esp. Figs. 1, 3, 13, 15, and 27).

There were other types besides the civilian. For example, the cuirassed statue (breastplate over tunic) was especially popular in representations of imperial figures.[72] The toga could be worn in differing ways, notably with its edge pulled over the head when the subject was represented as engaged in sacrifice. Members of the imperial family, male and female, could be assimilated to deities, and a costume of full or partial 'heroic' nudity was sometimes employed for the men.[73] Other details constructed a more specific identity for the portrait subject. In particular, the colour or decoration of a toga might specify rank. The same is true of finger rings, and different types and colours of footwear. It must be said, however, that these details are improperly understood today, especially given the relative lack of visible pigment on ancient sculptures, and attempts to relate clothing types rigidly to the formal social status of the person portrayed (for example, with *calcei patricii* – 'patrician shoe-boots') may be unreliable.

The sort of formal dress usually worn by portrait-statues was extremely cumbersome and impractical. In reality perhaps this was the chief reason for continuing to wear it in appropriate settings. The toga was hot and virtually impossible to keep in place. In fact Quintilian (late first century AD) acknowledges this fact in his explanation of the suitable deportment of the Roman orator: the toga should be carefully and deliberately arranged to begin with, but can be more dishevelled as the orator becomes hotter and the tone of his address more animated; finally it may be in total disarray by the end of the speech. For Quintilian the toga, like the orator's gestures, is almost a metaphor for the speech, if not the speaker; it is certainly to be used as a form of visual rhetoric. Consequently it is

[70] Virgil, *Aeneid* 1.282. Juvenal 8.234.
[71] The 'Greek' himation is contrasted with it in e.g. Lucian, *De Mercede Conductis* 25; cf. Plutarch, *Camillus* 10 on Falerians in 'himatia'.
[72] See Niemeyer 1968 for different imperial types, and esp. 47–54, 91–101 for cuirassed statues.
[73] See full treatment in Hallett 2005b.

significant that togate men in statuary are always neatly composed and poised.[74]

There were similar problems with women's formal dress and they are made to appear much more obvious in sculptural representations. Many female statues and busts show the subject clinging on to her drapery, partly in order to hold it in place. One popular, standardised body-type – the 'Small Herculaneum Woman' type (named after a sculpture from the theatre at Herculaneum) – which was used to represent aristocratic women, probably including female members of the imperial family – portrays the woman apparently hitching her mantle over her left shoulder. The pose provides an eternal memorial to the imminent disintegration of her outfit.[75] As a result it is also an impressive statement of her actual composure: her modesty and self-control. Once again, perhaps, the dress is a metaphor for her general demeanour. But on a more basic level, this kind of clothing demands self-control. Most female portrait-statues clutch their drapery tightly around them, allowing it to envelop their bodies and even their hands. Beneath the mantle the tunic or *stola* fell right to ground, partially obscuring the feet. In real life such dresses would have been easily soiled and damaged (but why worry when one has the servants and resources to have them cleaned, repaired, or replaced?), and no lady in this attire would have been able to move fast or far (but why would such a lady need or want to?). Such statues obviously made a statement about the ideal modesty of the women portrayed. Yet there is absolutely no reason to suppose that their clothing is merely an artistic fiction. Statues simply make permanent and draw attention to the sort of display in which women of the class depicted were actually engaged.

To many modern eyes, such representations may appear to be highly ideological in their implications, not to say repressive. They certainly convey an image of the ideal upper-class woman whose activities are restricted, subordinated to men's, and whose behaviour is impeccably modest and matronly. This is true, though it should be remembered that it was precisely those women represented in portrait-statues who were the most powerful, and in some ways the most independent, in the empire.[76] Moreover, the conventions of female modesty in statuary are rather more complex than they first appear.

[74] Quintilian, *Institutio Oratoria* 11.3.137–49. See Davies 2005 on togas in the construction of masculinity.

[75] Trimble 2000. Davies 2005: 125 on the dress arrangement.

[76] On women as recipients of honorific portraits, and the image of them projected, see MacMullen 1980; Forbis 1996; Van Bremen 1996.

Fig 22. Replica of the statue of Eumachia, in its original location in the 'Eumachia
building', Pompeii. First half of first century AD. The inscription on the
base indicates that the statue was erected by the town's fullers.

Compare Figures 22 and 23. The former is the statue of a wealthy
benefactress in early first-century Pompeii. It was set up by the fullers of
the town (as the inscription records) in a public building on the forum
which she had built.[77] The second example is a 'Venus-portrait'. It is one
of the more surprising examples of a phenomenon that started in the first

[77] Zanker 1998: 93–102.

Fig. 23. Statue of a woman in the guise of Venus. Italy, *c.* AD 90.

century AD, possibly in representations of imperial women, and probably
became quite popular in the second century, though only a few such
sculptures in the round survive. It was perhaps especially popular among
freedmen (truly 'freed*men*' here, if the statues in this format were gen-
erally posthumous memorials commissioned by male relatives).[78] Such
Venus-portraits combine the realistic head of the recipient with a

[78] On Venus-portraits see Wrede 1981: esp. 306–23 (and passim); D'Ambra 1996; Stewart 2003: 51–3;
Hallett 2005b. For this example see Wrede 1981: 306–8, no. 292.

standardised divine body which figuratively elevates her to the level of the
immortal goddess and associates her with physical qualities of beauty,
maturity, and fertility as well as dignity and modesty (in this case the body
is of a type known today as the 'Venus Pudica' – the modest Venus,
shielding her breasts and genitals from the observer).[79] Evidently these
naked matrons' memorials posed fewer problems for Roman viewers than
they seem to do for modern scholars. But there is no denying their sexual
connotations.

At first sight, the conventionally draped, modest and restrained, hon-
orific statues of wealthy ladies like Eumachia (Fig. 22) could hardly be
more different. And yet there is an echo of Venus's pose in the very
slightly stooped posture of the woman, in the position of her hips and
legs, and particularly in the position of her right hand and left arm. More
than this, as Jennifer Trimble notes, in many female, draped portrait-
statues there is an ambivalent approach to the concealment or revelation
of the body beneath the clothing.[80] The contours of the clinging tunic or
mantle frequently draw attention to the form of the breasts; sometimes
the feet are exposed by open sandals. Conspicuous modesty is therefore
the counterpoint to a measured display of anatomy which, like the naked
portraits, may have suggested individual qualities such as beauty, health,
and fertility. In representations of female members of the imperial family,
it should be said that these are political as well as personal values. So, in
reference to early imperial works of the Herculaneum Woman types,
Trimble suggests: 'The tension of sensual control and delight takes on
ideological connotations in the context of Augustan constructions of
female sexuality, marriage and childbearing as affairs of state.'[81]

We can see from these examples alone that much more is implied by
Roman statues than their stereotypical poses and costumes immediately
suggest. Some of these messages are no doubt consciously intended; others
reflect the values and assumptions of the society in which the statues were
expected to work.

Aesthetic considerations, however, while central to any conventionally
art-historical treatment of Roman sculptures, provide only part of their
explanation. A series of hierarchical variables determined the more precise
significance of portrait-statues for those who made, received, or viewed
them. Besides choices about dress, attributes, facial features, or hair,
the scale (under- or over-lifesize), material (e.g. marble, bronze, gilded
bronze, silver), and monumental format (e.g. pedestrian, equestrian,

[79] See D'Ambra 1996 for the connotations conveyed. [80] Trimble 2000: 65–66. [81] Ibid. 66.

statues in chariots) were all highly significant. Similarly, the exact architectural context and location were important determinants of the messages conveyed by portrait sculptures and of the honour that resulted for those portrayed.[82] In the erection of honorific statues (as well as more 'private' funerary portraits) there was a premium on prominent exposure (portraits are often decreed to be set up 'in celeberrimo loco' – in the busiest spot). But specific sites and buildings could hold a particular relevance for some portraits.

A striking, if exceptional, illustration of how different variables inter-related is provided by the posthumous honours decreed by the senate in AD 56 for the extraordinarily long-lived and respected magistrate L. Volusius Saturninus. They included a variety of statues that linked his public roles to the places apparently relevant to their performance. These are recorded in an inscription from his family's villa at Lucus Feroniae:[83]

> ... triumphal statues for him – a bronze in the forum of Augustus and two marble statues in the new temple of the deified Augustus – and also consular statues, one in the temple of the Deified Julius, a second within a three-pillared monument on the Palatine, a third in the precinct of Apollo within sight of the Curia; and also an augural statue in the Regia, an equestrian statue next to the Rostra, and a statue of him seated in the curule throne at the theatre of Pompey, in the portico of the Lentuli.[84]

Saturninus's array of statues in the city of Rome collectively embodies the different facets of his public, political persona, and in a rather less systematic way, other public portraits evidently sought to do the same.

PORTRAITS AS A CURRENCY FOR SOCIAL EXCHANGE

Portraits can be seen as a sort of self-representation inasmuch as we may assume that individual sitters had a say in how they were portrayed. Yet we can already see that the usage of portraiture is more complex. The sorts of public, honorific statues described above were not set up by those whom they represented. Their hierarchical symbolism provided a vehicle for other people to express their feelings of gratitude and loyalty towards the recipients. As we have seen, this applies even (or especially) to members of the imperial family, whose portraits dominated public spaces. There is little to suggest that they were directly involved in this

[82] Lahusen 1983: 45–65; Stewart 2003: esp. 90–1.
[83] Tacitus, *Annals* 13.30. Eck 1972; Stewart 2003: 80–2. [84] Eck 1972: 463.

proliferation of their images; if anything, the ancient sources suggest an ostentatious reluctance to receive such honours.[85]

In fact, surprising as it may seem from the modern perspective, there is little concrete evidence of *any* Roman portraits being overtly commissioned and set up by the sitters themselves. It does seem to have happened, especially in private locations and on funerary monuments, but it was not the norm.[86] Most Roman portraits were made in honour or memory of other people. Sometimes the recipients were close relatives or friends of the dedicator; sometimes they were patrons or others who had provided help and deserved the display of gratitude. Above all it was groups of people, particularly whole communities and their governing councils, that erected prominent portraits in honour of their benefactors. This was a modification of the Hellenistic custom of voting public honours in exchange for or in anticipation of civic benefactions or assistance from rich and powerful individuals, and all through the Roman empire towns and cities dedicated portrait-statues to those men and women who had financed public works or provided other services. When eventually, by the fourth century AD, such public portraits begin to drop dramatically in numbers, this seems to represent not only a decline of portrait sculpture per se, but a reduction in the investment of wealthy individuals in their communities, that is to say in the 'euergetism' (doing good works) which had traditionally given rise to statues as signs of public gratitude.[87]

An essential characteristic of this custom of 'gift-exchange' is that, although formalised, it was not completely predictable.[88] Public portraits were rewards, freely given by others, not set up by oneself. Notionally at least, the reward of a statue could not be taken for granted, nor did one know exactly what form a portrait or another honour would take, and how the decision to grant it would be couched. The prestige and pleasure of the reward would have been diminished if its production had been entirely automatic and routine (in these respects Roman honours have something in common with the modern British honours system of knighthoods and other awards).[89] The receipt of an honour like a public statue not only showed gratitude for services rendered by the recipients, it

[85] See note 43, above. Note esp. Rose 1997b for social contextualisation of imperial and other portraits in the Greek east.
[86] Stewart 2003: 84–6.
[87] On the decline of portrait-statues see Stichel 1982; Smith 1985, 209–21; Bauer 1996, 339–62. On euergetism in general see Veyne 1990.
[88] Cf. Bourdieu 1977: esp. 5–9. [89] Stewart 1979: 120–32; Tanner 2000: esp. 25–30.

also strengthened their emotional investment in the community involved, and therefore the likelihood of their continued support.[90] The relationship is nicely described in a late Roman poem by Rutilius Namatianus, whose father had been governor of Tuscia et Umbria, an administrative region of Italy, in AD 416. Rutilius visits his father's statue which still stands in the heart of Pisa, the local capital, where it reminds the inhabitants daily of how good their old governor was. The statue prompts the poet to remember his father's own affection for the people. The mutual good-will of governor and citizens is therefore literally embodied in the statuary honour. Apparently alluding to a verse inscription on its base, Rutilius concludes that, 'mutual affection sings eternal gratitude'.[91]

The relationship was not always so happy. Just as honorific portraits were freely given, so they might be quickly, and violently, removed when the recipient caused displeasure or fell from favour.[92] Such was the case with the second-century sophist Favorinus.[93] A more drastic approach to the removal of images, especially portraits of fallen rulers, was the rigorously destructive practice of 'damnatio memoriae' to which we shall return in Chapter Four.

This explanation should be qualified: we have already seen that the form of imperial images must have been determined centrally, and presumably with input from the imperial family itself. The same probably applies on a smaller scale to portraits of private individuals. At some stage they must have actually sat for a portraitist or approved the model that was used. They may have had some influence over the inscriptions added to statue-bases. They may indeed have pulled strings behind the scene, ensuring that they got the rewards they wanted, though we have no evidence of this. We do know that recipients of honorific statues sometimes financed the monuments. But the whole process is consistently represented by Roman sources as a delicate kind of social intercourse. For example, even when the honorand was paying for a statue – presumably with cash up-front? – this outlay is presented in inscriptions as an act of generosity in itself, 'paying back' the expense of the local *decuriones*, the populace, or whoever had decided on the honour.[94]

This sensitive etiquette is exemplified by a uniquely informative statue-base from Fossombrone (the ancient town of Forum Sempronii) in Umbria, probably erected in the second quarter of the second century

[90] Tanner 2000; cf. Tanner 1992. [91] Rutilius Namatianus, *De Suo Reditu* 588.
[92] See e.g. Dio Chrysostom, *Oration* 31.28 (*Rhodian Oration*) Tanner 2000: 32–3.
[93] Dio Chrysostom, *Oration* 37; Philostratus, *Lives of the Sophists* 489–92. [94] Martin 1996.

AD.[95] It is not necessarily entirely typical, but it is at least symptomatic of the way in which statuary honours were regarded. It bore the over-lifesize statue of a local dignitary, whose career, titles, and accomplishments are inscribed in conventional fashion on the front of the marble base:

To Gaius Hedius Verus, son of Gaius, of the Clustumina tribe, with publicly provided horse, prefect of the cavalry regiment Indiana 'pious and true', military tribune of the second Trajanic legion 'the Strong', prefect of the second mixed cohort of the Lingones, quinquennial duumvir, quaestor, patron of the municipium, flamen; similarly at Pitinum Mergens quinquennial quattuorvir, quattuorvir with aedilician power, patron of the municipium, pontifex, because when previously a statue had been decreed to him in the name of the people on account of his merits, and he had spared public expense, content with the [mere] honour, the decuriones set it up at their own expense; to them Verus donated 70 sesterces each for the dedication.

What we can deduce from this rather convoluted text is that the people of Forum Sempronii originally voted to set up a statue for Hedius Verus. Verus then generously said that he was happy simply to have been awarded such an honour, and he prevented them from wasting their money on the actual purchase of a statue. At this stage the town-councillors, the *decuriones*, step in and pay for the statue. In gratitude Verus then gives each of them a gift of 70 sesterces – a very considerable sum when multiplied by up to perhaps a hundred men, and very possibly much more than their actual expenditure![96] So we can see that the statue is at the centre of a kind of social ballet. It is a dynamic relationship – not without tension – in which the gift of the honorific portrait works to secure the recipient's sense of obligation to his peers and community, while his own generous reciprocation threatens to cancel out this moral 'debt'. But ultimately the statue can probably be seen as serving a long-term relationship of mutual affection, generosity, and gratitude – between the benefactor, his upper-class peers, and the local citizenry at large, not to mention the statue's ultimate public audience.[97]

In this case, however, the statue-base has more to tell us. For on its side is inscribed the entire text of a letter from the *decuriones* to Verus:

The duumviri and decuriones of Forum Sempronii to Verus, greetings. Both the numerous and considerable distinctions of your rank, adorned with

[95] *CIL* XI 6123. Hedius Verus is attested (and dated) in a recently discovered military diploma: *AE* 1997, 1779b; Nollé and Roxan 1997: esp. 6–7; Birley 1999: 246. For a photograph of the base, and speculation about the source of the statue, see Luni 2001: 21–24 with fig. 6.

[96] On the cost of statues see Duncan-Jones 1982: 78–9, 93–9, 126–7, 162–6; Oliver 1996: 146–7.

[97] Cf. Smith 2002: 65. On the precarious equilibrium of such gift-exchange relationships note Bourdieu 1977: esp. 5–9.

marks of imperial esteem, and your conspicuous munificence towards our community, and the feelings of affection that you yourself show to our citizens and then perceive coming from them, and especially the outstanding modesty of your behaviour, your notable respect – [all this] has obliged us of necessity to render at last thanks that are worthy of you – as far as that is possible – without your knowledge. For some time ago we decreed the erection of a pedestrian statue for you at our own expense, but we did not send the decree to you lest now also [you should do] what you did before when a statue was decreed for you at public expense, and write back that you are content with the honour alone – which truly illustrated your modesty: in fact it reproached us, as it were, with our feebleness. Therefore the statue has been decreed and, so that you cannot turn it down, it has already been made and it is on its way. It only remains to say: indulge our wishes and, as we request, make known to us what sort of inscription you think should be put on it. We wish you well.

The letter was originally written after the *decuriones* had commissioned the statue (secretly, so that Verus could not refuse it this time), and the main, dedicatory inscription on the front of the base evidently gives us the sequel. When told of the statue and offered the chance to comment on the form of the inscription for its base, Verus must have responded with his gift of money for each *decurio* and then asked that the letter recounting the whole exchange should be reproduced on the monument. Between them the two inscriptions tell us the whole gratifying story of local aristocratic solidarity and social cohesion.

 It is sad that the bronze statue itself does not survive, because its design should theoretically have contributed to the statement that the *decuriones* were trying to make about Hedius Verus. He may have been portrayed in the cuirass of the officer, complementing the list of past military commands in the dedicatory inscription (indeed the 'footprints' for attachment on the top of the base imply the posture of such a statue). Alternatively, given the civic context, the *decuriones* may have wished to emphasise Verus's civilian career as a local magistrate and patron of communities by commissioning a togate statue. As for his portrait features: did they resemble those of the ruling emperor, Hadrian or Antoninus Pius, and thereby bestow some imperial virtues on this image of an excellent benefactor? And did their expression or physiognomy help to convey the sorts of qualities that the *decuriones* praise in their letter, such as *modestia* (modesty) and *reverentia* (respect)? As it is, we know virtually nothing of the statue's appearance, or even its original location. But such questions should serve to animate not only the numerous vacant inscribed bases that survive today, but also those extant sculptures that are now divorced from their bases but which must have served similar functions to that of Verus.

In recent years this sort of reconciliation between the separated sources of evidence has been attempted with interesting results. In a very few cases it has proved possible to reconnect statues with their own inscribed bases and to show how text, sculptural style, and iconography contributed in complementary ways to the construction of a suitable image for the recipient of a statue. The city of Aphrodisias in Caria (western Asia Minor) has yielded particularly rich evidence for the usage of honorific statues in late antiquity (from around the fourth to sixth century), for a number of works have been found in situ, together with inscribed bases.[98] In a few cases the association of heads, bodies, inscribed bases, and architectural contexts contributes to a holistic view of how these images worked in society. As R. R. R. Smith argues, this approach allows us to see, for instance, how the stern facial features of a provincial governor's portraits might be intended to complement the conventional inscribed praise for their uncompromising honesty and austere commitment to justice.[99] This is in contrast to the conventional academic tendency to appreciate late antique portraits in isolation, imagining their remote facial expressions as manifestations of some kind of ill-defined late Roman spirituality.

We do not know what proportion of the population could read inscriptions – perhaps only a small percentage understood them fully – but that hardly matters, for they are conceived as labels, as commentaries, as declarations of purpose, and as parallel monuments in their own right. Their omission from histories of Roman art fragments our picture of ancient portraiture more than is necessary.

In conclusion, it must be said that even in isolation inscriptions – epigraphy – tells us much about what we might call the life of statues in Roman society. This chapter has concentrated on many of the traditional concerns of classical art historians in their study of portraits. For example, we have looked at faces and their identification, the significance of the physiognomy, the symbolism of statues. And we have put these aspects of the portrait in some kind of social context by considering other forms of evidence. Yet all of these interests remain focused on the individual images themselves. A broader account of Roman portraiture, informed mainly by written, rather than visual sources, would shift our attention away from works of art towards issues like the complex and highly variable patterns of display in different regions or provinces of the

[98] Smith 1999; Smith 2002. Cf. Smith et al. 1998 for earlier material. Also Smith 2006: 21–6.
[99] Smith 1999: esp. 185–8.

empire. Indeed, as noted above, attempts of this kind, heavily reliant on epigraphy, have sometimes been made.[100] This difference of emphasis is analogous to the different approaches to Pompeian wall-painting that we examined in Chapter Two – at one extreme statistical surveys, and at the other, the study of the style and imagery of individual paintings. They are a reminder, once again, that the social history of art means different things. The account offered here is selective, and needs to be read with parallel histories in mind.

[100] See note 14, above. Cf. also Stewart 2003: esp. 157–83.

CHAPTER 4

The power of images

> Insofar as power is a matter of presentation, its cultural currency in antiquity (and still today) was the creation, manipulation, and display of images.[1]

All Roman art – all art indeed – has something to do with power. We have seen repeatedly how various kinds of Roman art were used as instruments, working in society to achieve particular ends. We have also seen – for example in the gendered use of clothing and hairstyles in portraits – how works of art embodied and perhaps reinforced ideological assumptions about how society was structured and which values it should enshrine. Such issues are central to this book. But this chapter is about two rather more obvious aspects of the power of art. First, it concerns the power of political imagery – of visual 'propaganda' – a subject which has long been central to studies of Roman art and which continues to attract interest (Paul Zanker's 1988 volume *The Power of Images in the Age of Augustus* is one of the most widely appreciated books to have been written on Roman art[2]). Second, we shall examine the power of works of art to affect people's feelings and behaviour, even to prompt them to acts of violence. This is an unsettling area of study that has only quite recently attracted the interest of art historians, for it concerns response, reception, and 'audiences' of art, rather than traditional subjects like artists or patrons.[3] We shall concentrate here mainly on religious images. As we shall see, the themes of political art and religious art are by no means unrelated.

PROPAGANDA?

One need only consider the portrait heads and visual 'slogans' that appear on Roman coinage to appreciate that even small-scale imagery was

[1] Elsner 1998b: 53. [2] Zanker 1988b; first published in German (Zanker 1987).
[3] Freedberg 1989 is a groundbreaking book on the subject. In the study of Roman art cf. Gregory 1994.

potentially important for disseminating messages about late republican statesmen or imperial rulers through the vast territories of the empire (cf. Fig. 18). Yet monumental works of sculpture and architecture had a more prominent role in celebrating and advertising power in Rome itself and in countless other communities in Italy and the provinces. It is these monuments, and especially works of the imperial period, that receive most art-historical attention. In any significant town during the principate, images of the emperor and his family were probably everywhere, particularly in public places. There were, as we have seen, public as well as privately displayed portraits of the imperial family. Among these were imposing statues of emperors, often represented riding in chariots or on horseback. There were temples or cult rooms in various forms, dedicated to the veneration of dead, and in many cases living, emperors.[4] There were victory monuments, honorific arches, public altars, and columns. There were, moreover, numerous temples or public amenities like baths and basilicas which had been erected or restored by the emperor himself. Whole swathes of the city of Rome, for example the forum complexes at its heart or the buildings and piazzas of the Campus Martius, eventually came to be dominated by these kinds of monument.[5] At Pompeii in the first century AD, at least four buildings along one whole side of the forum were either dedicated to or closely associated with the veneration of the imperial family and imperial regimes.[6]

In one way or another such buildings testified in themselves to the power or authority of the emperor. They were, in a sense, symptoms of his pervasive influence, and of course the emperor's own benefactions demonstrated his wealth, his concern for the communities that he ruled, and his sheer capacity for shaping the urban environment at will. Yet it was also normal for many sorts of monuments and public buildings to be adorned with sculptures (and sometimes with paintings) that portrayed the emperor in positive ways or otherwise advertised his power and his qualities. These include the important 'genre' of historical reliefs – relief sculptures that display an apparently documentary interest in specific events of the recent or more distant past. This particular class of public images, which inevitably served as artistic 'advertisements' for the benefits of particular Roman regimes, is regarded by many scholars as characteristically Roman. Indeed, they receive much attention in general

[4] See e.g. Price 1984: esp. 133–69; Witschel 1995a; Witschel 2002 (with a cautious approach).
[5] For a survey of the subject see Patterson 1992: esp. 190–200, 207–10. [6] Zanker 1998: 85–102.

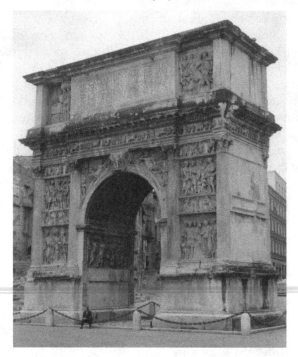

Fig. 24. The Arch of Trajan at Beneventum (Benevento; 'country' side). *c.* AD 114.

discussions of Roman art, and offer an instructive introduction to the art of power.[7]

The almost nine-metre high Arch of Trajan at Beneventum, about 150 miles south-east of Rome, is a good, if unusually extravagant, example of what we are dealing with (Figs. 24 and 25).[8] The arch was built by the senate and people of Rome in honour of the emperor and dedicated (if not necessarily completed) in AD 114, near the end of his reign. It was unusual for the senate to commission such a monument outside the capital, and its erection is probably connected with Trajan's extension of the Via Appia to Brundisium (Brindisi) around this time, for the road passed through it. Appropriately for its somewhat liminal location, the arch's extraordinary sculpted reliefs appear to celebrate the emperor's policies and activities at home and abroad, that is respectively in the civic

[7] On historical reliefs generally see e.g. Brilliant 1974: 187–96; Holliday 2002.
[8] On the arch generally, with various interpretation, see Hassel 1966; Fittschen 1972; Gauer 1974; Hannestad 1986: 177–86. For an overview see Kleiner 1992: 224–9.

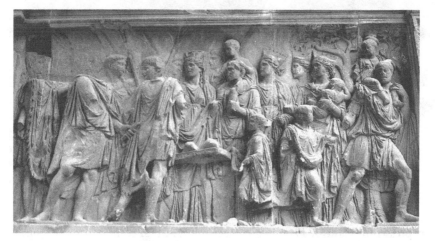

Fig. 25. So-called *alimenta* relief from the passage of the
Arch of Trajan at Beneventum (Benevento).

and military spheres. Trajan himself appears within groups of other
mortal and divine figures in six large, crowded figurative panels on each
face of the arch. A frieze showing a triumphal procession runs around the
whole structure below its attic level. Further smaller reliefs divide up the
lower zones with scenes of ritual candelabra being decorated and Victories
sacrificing bulls. Victory figures also adorn the spandrels (the areas
flanking the curve of the arch itself), and there are scenes of *alimenta*
(distribution of money for needy children; Fig. 25) and of sacrifice on the
sides of the central passage.

Each main facade is saturated with sculptural imagery that would
originally have been painted so as to be yet more conspicuous. The
monument is sometimes likened to a billboard.[9] It was certainly spec-
tacular. One can imagine the intended impact from the poet Statius's
florid praise for a no doubt rather similar arch built some twenty years
earlier for one of Trajan's predecessors, Domitian: '[The road's] portal,
its propitious threshold, was an arch that gleamed with the commander's
warlike trophies and all the stones of Liguria, as great as that which decks
the clouds with rain'.[10] On the other hand, it is important to note that the
precise subjects of the principal relief panels and the explanation of the

[9] E.g. in the textbook Kleiner and Mamiya 2003: 207–8.
[10] Statius, *Silvae* 4.3.97–100. No traces of Domitian's arch are known. For commentary on this and
 other arches note Coleman 1988: 127–8.

overall programme of Trajan's arch are fairly baffling and have allowed no scholarly consensus – a point to which we shall return. But they clearly constitute a series of visions of imperial virtue and accomplishments, including the emperor's journeys to and from Rome, his founding of new colonies (for military veterans) and the *alimenta*, a subject also celebrated on contemporary coinage. All of this happens with the direct and personal encouragement of a host of major and minor deities. For the moment more precise iconographical analysis need not concern us.

Most modern observers of monuments like the Beneventum arch would not hesitate to characterise them as visual propaganda. They are certainly 'propagandistic' inasmuch as they foster a supremely favourable conception of the ruling power, publicising it in the most conspicuous manner.[11] But does this really amount to *propaganda*? In Chapter Three I expressed reservations about the application of that term to Roman public portraits, and it is no less problematic in the consideration of other kinds of imperial art. The very word 'propaganda', though Latin in origin, is a relatively recent invention and its associations derive from the experiences of the twentieth century.[12] The Roman world, as far as we can tell, had nothing like a modern propaganda machine: no organs of systematic publicity; no ministry of information; certainly no spin-doctors. Many public works that presented the ruler in a positive light, like the statues examined in Chapter Three, were commissioned by people other than the emperor. No one forced the population to make these things; there was no methodical propagation of the imperial image as, arguably, dictators' images are deliberately propagated in many modern states. It would be unacceptably cynical and anachronistic to dismiss the spontaneous, vol-untary impetus behind a lot of Roman 'propagandistic' art.[13] Indeed it is a particular strength of Paul Zanker's work that he seeks to move away from the notion of centrally orchestrated propaganda. He sees the first emperor Augustus as an authoritative point of reference towards whom the com-munities of the empire willingly directed their devotion through images.[14] We shall return to that idea shortly.

Yet even if we do adopt a more cynical view of Roman political art, acknowledging that it served primarily to legitimise the authority of a statesman or regime, or to enhance a ruler's public persona, it is important

[11] For positive attitude to the idea of Roman (artistic) 'propaganda' and an analysis of its forms see Evans 1992: esp. 1–16.

[12] Hannestad 1986: 9; Levick 1982: 105–6; cf. Burke 1992: 4–5.

[13] Cf. Burke 1992: 13 on the image of Louis XIV as 'a collective creation'.

[14] Zanker 1988b: 3. Cf. Galinsky 1996: 10–41.

to appreciate the terms in which Romans perceived this process. Consider, for example, the Ara Pacis Augustae (the Altar of August(an) Peace), which we briefly encountered in Chapter One (Fig. 1).[15] Reconstructed under Mussolini in the 1930s, it is one of the most famous of Roman public monuments, and one of the most obviously political in the way that it celebrates Augustus and the values of his regime in its rich, resonant imagery. The structure is really a marble enclosure for an altar. It was dedicated in 9 BC. It is elaborately decorated with reliefs which accord with recurring themes in Augustan public art and poetry, though frequently the precise significance is disputed.

On its sides are large-scale processional friezes (seemingly conceived as two parts of the same group of figures) which show Augustus and his family, senators, and citizens, all engaged in a sacrificial ceremony. At each end of the structure are panels with personifications associated with Roman war and peace (possibly including Pax, 'Peace', herself) and subtly rendered scenes from Roman myth-history; Romulus and Remus are there, as is Aeneas. Beneath all of these reliefs, and dominating the outside of the enclosure to a surprising extent, is a vigorous growth of idealised, abstract vegetation – a fantastic mixture of blooming plants inhabited by small animals – which is probably to be associated with the prosperity and fertility of the peaceful age accomplished by Augustus. Carvings on the interior of the enclosure mimic a wooden palisade and sacrificial objects and fruitful garlands – hints, within this innovative site, at good, traditional Roman ritual and its benefits. Sculpture on the altar itself included a further small-scale frieze showing a sacrificial procession.

However, for all its celebration of Augustus's version of Roman tradition, it is essential to note that, strictly speaking, the Ara Pacis is a commission by the senate, not the emperor, and it is also a religious monument, dedicated to a goddess, although Pax's epithet 'Augusta' unmistakably aligns her with the emperor. These qualifications may seem trivial, especially if we remember that the construction of the altar was voted by the senate in 13 BC, when Augustus's own stepson (and ultimately his successor), Tiberius, was consul.[16] We might say that the monument originated as close to the emperor himself as makes no difference. But the relevance of the senate's official role becomes clearer if we consider Augustus's own reference to the Ara Pacis in his *Res Gestae*, the statement of his life's achievements. For here the whole point of the altar

[15] See e.g. Moretti 1948; Simon 1967; Zanker 1988b: passim. [16] Conlin 1997: 41.

is that it is a gift from that body. If it is propagandistic art, then it works as such only because it is *not* the emperor's own creation:

> ... the senate decreed that there should be consecrated in honour of my return (*pro reditu meo*) an altar of Pax Augusta in the Field of Mars, at which it ordered that the magistrates and priests and Vestal Virgins should make an annual sacrifice.[17]

This valuable reference comes in the context of a prolonged boast by the emperor about his honours and achievements. There is no doubt whatsoever that the monument is perceived to be connected with his power and authority. Indeed, paradoxically, the site, subject, and circumstances of the altar suggest that it served as a sort of victory monument for the emperor, who had returned from campaigns in Spain and Gaul.[18] So there is no attempt to claim that this religious dedication is free from political intent (the modern usage of the word 'propaganda' misleadingly tempts us to see it as something invariably underhand and dissembling). However, the political value of the altar is expressed in terms of the senate's *gift* – one of a series of honours that it decreed.[19] The Ara Pacis and its reliefs must be viewed in this light: not as Augustus's own propaganda, but as the product of senatorial choices about which imagery would best redound to the emperor's credit and most appropriately comment on the benefits of his victorious return. Since the honour of an annual sacrifice appears to be as important to Augustus as the altar itself, it is unsurprising that a scene of just such a sacrificial ritual dominates the processional reliefs on its north and south sides. This does not mean that the sculptures are not directed at an 'audience' of the Roman public, or indeed at persuading that public of the emperor's achievements and merits. But the purpose of this 'propaganda' is to make the altar succeed as an honour to the emperor. The success of the altar in propagating Augustan ideology is inextricably linked to its function as a reward for the emperor, just as the prestige of honorific statues depended in large measure on their public prominence.[20]

Consequently, major monuments like the Ara Pacis embody a more complex relationship than the notion of propaganda normally accommodates. In fact the relationship is more complicated still in this case for, after 2 BC, the text of Augustus's *Res Gestae* was itself disseminated in monumental form.[21] It was displayed on bronze pillars in front of the

[17] Augustus, *Res Gestae* 12. [18] Torelli 1982: 29–30. [19] Augustus, *Res Gestae* 9–14.
[20] Cf. Smith 2002: 65 on statues within 'a dynamic three-cornered relationship'.
[21] See Elsner 1996b.

Mausoleum of Augustus, and ultimately at other sites in the eastern empire at least (the text survives best on the wall of the first-century Temple of Augustus and Rome at Ancyra in Asia Minor).[22]

There were, of course, public monuments commissioned by the imperial family itself. In Rome the imperial fora offer splendid examples, and the Forum of Augustus, only briefly mentioned in the *Res Gestae* as the product of the emperor's personal piety and generosity, we know from other sources to have been replete with sculptures that celebrated Augustus, his family, and his divine supporters.[23] In general, however, imperial public monuments worked like the Ara Pacis: ostensibly at least (and this is perhaps all that matters) they are other parties' attempts to participate in the glorification and legitimation of imperial power, though the traditional vocabulary applied to such monuments involves at the most qualities like honour, excellence, and strength, rather than 'power' as such.[24] Authorship of the monument is always declared; the initials SPQR, for 'the senate and people of Rome', are especially prominent in monumental inscriptions of the capital. Nevertheless, modern commentators have very often elided the distinction between the emperor and those who honoured him. To do so misses the point, as we can see from a comment by the historian Tacitus. In his cynical account (written a century after the event), he describes the spate of honours from the senate that followed the emperor Tiberius's request to grant his son Drusus tribunician power in AD 22, thereby nominating him as his de facto heir:

The senators had anticipated his address, so that their sycophancy was all the more carefully planned. But they could think up nothing except decreeing images of the Caesars, altars of the gods, temples, and arches, and all the other conventional things.[25]

Of course, it could be difficult to walk the line between expressions of fidelity and sycophancy, and in this case some more exceptional honours suggested by particular senators were reportedly regarded as over the top, making their proposers into a laughing stock. What is important is that even from his critical perspective, Tacitus does not imagine such honours as anything we would recognise as propaganda.

[22] Suetonius, *Augustus* 101.4.

[23] Augustus, *Res Gestae* 21. Other sources include Ovid, *Fasti* 5.544–602; Suetonius, *Augustus* 31. See Zanker 1988b: esp. 111–114, 194–215; Evans 1992: 109–18.

[24] Cf. Wallace-Hadrill 1981: esp. 314–17 on the association of virtues on coinage with charismatic imperial power.

[25] Tacitus, *Annals* 3.57.

As a final comment on this relationship, let us return to the arch at Beneventum. We cannot be certain that Roman viewers would have appreciated or thought much about the mechanisms by which such a monument was created. After all, even Statius presents Domitian's arch simply as a glorious embellishment of the road that he has constructed, though it is likely to have been an honorific dedication.[26] Was the arch at Beneventum regarded as a beautiful adornment, hazily reflecting the beneficial power of the emperor? Perhaps. But it is hard to avoid the dedicatory inscription that dominates the facades and their sculptures, and the letters SPQR were there for all, even the illiterate, to recognise. This is boldly and explicitly the seal set upon Trajan's road by the senate and people of Rome. Its images of imperial virtue and accomplishment are the products of senatorial patronage, in this case almost certainly designed with specific guidance from the patrons. They may be unduly abstruse, reflecting rather subtle senatorial thinking, but they do not exist in a vacuum; their *raison d'être* is display. They are conceived as communicating with the notional passers-by who will benefit from the road. They are the senate's commentary on the emperor to these people.

The sculptures of the arch at Beneventum have been likened to panegyric speeches, specifically to Pliny the Younger's *Panegyric* to Trajan, delivered in AD 100, which seems to share some of the arch's themes, some of its vocabulary of praise. The panegyric is a better model for understanding the motivation behind such works than is the modern idea of propaganda.[27] This is not to say that sculptures in praise of the emperor were not intended to be persuasive, for persuasion is one part of the dynamic relationship in which they were embedded. Though it refers to a rather different kind of imagery, Andrew Wallace-Hadrill's explanation of imperial coinage is relevant here:

It is the coin that speaks, not the emperor: and its message is an appeal to a power outside itself, the emperor to whom it does honour. But by paying tribute the coin sets a model to the user, appeals to values which he ought to share, and so encourages him to share them.[28]

[26] The claim in Suetonius, *Domitian* 13 that Domitian (reigned AD 81–96) set up his own arches (besides many other outrages) is to be distrusted.
[27] See Torelli 1997: esp. 167–71; Hannestad 1986: 177. The opening passages of Pliny's *Panegyric* offer a self-conscious explanation of the value of such 'spontaneous' praise.
[28] Wallace-Hadrill 1986: 69. Cf. ibid. 68 with reference to Pliny. Wallace-Hadrill is keen not to over-emphasise the distance between the emperor and the producers of ideological imagery and to recognise the importance of its persuasive function. In this he differs from Levick 1982.

THE RHETORIC OF POLITICAL ART

Propaganda is seldom untrue. Its tendentious communication of political information is based on selection, implication, and emphasis, rather than distortion. The same is true of Roman imperial imagery. It tends to concentrate on the 'real' and the specific to such an extent that the term 'historical relief' is applied to many of the sculptures that adorned monuments like honorific arches, columns, and altars. A particular pre-occupation is the emperor's achievements in war, and his religious and civic deeds, which are presented as evidence of the ruler's merits. Such art does not make statements; it presents 'facts' and tells stories from which the qualities of the ruler can be inferred. It could be argued that political imagery is more effective when presented in this way. After all, ideology resides, to use Roland Barthes's phrase, in 'the decorative display of *what-goes-without-saying*'.[29] Representational art serves this purpose especially well as it purports *not* to be selective: it appears to present things as they appear. This is how things were – it seems to declare – take it or leave it![30]

Trajan's Column presents one of the most sustained visual commentaries of this kind in Roman art, a monument of extraordinary technical sophistication that was emulated several times under subsequent rulers.[31] The 35-metre high column on a podium was built between about AD 106 and 113 as part of the emperor Trajan's massive forum complex in the heart of Rome. It was surmounted by his colossal bronze statue and an inscription on its base claims that it was built by the senate and people of Rome as a testimony to the extent of excavation work required for the project. In itself this is a statement of imperial power. But the column's main point of interest – conceivably a later addition under Trajan's successor, Hadrian[32] – is a low-relief frieze that spirals for 200 metres around it, recounting the progress and ultimate success of the Trajanic campaigns against the Dacians between AD 101 and 106.

The continuous frieze with its illusionistic, painterly, manipulation of space and time is extraordinary for its attention to details. The greater proportion of its length is devoted to the minutiae of troop movements and the practicalities of campaigning (military historians love it for the information it provides), rather than victorious battle or, indeed, the emperor's prowess. In general, the imagery of the column is hardly subtle.

[29] Barthes 1993: 11 (from his Preface); trans. A. Lavers. Cf. Gordon 1990. [30] Cf. Smith 2002: 79.
[31] Generally, see Lepper and Frere 1988; Settis 1988; Coarelli 2000. [32] Claridge 1993.

Fig. 26. Detail from Trajan's Column, Rome, AD 106–13(?):
Trajan receives a Dacian envoy.

Large-scale relief representations of barbarian spoils adorn its base. All of
the sculptures remind us that the whole forum complex to which they
belonged was financed by the spoils of war. On the other hand, the
narrative of the column's frieze *is* subtle. The emperor is indeed central,
playing a very active role in his wars. Fifty-nine times he appears, each
time performing some virtuous or diligent imperial duty such as
addressing the troops, showing clemency to defeated enemies, piously
sacrificing, or dealing with envoys (Fig. 26). But his emblematic figure is
enmeshed in the complex realia of life on the frontline. It was from his
gesture, his position, the attention of others, and perhaps his original
colouring, now lost, that his importance would have been recognised.

The narrative of this frieze was effectively illegible because of its height,
helical shape, and architectural setting. Consequently, it has been sug-
gested that the parallel narrative of Trajan's virtuous activities on cam-
paign are the *real* story being told. This is probably true in a sense, but the
image of the emperor promoted in these sculptures was underpinned by

documentary detail. Its ideological meanings are literally given verisim-
ilitude by their realistic narrative context.[33]

It is perhaps for this reason that the representation of the emperor on
public monuments so often takes the form of 'historical' reliefs. On the
Arch of Trajan at Beneventum the touching details of the figures with
whom the emperor interacts, including children, and the naturalism with
which their behaviour is rendered succeed even in making the accom-
panying deities and personifications plausible and intimate.

It appears, however, that generations of monuments constructed in
honour of emperors ultimately diminished the realism and originality of
historical reliefs.[34] Time and again from the second century on we can see
the same themes played out in sculptural reliefs. It becomes more
important to identify any given emperor in relation to his good (and bad)
predecessors than to describe his own specific accomplishments. Particular
monumental types are repeated. The Column of Trajan was imitated
around the 180s AD in a new column in honour of Marcus Aurelius.[35] It
emulates the earlier relief, presenting Marcus Aurelius's campaigns against
the Germans and Sarmatians in the mould of Trajan's Dacian wars. The
main difference is one of style and composition, rather than iconography.
The figures are bolder, larger, in higher relief and in simpler formations,
while the emperor is more prominent in the lower, more visible parts – all
innovations that may have been intended to make the ruler's exploits
more obvious. Arguably the Column of Marcus Aurelius abstracted the
'real' political message from the complexity of its earlier model.[36]

At about this time, in the 170s AD, a series of reliefs in honour of
Marcus Aurelius was executed, apparently destined for one or more
triumphal arches at Rome. Eleven relief panels survive from this uniden-
tified commission.[37] They show the emperor performing ideal, typical
activities at home and at war: setting out on campaign; the purificatory
ritual of *lustratio*; addressing the troops; receiving barbarian prisoners
with clemency and administering justice to them; presenting a subjugated
leader to the troops as a new ally; returning to the city of Rome; cele-
brating the triumph; sacrificing on the Capitoline Hill (Fig. 27); and
distributing largesse. The proper behaviour celebrated by these reliefs
was so generic, even ritualistic, that the images might have been applied
to any worthy ruler. Jas Elsner refers to such images as state 'icons'. They

[33] See Brilliant 1984: 90–123, esp. 100–101. Cf. Smith 2002: 79. [34] Cf. Gordon 1990: esp. 214–19.
[35] See e.g. Becatti 1957; Scheid and Huet 2000. [36] See Brilliant 1984: 112–15.
[37] Ryberg 1967; Angelicoussis 1984b (with different theories).

Fig. 27. Relief from an honorific arch showing Marcus Aurelius sacrificing.
Rome, AD 176–80.

certainly represent a formulaic vision of imperial qualities that is to be
found in many other public monuments.[38] It is unsurprising, therefore, that
eight of the panels of Marcus Aurelius were reused on the fourth-century
Arch of Constantine (where they bore Constantine's head) alongside new
historical reliefs and other salvaged works from earlier periods.

[38] On their role as ideal images of imperial behaviour see e.g. Elsner 1998b: 32, 35, 147 (all referring to
'icons'); Ryberg 1967: 90–4.

It is also unsurprising that such transferable representations of the emperor's virtue were adopted into private art of the later second century AD. Among the 'biographical' scenes on expensive marble sarcophagi of that period we sometimes encounter scenes of a deceased man's ideal behaviour that echo compositions on the Column or relief panels of Marcus Aurelius (cf. Figs. 15 and 27).[39] We have already seen how ideal images of this kind constitute an abstraction of emblematic images of virtue from the narratives to which they notionally belong. The process of abstraction in public, monumental art is rather similar.

The fact remains, however, that even abstract 'icons' of imperial power are far removed from modern expectations about centralised 'propagandistic' art. A further paradox emerges within less obvious media for the display of political imagery. For some of the images that most emphatically proclaim the power and status of the imperial family, even assimilating its living members to divinities, are to be found on private, luxury, aristocratic objects rather than on works intended for mass distribution or conspicuous public display.[40]

Imperial cameos are among the most impressive examples, although they are frequently hard to date and interpret. Cameos (reliefs carved in banded stones like sardonyx) were popular throughout the Roman empire. They were worn, for instance, on rings and clasps. But a small number of very large pieces survive that probably circulated as gifts among the emperor's family and close associates. Such luxury works of art, the most splendid of the so-called 'minor arts', were evidently admired for their quality. Often highly classicising in style, they occasionally display some of the finest craftsmanship in the Roman empire.[41]

The renowned Gemma Augustea, for example, is an extraordinary 23 cm wide sardonyx carved with dynastic and triumphal scenes on two registers (Fig. 28).[42] In the upper register Augustus is enthroned, half-naked, with the trappings of Jupiter; there is an eagle beneath him and a sceptre in his left hand. His right hand holds a *lituus*, a special kind of priestly wand. A personification of Oikoumene (the inhabited world) crowns him from behind, accompanied by the figures of, perhaps,

[39] Brilliant 1984: 112–14. Kleiner 1992: 301–3.
[40] Hannestad 1986: 77–8, 82. Cf. Kuttner 1995: esp. 17–18 (there are, however, a number of public monuments that do celebrate the emperor as divine or divinely favoured, including divinising statues employed in the imperial cult).
[41] See e.g. Henig and Vickers 1993; Henig 1983a: 152–8; Megow 1987 (mainly a catalogue). For an introduction to engraved gemstones (intaglios) see Zazoff 1983.
[42] See e.g. Megow 1987: 155–63, A10; Pollini 1993. Kleiner 1992: 69–72 for summary.

Fig. 28. The 'Gemma Augustea' (sardonyx cameo). Shortly before AD 14?

Oceanus and Terra Mater (Mother Earth) with two infants. Roma is enthroned with the emperor in the centre. Their feet rest on enemy armour. Between their heads is the symbol of the Capricorn – a zodiacal symbol of great importance for Augustus.[43] To the left of them is Germanicus(?), Augustus's grandson by adoption, dressed in armour, while a togate figure of his stepson and ultimate heir, Tiberius, arrives in a triumphal chariot driven by the goddess Victory herself. The attention of nearly all the figures, divine and mortal, is focused on Augustus. The lower register contextualises this image of imperial power and divine sanction with a more worldly view of victory, in which Roman legionaries and non-legionary companions erect a trophy and deal with barbarian prisoners. The cameo probably refers to Tiberius's triumph of AD 12, if not an earlier event, in which case it should be dated soon after that but before Augustus's death and Tiberius's accession in AD 14.

[43] Not merely his birth-sign: Barton 1994: 40–7, esp. 44; Barton 1995.

The extravagant claims that such objects make on behalf of the emperor and his family are generally regarded as 'political allegory'. The modern concept of allegory sits a little uneasily with an ancient society that believed in classical gods and worshipped them.[44] Yet perhaps images of godlike emperors among divine supporters are indeed best understood as explicit metaphors, mere symbols of imperial power. They were, after all, made to appeal to the emperor's highest ranking subjects – the people most intimate with the man himself, and least likely to regard him as a distant deity. There is a comparable elevation of the imperial family in the Latin verse written by and for the Roman upper classes. Perhaps, with their complex and sophisticated metaphors, with the obscurity of the references which underlie their obviously encomiastic overall message, the images on cameos, and on some other luxury works such as engraved gems, can be imagined as the 'poetry' of Roman imperial art.[45]

RESPONSES TO ARTISTIC 'PROPAGANDA'

Obscurity is an important issue. It is easy to appreciate why the difficult and obscure imagery of objects like cameos and engraved gems might have appealed to the tastes of a highly educated, sophisticated Roman nobility. But how accessible, in fact, were the images on conspicuous public monuments? Scholars find it impossible to agree on the interpretation of the visual programmes on the subtle Ara Pacis, the arch at Beneventum, and many other 'propagandistic' works; but our confusion is surely not only the consequence of modern ignorance. Did the majority of Roman observers get out of these works what was put into them?[46] More to the point, did political imagery of this kind *succeed* in fostering favourable attitudes to the ruling power?

Such questions have become more central to art-historical enquiry as attention is paid increasingly to 'the viewer' and to the reception of art, rather than merely its production and intended meaning. It is, however, barely possible to determine the effect of Roman art on its 'audience', still less to see it 'through Roman eyes'. We do not have the evidence to

[44] Cf. Burke 1992: 197.

[45] On the sophistication of cameos and gems see Hölscher 1984: 25. On the analogy with poetry cf. Kyrieleis 1971: 185.

[46] Cf. Hannestad 1986: 179 on the arch at Beneventum. Note Crawford 1983 for scepticism even about the informative and persuasive effect of reverse images on coins; critique in Wallace-Hadrill 1986. Cf. also Evans 1992: 3–4, 6–7 on reception. A pioneering essay on audience/reception of Roman public monuments is Hölscher 1984 (with 22–3 on the Ara Pacis).

quantify the impact of political art, as we might gauge the success of a modern advertising campaign through the measurement of a product's sales. John Clarke wrestles with this problem in his book, *Art in the Lives of Ordinary Romans*, and ultimately carries out experiments in imagining how different sorts of Roman, 'non-elite' viewer might have responded to monuments like the frieze of Trajan's Column:

A free foreigner from the Danube region viewing the Column's imagery would have recognised the people – perhaps his former neighbours – and would have recalled his own experiences of the imposition of Roman military and civic order. He may have either applauded or detested the way the Column translated the conquest into heroic, monumental form ... he may have enjoyed [Rome's] grand public spaces ... Or he may have rankled at the way the Column celebrated Rome's inflexible cultural imperialism.[47]

There are few circumstances in which we can go beyond this kind of speculation and chart the public reception of political art with greater clarity, though we can be certain that responses did differ and that some of the more delicate meanings that scholars can read into a work like the Ara Pacis would have been lost on many of its ancient, uneducated viewers. This assumption is nicely conveyed in verses by the Augustan poet Ovid, though it is important to remember that Ovid is writing from an ironic, upper-class perspective and his own stance is arguably idiosyncratic or even subversive. The poet is advising a young man on how to behave when watching a triumphal procession with his girlfriend. When called upon to explain the various battle-paintings and effigies that were customarily carried in these processions, he should conceal his ignorance:

Answer everything, and not only the things she asks;
and what you don't know, tell her as if you did:
This is the river Euphrates, with reeds wrapped around his forehead;
the one with blue hair hanging down must be Tigris ...
that man, and that one, are generals; give their real names
if you can, but if you can't, make them up.[48]

Although Ovid's advice represents an urbane fiction, in reality the diverse Roman population may often have struggled with difficult iconography in just this way. Incidentally, personifications of the Rivers Euphrates and Tigris appear in a relief on the Arch at Beneventum. (Or do they?)

[47] Clarke 2003: 41.
[48] Ovid, *Ars Amatoria* 1.219–24 and 227–8. Cf. Clarke 2003: 10. I owe the reference to Jessica Hughes.

There is an implicit challenge here to the methods of the art historian. Clarke warns of the limitations of traditional interpretations, which rely on the specialised perspective of the all-seeing scholar. The art historian has conventionally been concerned with the decipherment of ancient imagery – with overcoming gaps in evidence to determine the full, intended meaning of a representation – or contextualising it by finding parallels in other ancient works. Clearly, however, few ancient viewers, if any, will have appreciated the art that they encountered on this level of detail. So which level of interpretation should matter to us? The 'true' meaning of a monument or its actual effect in Roman society?

The problem becomes more acute when we consider unusually obscure or 'invisible' works of art. The frieze of Trajan's Column notoriously fits into this category, because it would have been literally impossible for any ancient viewer to 'read' its spiralling visual narrative effectively from bottom to top. In such cases we know for certain that there is a discrepancy between the message that the monument seems to intend and what viewers could have seen, even if it remains impossible to determine their precise response.[49] Yet it would be nonsensical to ignore what the modern viewer can see and understand in such a work, just because its ancient impact was restricted. Consequently, the recent scholarly focus on reception has theoretical as well as practical limitations.

Leaving aside the consideration of individual monuments, the general question of whether 'propagandistic' art succeeded invites similarly speculative conclusions. Take, for example, the political imagery that appeared on coins and in other art-forms during the civil wars of the 40s and 30s BC, which saw the young Octavian defeat first the enemies of his assassinated adoptive father, Caesar, and then his own former ally Mark Antony, before becoming effectively the first emperor, Augustus. Paul Zanker has described how the 'parties' of Octavian and Antony in particular devised 'rival images' of power which, amongst other strategies, associated Antony with the wine-god Dionysus, in the mould of Hellenistic Greek kings, and Octavian with the deified Caesar and with Apollo, the sober god of prophecy.[50] The programmatic use of politically resonant religious and mythological images comes closer to the modern phenomenon of propaganda than any of the later, imperial works considered above, and it might reasonably be assumed that media like coins had a recognised power and mass appeal: that they made a difference to the course of the conflict. Zanker tentatively suggests that Antony's espousal

[49] See the excellent anthropological discussion in Veyne 1988. [50] Zanker 1988b: 33–77.

of regal, Hellenistic imagery was a miscalculation that alienated Italy and
fuelled Octavian's own campaign of mud-slinging: Antony was 'betrayed
by his own image'.[51] Certainly, this was a period of experimentation and
innovation in political imagery, and perhaps especially in coinage. We
should not be surprised if some kinds of imagery were less successful than
others, and there are indications that Octavian and others responded to
that fact.[52] Ultimately, however, we cannot clearly determine what effect
propagandistic imagery really had. Did it work? If Antony had triumphed
militarily and become ruler of Rome himself, would his visual propa-
ganda now seem to have been well calculated and eminently effective in
appealing to the mass of the empire's inhabitants?

Perhaps the difficulty in answering such questions says something
about the very nature of visual 'propaganda': that even in the period of the
civil wars, we are not dealing with the simple, unilateral propagation of
political messages. Rather, the political imagery of this and other periods
represents a package of ideas and values that have infiltrated people's lives.
It is, in fact, that phenomenon which mainly preoccupies Zanker in *The
Power of Images in the Age of Augustus*.[53] He shows how even ostensibly
political images, originally generated in the reign of Augustus, became
part of the common visual vocabulary of the imperial population – part of
the fabric of their lives. So it is, for instance, with the statue group
showing Augustus's ancestor and role-model Aeneas, piously rescuing his
father, son, and divine images from the flames of Troy, which was evi-
dently set up in the Forum of Augustus in Rome. In the early principate it
was replicated in the public buildings of other cities in Italy and in Spain,
imitated on tombstones, integrated into domestic painting, and repro-
duced on coins, gems, and lamps.[54] It even appears to afford a very rare
example of subversive imagery in the private sphere, for a version of the
group appears in a wall-painting from a villa near Stabiae on the Bay of
Naples. Here the selfsame figures have been rendered as caricatures – as
apes with enlarged penises.[55] According to Zanker, this early imperial
picture 'documents the reaction of a homeowner fed up with the surfeit of
ponderous imagery in Imperial art'.[56] But the irony is that 'subversion' of

[51] Ibid. 57–65.
[52] E.g. much of Zanker 1988b is devoted to the evolving portrait imagery of Octavian.
[53] Zanker 1988a; Zanker 1988b: esp. 265–95.
[54] See Fuchs 1973; Zanker 1968: 17; Zanker 1988b: 201–3, 209. Cf. Hölscher 1984: 30–3 on the
 influence of such metropolitan imagery.
[55] Seemingly *not* with dogs' heads, as has been suggested.
[56] Zanker 1988a: 1; cf. Zanker 1988b: 209.

this sort was possible only when the imagery it mocked had become utterly familiar and inextricable from the visual environment of everyday life. When this happens, questions about the effectiveness of propaganda, about its reception, and even about the likelihood of subversive responses, cease to be very meaningful.

ENGAGEMENT WITH IMAGES

Let us turn now from intellectual responses to political art towards a rather different kind of response: one which brings us away from overtly political imagery towards that of cult. We are concerned with the sort of physical engagement with works of art like paintings or statues which is well attested in the ancient world, but which has only quite recently received art-historical scrutiny. The following very different quotations give a suggestion of the extremes of behaviour involved:

It was a pleasure to dash the haughty faces on the ground, to assault them with the sword, to savage them with axes – as if each blow could give rise to blood and pain. No one was so restrained in their long postponed joy and delight that they didn't see a kind of revenge in observing the mutilated limbs, the hacked members, and finally the cruel and terrible images thrown in the fire and melted down, so that the flames might convert them from that terror and menace to the use and pleasure of mankind.(Pliny the Younger, *Panegyric* 52; originally delivered AD 100)

The people of Agrigentum have a temple of Hercules not far from the forum, which they consider extremely sacred and holy. In it there is a cult-statue of Hercules himself, made from bronze. I could not readily say that I have seen anything more beautiful ... its mouth and chin are rather worn because people are accustomed not only to venerate it when they pray or give thanks, but even to kiss it.(Cicero, *Verrine Orations* 2.4.94; *c.* 70 BC)

These sources have their very particular contexts, but the information they provide is representative of various, widespread practices in the Roman world.

The first quotation refers to something like the reverse of the normal practices of honouring people with images. In this case the subject is the toppling of the portraits of the emperor Domitian in AD 96, and it comes from Pliny's *Panegyric* to Domitian's successor but one, Trajan. This is one of the most eloquent descriptions of a violent practice that recurred regularly throughout Roman history, from at least the early first century BC to the fifth century AD. Indeed, similar violence occurred from time to time through Greek history and is probably typical of all cultures that use public portrait statues. (In modern times the collapse of the

USSR and the fall of Saddam Hussein in Iraq have produced photogenic parallels.)

Roman historians call this *damnatio memoriae* – the condemnation of memory.[57] Prominent individuals who had fallen from favour, and especially emperors who had fallen from power and were condemned as traitors, were punished while alive or after their death with the destruction or obliteration of all those monuments and texts originally intended to honour them and preserve their memory (Fig. 29).[58] That included not only statues and other portraits (sometimes even the heads on coins), but also inscriptions and documents. The notional purpose was genuinely to remove the evil-doer from memory, though in practice *damnatio memoriae* was not universally effective or systematic. It amounted to a rather staged display of social oblivion rather than a true, Orwellian obliteration of identity. Indeed many partially erased inscriptions remained on view. Clearly everybody knew who had been 'forgotten'.

Sometimes the sources suggest that *damnatio memoriae* was a more or less official act, inasmuch as the senate formally decreed the destruction of someone's identity.[59] In other cases the violence appears spontaneous, though it may have been prompted by official encouragement.[60] Probably no sharp distinction can be maintained between 'official' and spontaneous *damnatio memoriae*. Perversely, the destruction of public portraits involved the ready cooperation of the populace as much as their creation did.

For many years the destruction of portraits and other monuments as part of the process of *damnatio* received barely any attention from classical archaeologists and art historians. Indeed the material evidence for this sort of iconoclasm is inherently difficult to interpret: many portraits were actually eliminated; some were reworked; in other cases it may be hard to distinguish deliberate, ancient damage from the normal ravages of time. Since the 1980s, however, there has been an explosion of research, including two monographs and an exhibition devoted to the subject. This reflects the scholarly shift already mentioned, towards various kinds of reception studies.

The second quotation points to the physical veneration of statues as sacred objects.[61] Such objects might be regarded as fine artistic masterpieces.

[57] Generally see Stewart 2003; Varner 2000; Varner 2004; Hedrick 2000.
[58] On the illustrated example, a statue of an early third-century empress(?) found buried at Sparta, see Riccardi 1998. She suggests (wrongly in my view) that the damage was caused by Christian iconoclasts.
[59] For references see Pekáry 1985: 137; Stewart 2003: 270–1. [60] Stewart 2003: 267–72, 283–90.
[61] On this large subject see e.g., generally, Bevan 1940; Freedberg 1989; in respect to classical art: Steiner 2001: esp. 105–20; Stewart 2003: 263 n. 11.

Fig. 29. Bronze statue of a Severan empress(?) displaying signs of assault. From the
Acropolis of Sparta, early third century AD.

Cicero is here referring to a cult image in a Sicilian Greek community
which the corrupt governor Verres attempted to steal for his own art
collection; indeed, he suggests that the reverence in which it is held by the
Sicilians owes something to its sheer beauty. But this quotation also
reminds us that many works of this kind were intended as religious objects,
and moreover that their appearance could inspire worshippers to bestow on

them signs of affection aimed at the god himself: prayers, gestures of gratitude, and kisses.

Diverse though they are in character and context, the sources quoted above both refer to a particular kind of response to art. In each case, the authors lead us to believe that images themselves were exercising a powerful psychological effect on those who experienced them, and that the beholders' actions are the consequence and symptom of their effect. This is the sort of emotional reaction which David Freedberg addressed in his innovative book of 1989, *The Power of Images*.[62]

Pliny's account of the destruction of Domitian's statues is, for all its fervour, the rationalising response of a self-consciously upper-class, educated Roman. The images, he suggests, provided an outlet for everyone's bloodlust: hacking at them was a *kind* of revenge, *as if* the fallen emperor himself were the victim. Similarly, Cicero's reference to the worn face of the Hercules statue at Agrigentum evokes popular responses, and more particularly popular *Greek* responses. He is keen to distance himself from any such devotion to sculptures. Yet both of these sources point to deeply rooted practices that were ubiquitous throughout the ancient world (and which are not as remote as we might like to imagine from modern western life). The truth is that anthropomorphic images, whether portraits or cult images, frequently have the power to provoke respectful, hostile, violent, even erotic responses,[63] many of which have tended in the past to remain on the margins of ancient history or art history. These responses are as important as any others for understanding the role of works of art in Roman society.

THE RELIGIOUS IMAGE

With this in mind we should turn briefly to the particular functions of art in Roman religion, for it may already be clear that strong affective – that is to say approximately 'emotional', rather than rational or cognitive – responses to images are often most obvious in this sphere. Art was used for a variety of religious purposes in the Roman world, but of central importance was the use of statues to represent the gods in human form. Many statues of deities were prominently set up in temples or shrines and

[62] Cf. once again Gregory 1994.
[63] For tales of erotic responses see e.g. Stewart 2003. More mundanely, of course, many images such as paintings in Roman houses, baths, and brothels probably exercised a 'pornographic' power to arouse their viewers: for such imagery see Clarke 1998, though note his qualifications pp. 12–13.

to an extent they provided a focus for worship. As cult images they stood in for the absent gods, serving as their proxies. In certain circumstances people spoke to them, or left them letters and written prayers. Sacrifices were made in front of them. The images were treated with respect: garlanded and crowned, anointed with oils, even sometimes dressed and fed.[64] Occasionally they were thought to speak, move, or show other signs of animation.[65] We have already seen some evidence of such treatment in the statue of Hercules at Agrigentum.

In theory, the cult statues were not considered to *be* gods themselves, and educated Roman writers are emphatic about their status as mere symbols or visualisations of divinities who could not otherwise be observed or approached physically.[66] From this perspective, even activities like clothing and tending the sculptures were simply symbolic rituals. Yet, as in some modern anthropomorphic religions, the images themselves with their naturalistic, human features held a strong charismatic appeal. It is hardly surprising that they were often regarded as if they were living beings. For this reason the Christians of the later Roman empire found pagan cult images particularly threatening.[67] Unsurprisingly, different Romans clearly held different views about the status of cult images. Perhaps many gave the matter little thought because, like the portraits of emperors, these works of art were to all intents and purposes the reality of divine presence in people's lives.

Despite this fact, Roman cult statues seem often to have been lofty and aloof: idealised works in the Greek tradition, frequently colossal in scale, enthroned or standing, staring remotely over the heads of viewers. Often they were gilded or adorned with precious or polychromatic materials. We should expect nothing else of the gods' images, but many other forms were, in fact, employed. Some cult images were stiff and archaic in style, which lent them an air of venerability;[68] some were made in perishable materials such as wood; some presented the gods in very human, accessible guises (naked Venuses etc.) or in action poses (Diana as huntress); some cult images, especially in Greece, Asia Minor, and the Near East, were actually aniconic – that is, eschewing human shape – and

[64] See n. 61, above. Note also Elsner 1996a on images within ritual.
[65] See e.g. Poulsen 1945. Cf. Stewart 2007b.
[66] Note e.g. Dio Chrysostom, *Oration* 12 (*Olympian Oration*). See also Donohue 1988: 122–6 (with extracts from various relevant texts at 281 and 350–5); Feeney 1998: 76–114.
[67] See e.g. Donohue 1988: passim.
[68] On the connotations of archaism and other stylistic choices see esp. Hölscher 2004: 58–73; Zanker 1988b: 243–5.

Fig. 30. Bronze coin of Pergamon showing the statue of Asklepios inside temple.
Reign of Commodus, AD 175.

took the form of meteorites or special stones which had their own unique, sacred aura.[69]

Schematic depictions of cult statues in their temples frequently appear on coins minted in Rome or in the Greek communities of the Roman empire, and simple though they are, they offer a good impression of the range of iconography employed (Fig. 30).[70] Unfortunately it is often hard to identify surviving cult statues themselves. That is to say, it is difficult to determine whether a particular sculpture was used as the object of active worship in a temple.[71] For sculptural representations of gods were used in other ways. Like many other kinds of object, they were commonly

[69] On Roman cult statues generally see Vermeule 1987; Witschel 1995b; Stewart 2003: esp. 184–222. On the concepts of cult images, the aniconic as well as the anthropomorphic, see Gordon 1979; Stewart 2007b; Stewart (forthcoming, a). Cf. Freedberg 1989: 54–81.
[70] See e.g. Price and Trell 1977; Vermeule 1987; Hill 1989; Stewart 2003: 208–14.
[71] Cf. Witschel 1995b: 251. This fact explains the relative lack of scholarly attention to cult statues as compared with e.g. portraits.

deposited as dedications in sanctuaries. These dedications or 'votives' were presented as gifts, usually to the god whom they represented, in gratitude for, or anticipation of, divine help, or simply as benefactions to sanctuaries or communities. Votive statues functioned rather like the honorific statues discussed in Chapter Three, for gods were like powerful human benefactors.[72]

Dedicated statues could themselves become the object of veneration. In Roman thought there is only a hazy distinction between the main cult images in temples and other religious sculptures. Indeed some scholars might dismiss the distinction altogether as a modern invention.[73] To complicate matters, images of gods were very regularly displayed with other mythological figures in contexts that were not obviously religious. Statues and statuettes of classical deities, Dionysiac characters, nymphs, and demigods predominated in the sculptural decoration in baths, houses, and villas, for example. It has been argued that works of this kind were not straightforwardly secular in significance, and certainly not 'mere decoration'. The reality is probably that Roman religious art, like Roman religion, is an elastic phenomenon.[74] In one setting a sculpture of Dionysus, say, might be the appropriate sculptural furniture of a cultivated man's garden; in another setting it might become a revered cult object or religious offering. At the very least perhaps we should say that the divine figures of Roman domestic art are not *un*-religious.

To an extent there is a parallel in the usage of mythological wall-paintings. For images of the kind examined in Chapter Two – erudite patrons' panels with episodes from Greek myth – are fundamentally indistinguishable in style and iconography from those that adorned public buildings (where such public images survive). Yet their significance in the latter setting is presumably much more closely related to political and religious concerns. In the eighteenth century the so-called 'Basilica' at Herculaneum, which was probably a public portico loosely associated with the veneration of the imperial family, if not actually a temple of the imperial cult as some believe, yielded some of the most spectacular frescoes and sculptures from the site. They include a series of wall-paintings depicting, respectively, Hercules finding his infant son Telephus, Chiron the centaur educating the hero Achilles, the triumphant Theseus, having

[72] On classical votives generally see Van Staten 1981. Note also critical comments on scholarly approaches to 'votives' in Elsner 1996a: 526–7. For comparative discussion of votive art note Freedberg 1989: 136–60.

[73] Donohue 1997. Cf. arguments in Stewart 2003: 184–95.

[74] See Touchette 1995: 32–6; Jashemski 1979: 121.

killed the minotaur and rescued the Athenian children from the Cretan labyrinth, and Pan and Olympus. These paintings were once erroneously used to identify the enigmatic building as a temple of Hercules or of Theseus. It was not in itself an unreasonable assumption that the themes should reflect a religious function, and some modern scholars have also seen them as reflections of the supposed activities carried out in the building.[75] Whatever the truth of these claims, it is significant that there is nothing inherently public or private, religious or secular about the paintings. Indeed, the representation of the triumphant Theseus outside the labyrinth has a close parallel in the House of Gavius Rufus in Pompeii, and both paintings may ultimately imitate a classical Greek work. Consequently, in the study of art, as in other fields of Roman cultural history, it is probably unhelpful to use labels like 'myth' and 'religion' inflexibly. They cannot be turned into autonomous categories any more than 'art' itself.

Nevertheless, we can see two differing ways in which art operated in the service of Roman religion. On the one hand, we have broadly narrative images that recounted stories relevant to the gods or presented viewers with a vision of their own place in the cult. So, for example, besides mythological paintings of the kind described above, religious buildings were often decorated inside and outside with suitable mythological scenes in sculptural relief. The functional altars might be appropriately decorated with images of sacrifice. On the other hand, as we have seen, works of art were often designed to make present the absent gods and provide a means of visualising them. It was not only cult statues and other large-scale sculptures that performed this role. One of the largest and most wide-spread categories of Roman art comprised small votive reliefs with isolated images of gods distinguished by their regular attributes (Fig. 31). These are, first, gifts to the gods, their imagery adding value to the object. But more than this, their frontally posed figures that look out at the viewer must have facilitated a sort of contact with the dedication's divine recipient; to that extent such votives must have functioned almost as Byzantine icons would later do.[76] Furthermore, inasmuch as these votives were durable monuments, albeit on a small scale, they could be seen as perpetuating the relationship between god and worshipper – standing as permanent markers of a beneficial relationship. Hundreds of these objects, usually

[75] On the 'Basilica' see Pagano 1996: 236–7 and 240–3; Torelli 1998: esp. 260–1; Najbjerg 2002 (with critique of earlier ideas about function).

[76] Note also a few surviving examples of pagan, painted 'icons': Mathews 1993: 178–87.

Fig. 31. Votive relief of Mercury, inscribed *'deo Me(rcurio)'*, from
Staunton-on-Arrow, Herefordshire.

carved in local stones, survive from the provinces of the Roman empire.
Although they tend to be overlooked in general surveys of Roman art
because of their simplicity and often poor technical quality, they represent
one of the commonest examples of sculpture working in the lives of the
imperial population.

So ubiquitous was the use of art in Roman religion, as in other spheres
of life, that it is easy to take it for granted. Its application is thrown into
relief only when we consider Roman cults that had unconventional
attitudes to visual imagery. Certain cults, in fact, made exceptional use of
artistic imagery to construct a distinctive religious and cultural identity for
themselves.[77] The very fact that we are tempted to refer to these as 'cults',
identifiably distinct from the all-embracing culture of conventional
Roman paganism, reflects their unusually exclusive character.

[77] See Beard et al. 1998: vol. 1, 260–78 on 'the visibility of religions'. For general discussion of the role
of art see e.g. Elsner 1998b: 205–11; Elsner 2003: 125–8.

One such cult is that of the Egyptian goddess Isis, which had come to flourish in the Hellenistic world.[78] This was a mystery cult, involving the initiation of adherents. Isis was associated, among other things, with death, rebirth, and fertility, and was sometimes conflated with traditional Graeco-Roman deities – Demeter/Ceres and Aphrodite/Venus especially. Sanctuaries of Isis, most spectacularly the large, first-century Temple of Isis and Sarapis in the centre of Rome, made extensive use of real and imitation Egyptian artefacts: statues of traditional Egyptian deities and sacred animals; obelisks; Egyptian religious symbols and inscriptions bearing hieroglyphs. They self-consciously used art to invent a little bit of Egypt in Rome.[79]

Another important initiation cult was Mithraism, which flourished across the empire from about the start of the second century AD.[80] The cult of Mithras notionally had Persian origins. Its temples – the mithraea – were not columnar shrines or grand public edifices for housing large statues, but small, subterranean halls intended to accommodate congregations of worshippers.[81] They were often in relatively inconspicuous or secluded parts of towns, and were called 'caves'. Mithraism was also a mystery religion – its male worshippers were progressively initiated into knowledge of sacred mysteries – so unsurprisingly, we know relatively little about its tenets, and what we do know is partly based on the hostile evidence of Christian writers. Nevertheless, it is clear that, unlike most traditional Graeco-Roman cults, Mithraism did indeed *have* tenets. It had a theology: an ostensibly coherent system of beliefs and a narrative surrounding the god Mithras which offered a paradigm for rituals and perhaps for beliefs about his powers of salvation.

The works of art in mithraea, which often included statues in the round, reliefs, paintings, and mosaics, refer to this narrative, and every mithraeum had cult images with a regular, recurring symbolically charged iconography.[82] Mithras is portrayed in conventional 'oriental' dress in the act of slaying a bull with a stab to the neck. He usually forces the animal to the ground with his left leg. The bull's tail turns to wheat, while a

[78] Generally, see Takács 1995; Beard et al. 1998: vol. 2, 297–305. Cf. Apuleius, *Metamorphoses*, the second century 'novel' often used as evidence for Roman Isiac cult.

[79] Beard et al. 1998: vol. 1, 264–6; 301–11 on the issue of homogeneity and exclusivity.

[80] Generally, see: Beck 1984 (detailed survey); Beard et al. 1998: vol. 1, 277–301; vol. 2, 88–91, 305–19.

[81] See Beard et al. 1998: vol. 1, 266 on seclusion as a means of differentiating Mithraism from traditional civic cult.

[82] On Mithraic iconography see e.g. Elsner 1995: 210–21; Elsner 1998b: 205–8; Beard et al. 1998: vol. 2, 207–8. Also various articles reprinted in Gordon 1996.

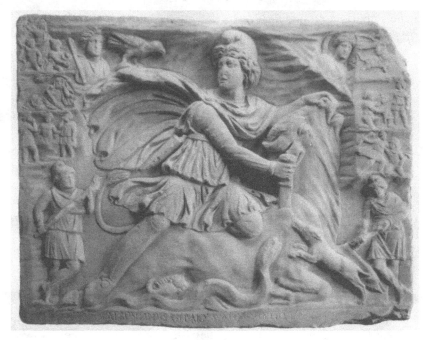

Fig. 32. Relief from the mithraeum at Nersae, Italy. The inscription records
that it was commissioned by a certain Apronianus in AD 172.

scorpion pinches its testicles and a snake and a dog lap up its blood. The
scene is beheld by a raven on the god's cloak. Figures of the Sun and
Moon are also typically present, along with the minor divinities, com-
panions of Mithras, called Cautes and Cautopates. In the manner of
much later Byzantine icons, subsidiary scenes are not uncommon and
apparently relate to particular incidents in the story of Mithras as hero-
god, though this imagery varies from site to site (Fig. 32). It would appear
that the image of Mithras slaying the bull represents the key episode in his
myth. The act was possibly regarded as the source of regeneration and life.

The iconic images of Mithras have much in common with conven-
tional cult images. They provided a focus for the attention of worshippers
and presented a vision of the god, distinguished by his own attributes.
Sometimes, like traditional images in sanctuaries, they were dedicated by
individual benefactors. Nevertheless, their emphasis is on a body of
knowledge which adherents of the cult either held or aspired to hold, and
to which the now obscure symbols referred. Perhaps they were fairly
obscure in antiquity also, for difficult iconography serves effectively to

create a mystique around a cult which centred on initiation and mysteries. In religion as much as in the public presentation of political power, art can serve to obfuscate as well as communicate.

The cult of Jesus Christ had at least superficial similarities with Mithraism. The Christian religion was born in the eastern provinces of the Roman empire, gradually grew to prominence even in Rome itself, and eventually came under imperial patronage through the emperor Constantine in the early fourth century AD. But, perhaps curiously, early Christian Romans did not use art to carve out an identity for themselves in the same manner as other 'eastern' cults. In fact, for about the first two centuries of its existence, Christianity is art-historically and archaeologically invisible. That is to say, no unambiguously Christian images or works of architecture are known from before about AD 200. The first purpose-built churches do not emerge until the fourth century.

There are several possible reasons for this lack of assertiveness. One is, of course, the persecution of Christians that occurred sporadically until Constantine's time. Another factor is the traditional Judaeo-Christian prohibition on the making and veneration of images (and Judaism is also iconographically fairly inconspicuous in the same period).[83] It may also be that the kinds of art used by Christians before the third century were relatively inconspicuous. For example, Clement of Alexandria, writing around AD 200, advocates the wearing of signet rings bearing innocuous symbols, which could nevertheless be given Christian meanings: doves, fish and fishermen, ships, lyres, and anchors, rather than pagan gods, weapons, drinking cups, lovers, or prostitutes. Many engraved gems from rings survive that have precisely these sorts of emblems on them, but there is no way of knowing if they were originally used by Christians.[84]

In any case, Christianity explodes into art-historical prominence in the early third century. This is largely because of the painted walls in burial chambers within the catacombs. Catacombs were underground funerary complexes of tunnels and rooms, cut into the soft rock around Rome and some other cities.[85] Not all of the complexes were Christian, or exclusively Christian, but most apparently were. They represent the crystallisation of

[83] For the insight that Jewish literature gives into the ancient negotiation with pagan imagery see e.g. Eliav 2000. See Finney 1994: 107–8 for contrast of Jewish and Christian material culture, and Elsner 2003 for critical discussion of the relationship.

[84] For this argument, and critical overview of other arguments on the earliest Christians' art, see Finney 1994: 99–145.

[85] On catacombs generally see Stevenson 1978; Carroll 2006: 260–6. On the emergence of Christian catacomb art see Finney 1994: 146–274.

a Christian identity within the larger society of Rome. The communal burial of the Christian dead in these places seems to reflect the growth of a community which saw itself, at least in death, as standing apart from the broader society. The use of distinctively Christian art from this period on seems to mark the emergence of such a distinct Christian 'sub-culture' in Roman society. Indeed, art possibly contributed to its existence. It may have helped, whether intentionally or not, to foster a common culture within a religious community that was notoriously divided in its beliefs from the outset, for Christian imagery seems to emerge with surprising consistency across the empire at about the same time.[86] The sudden emergence of a clearly Christian artistic culture in the third century is therefore a salutary reminder that art does not simply 'mirror' society or social change, but is implicated in it.

What, then, did this earliest Christian art consist of?[87] Before long a religious iconography would develop which is recognisable to anyone familar with later Christian art. In the decoration of churches and tombs, and in other Christian artefacts of Late Antiquity or the early Byzantine period, we encounter images of saints and prophets, important and more obscure stories from the Old and New Testaments, visions of paradise. The cross becomes a regular symbol of Jesus and his redeeming death, as does the chi-rho symbol – a monogram formed from the first two letters of the Greek for 'Christ'. By the early fifth century the crucifixion has become an important scene: a sure sign of the confidence of the Church, which could now boast of this ignominious form of execution reserved for slaves and common criminals.

But all of this came later. The very earliest Christian art across the empire, from the catacombs of third-century Rome to the extraordinary 'house-church' at Dura-Europos on the eastern frontier of the River Euphrates (*c.* AD 245: the earliest Christian building to survive), was relatively small in scale, humble, and allusive in character. It consisted of concise narrative images drawing on Christian stories of deliverance. There were *orant* figures – men or women with arms held in gestures of prayer – or figures symbolic of Christ's deliverance, such as the common image of a shepherd which is assumed to allude to Jesus as 'the Good Shepherd'.

[86] Cf. Elsner 1998b: 8 and Elsner 2003: 126–7 on the subsequent role of art as an agent in the communication of Christian identity. On the simultaneous emergence of Christian art see Finney 1994: 151–2.

[87] For early Christian iconography in general see e.g. Grabar 1967; Grabar 1969 (noting critique by Mathews 1993), passim; and excellent up-to-date overview in Jensen 2000.

Early Christian images have some striking qualities. The first is that they often depart little from the iconography of pagan – or rather 'non-christian' art – of the broader society to which the Christians belonged. For example, the 'Good Shepherd' figures can be seen as pastoral images in the Hellenistic Greek tradition,[88] and like the emblems that Clement refers to, they were only 'Christianised' by their new context. Even the narrative images draw heavily on existing forms. Noah in his ark, for instance, is rendered as a single man in a wooden chest (not a ship with animals!), in a motif which probably imitates the Greek myth of Danae, who was also cast adrift in a box.[89] Another popular figure is Jonah who, after his escape in the sea-monster or 'whale', is shown reclining from the shade of a gourd tree – a motif that remains very popular in the fourth century (Fig. 33). He is invariably depicted in the pose of the mythological hero Endymion (cf. Ariadne as in Fig. 16) as he appears on earlier non-Christian sarcophagi.[90] There are many other examples of this adaptation of traditional artistic motifs. Sometimes it is called 'syncretism', but syncretism strictly refers to the merging of different religious beliefs. In most cases we are probably merely witnessing the gradual evolution of a Christian iconography within the prevailing artistic culture of the empire. Indeed artists or craftsmen may frequently have worked for both Christian and non-Christian customers.[91]

The second conspicuous feature of these images is related to the first, for it also concerns the discrepancy between their outward form and the meanings with which different viewers imbued them. The earliest Christian images operated like signs.[92] They made little effort to tell a story, let alone to dress it up in convincing circumstantial details. Noah in his ark; Jonah thrown into, or ejected from, the sea-monster's mouth; Jonah under the gourd tree; the three Hebrews in the fiery furnace at Babylon; Daniel in the lion's den; the paralytic man healed by Christ, now carrying his bed; these and other popular images in early Christian art emphatically referred beyond themselves to a body of knowledge – specifically scriptural knowledge – which viewers, whether literate or not, were expected to possess. Moreover, they cannot simply be seen as

[88] Cf. Finney 1994: 125–6. However, the Good Shepherd does not appear particularly indebted to pagan religious images, though this is often claimed. I am grateful to Charlotte Appleyard for observations on the subject.

[89] On Noah and other cases of adaptation see Murray 1981: 98–111.

[90] See Mathews 1993: 30–33; Jensen 2000: esp. 171–8 (with further bibliography and references in notes).

[91] Elsner 2003: 118–19. For specific (lamps) example see Finney 1994: 116–31.

[92] Grabar 1969: esp. 7–29.

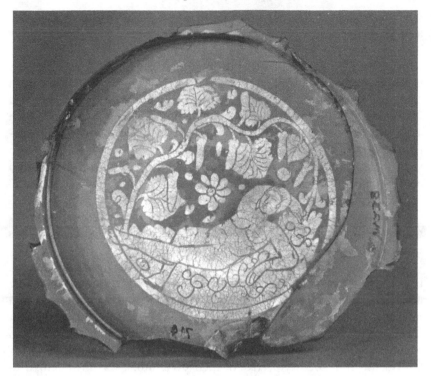

Fig. 33. Gold-glass medallion showing Jonah resting under the gourd tree.
Rome, fourth century AD.

illustrations of the biblical texts, for they often depart from the details of
the original narrative, as with the images of Noah and his chest. Evidently
these simple visual references to narrative were, from the outset, symbols
of Christian salvation. As such they assume a 'typological' quality. They
could be combined in different ways as paradigms or models from the
past, all pointing in different ways to the same fundamental Christian
messages of salvation. In some cases this mode of viewing them is pre-
figured in scripture. Thus, in the Gospel According to Matthew 12: 39–40,
Jonah's story is used by Christ as an analogy for His own death and
resurrection.[93] As we have seen, in more or less the same period something
similar was happening in the non-Christian use of Greek mythology for

[93] See e.g. Elsner 1995: 279–84; Jensen 2000: 64–93. Malbon 1990 explores typology through Old and
New Testament scenes on the fourth-century sarcophagus of Junius Bassus.

sarcophagus reliefs. The sarcophagi also abstracted general messages with a funerary significance from mythological narratives.

Finally we should note that images of Christ himself are surprisingly scarce in the earliest Christian art. Rarely does he appear clearly and unambiguously in the paintings of the catacombs. Only in the fourth century does the now stereotypical image of the long-haired, bearded Christ become common, possibly drawing upon the model of gods such as Jupiter, or conceivably upon the portraiture of charismatic philosophers. Even so it develops alongside more youthful portrayals, which also seem to owe something both to philosopher images of a different kind and to representations of deities like Apollo/Helios and Dionysus.[94] Indeed, the ancient Christians did not generally venerate the image of Christ. Theirs was, very deliberately, a cult without cult images, in which the role of art was initially marginalised. In this respect especially, it was unusual among the religions of Rome.

We have come a long way from the consideration of propagandistic art, or even the 'power of images', but perhaps not as far as it may seem. The distinction that we might be inclined to make between political art and religious art is an artificial one. This is, first, because Romans did not consider religion and politics, or indeed religion and political power, to occupy different spheres.[95] Indeed, one of the crucial problems posed by Christians, from the perspective of their persecutors, was their refusal to venerate the emperor through his images.

Second, the very workings of political and religious art shared certain principles. In both spheres we find imagery that is either lucid and communicative or obscure and mystifying, and very often the two approaches overlap. In both religious and political imagery we encounter the use of narrative to make sense of ruler or god and to explain what they are and where they belong in society. At the same time we find 'iconic' images, including statues, which make them – absent gods and distant emperors – materially present. Finally we find that all such images may serve not simply to reaffirm ideas of power relationships and social hierarchy, but to exercise power themselves over the minds of receptive viewers.

[94] See Mathews 1993: passim; Zanker 1995: 289–320; Jensen 2000: esp. 94–129.
[95] Cf. Price 1984: esp. 11–19 criticising the scholarly separation of religion and politics in the interpretation of Roman imperial cult.

CHAPTER 5

Art of the empire

The traditional story of the development of Roman art goes like this. From early stages in its growth the city-state of Rome was under the cultural influence of the Greek colonies of southern Italy and of the Etruscans and other Italian communities, which themselves owed much to Greece. So at no point is it very easy to identify a discrete Roman artistic culture, but a thoroughgoing Hellenisation of art in Rome really began around the late third century BC, as a series of conflicts led to the expansion of Roman power through the Greek world. That is how the Romans themselves later saw it, at least in rhetorical laments over the baneful influence of Greece.[1] Thus Livy writes of the Roman sack of Syracuse in 211 BC:

Marcellus ... carried the decorations of the city off to Rome: the sculptures and pictures which Syracuse had in abundance. Those were enemy spoils indeed, and acquired according to the rules of war; but from them stemmed the admiration of Greek works of art.[2]

The Roman armies and commanders were introduced to Greek art and architecture at first hand. Greek artistic spoils were paraded in 'triumphs' (triumphal processions) through the city of Rome itself and ended up being exhibited in temples and porticoes that have been likened to modern museums.[3] There was probably something of an influx of Greek artists into Italy, and certainly a taste for Greek sculptures and panel paintings developed, as aristocratic Romans sought to adorn lavish villas with the sorts of masterpieces that in Greek cities had more typically been displayed in public spaces and sanctuaries.[4] There is perhaps a sort of metaphor for this process in the celebration of 'Corinthian bronze', which

[1] See generally Pollitt 1978. [2] Livy 25.40.1. [3] On this aspect see also Strong 1973.
[4] For a summary of the now conventional view on the development of Roman republic villa-culture see Zanker 1988b: 136–42. Cf. Neudecker 1988: 5–6.

143

we briefly encountered at Trimalchio's fictional house in Chapter Two. *Objets d'art* in this precious alloy were much prized by Roman collectors; Corinthian bronze became a byword for connoisseurship. Interestingly, however, it had first been created, according to legend, when the Romans sacked Corinth in 146 BC and all the gold, silver, and copper of the city melted and mingled.[5]

THE GREEK HERITAGE

Our evidence for such a development of Hellenised artistic tastes in Rome is largely literary, but there is some direct attestation in underwater finds of sculptures and similar imports which were evidently lost in transit from Greece to Italy in the period of the late republic. A famous case from around the 70s BC is the wreck discovered off the coast of Tunisia near Mahdia: a cargo which contained an eclectic assortment of later Hellenistic bronze and marble sculpture (Fig. 34), decorative candelabra and kraters, furniture, architectural elements, and above all tonnes of marble columns, as well as genuine 'antique' reliefs (whether valued as such or merely carried as cargo 'fillers').[6] The sculptures of the Villa of the Papyri at Herculaneum (Chapter Two) show how wealthy Romans liked to display Greek or Greek-style sculptures as the backdrop to their private lives of leisure. We have also seen how thoroughly artistic production in the Roman world – public as well as domestic works – was shaped by Greek artistic traditions if not actually by Greek artists.

It is little wonder that some scholars have wanted to regard Roman art as simply Greek art in a new setting. On the other hand, there is no doubt that the setting is important. Greek art could evolve into something rather different in the context of Roman society. Perhaps mosaic demonstrates that better than most art-forms, for although it was originally a Greek invention, it ultimately spread to every part of the empire as a 'typical' aspect of Roman artistic culture, developing new forms and enduring into medieval Europe and the Middle East (cf. Figs. 2, 37, and 43). Yet even the Roman art-forms that remained most heavily indebted to earlier Greek models constitute a thorough assimilation and reinvention of the past. This is clear from the production of copies, which has become a subject of very vigorous debate in recent years.

[5] Pliny, *NH* 34.7–8. See Jacobson and Weitzman 1992 for full discussion of the sources and the science.
[6] See esp. the various articles in Salies et al. (1994). Also Fuchs 1963; Ridgway 1995 (review article).

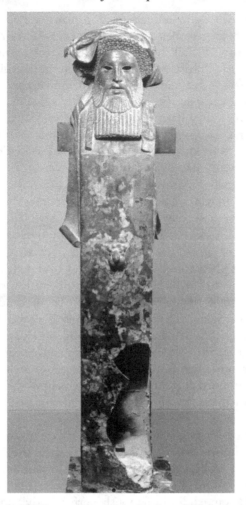

Fig. 34. Bronze herm of Dionysus 'signed' by Boethos of Chalcedon, from the Mahdia shipwreck off the coast of Tunisia. c. late second century BC.

Since the eighteenth century Roman art has frequently been regarded as derivative and imitative, and it is perfectly correct that Roman sculpture includes many pieces which are unquestionably[7] more or less accurate copies of classical or Hellenistic Greek works. The same is possibly true of

[7] In fact this is untrue, for the assertion has been questioned. But the evidence is strong, and revisionist treatments of 'copies' have tended to exaggerate the weaknesses of traditional copy-criticism. See Hallett 1995 for a defence of copies and Perry 2005 for an open-minded critique.

elements in Roman wall-paintings (cf. Fig. 10). As a result, these works have generally been regarded as crucial sources for Greek, rather than Roman, art history. Of all the most famous Greek artists – figures like Phidias, Polyclitus, Praxiteles, and Zeuxis who are regularly mentioned by Roman writers – not one single work demonstrably survives, and so presumed Roman copies become especially valuable. Since the late nineteenth century they have frequently been subjected to careful comparison and analysis – *Kopienkritik* ('copy-criticism') is the German term – in order to reconstruct the appearance of lost originals.[8]

However, various studies over the last 30 years or so have demonstrated two problems with this approach.[9] The first is that many supposed copies cannot be shown to be copies at all. Sometimes they are considered as such simply because they convincingly use styles devised in various periods of past Greek art. But in at least some cases this is sure to represent a sort of 'neo-classicism' on the part of artists in the Roman period who were often completely skilled and confident in manipulating such styles. Even works which seem to have a common model, or which reproduce a popular figure-type, need not be descended from some important, early original. The other problem is that even those works that can be confidently considered true copies – and which are indeed valuable as sources for earlier art – do not always seem to have been made explicitly to be copies. In other words, their subject-matter or style appears to have been at least as important as any acknowledgement of the original work or the master who made it. This is despite the conspicuous interest that Roman writers show in those artists of the past.

The celebrated *doryphoros* ('spear-bearer') by Polyclitus is one fifth-century BC sculpture that is agreed to survive in the form of Roman copies. But these replicas are hardly treated as intentional reproductions of a masterpiece. One bronze version has been reduced to a herm-mounted head (so much for its famously perfect body!) and it is signed by the copyist. Another, full-scale, replica at Pompeii stood in a sort of exercise ground, the Samnite Palaestra, where its athletic subject might be deemed more relevant than its artistic pedigree.[10] In other cases, bodies or heads of identifiably famous works appear to have been combined to create new figures, or they have been adapted for a new purpose. The

[8] Furtwängler 1893 (translated in 1895 as *Masterpieces of Greek Sculpture*) is the seminal text. For critical history of copy-studies see Gazda 2002: 4–11; Perry 2005: esp. 78–90.
[9] For various critical discussions see the essays and introduction in Gazda 2002, as well as Ridgway 1984; Marvin 1993 and 1997; Stewart 2003: 231–49; Perry 2005.
[10] Cf. Marvin 1997.

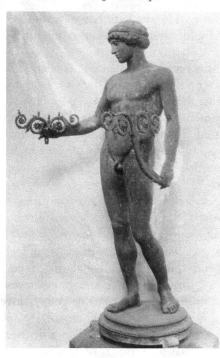

Fig. 35. Gilded bronze lamp-holder statue from the House of the Ephebe, Pompeii. *c.* late first century BC/early first century AD.

renowned Prima Porta statue of the emperor Augustus, which modern scholars recognise as having the pose of the *doryphoros* beneath its Roman armour, is one good example. A less elevated illustration is provided by examples of 'Polyclitan' figures converted for use as lampstands (Fig. 35).[11] Moreover, sometimes multiple copies were used in villa decoration, deployed, for example, as 'pendant' pairs, balancing each other on either side of a door. Sometimes their poses were reversed.[12] Frequently the medium was changed, particularly from bronze to marble.

So it is clear that even if these works were indeed intended and acknowledged to reproduce famous works of art, their owners' art-historical sensibilities were not the only factor. It has been argued that a major consideration was the appropriateness of sculptural and other decorations, in terms of form, style, and subject, to the locations in which they were displayed. In ancient literature this notion of aesthetic

[11] Zanker 1998: 178–9. [12] See e.g. Bartman 1988.

appropriateness is conveyed by the Latin words *decor* and *decorum*, which simultaneously connote 'decoration', 'beauty' 'suitability', and 'decorum' in the modern sense.[13]

There is no consensus yet on the balance of concerns that motivated the Roman use of copies – on how many of them are 'copies' as such. But one thing is beyond doubt: that already by the end of the republican period the patrons and customers for Roman art, as well as the artists themselves, were completely versed in the iconographic and stylistic 'language' of Greek art and understood the appropriate ways in which the spectrum of much earlier Greek models could be used. The entire repertoire of past art lay available to them.[14]

Even archaic Greek styles first used five centuries before could be employed to give an air of antiquity and venerability to the image of a god. We see this in the stiff features and schematic beard of the Mahdia Dionysus herm (Fig. 34), which is actually a signed Hellenistic work of around the mid-second century BC, though in other contexts it was common to use later, sinuous, rather effeminate faces and bodies to emphasise the languid sensuality of the wine-god. Conversely, the ideal Polyclitan body of the lampstand from Pompeii (Fig. 35) was given an early classical style female head, perhaps to combine ideal aloofness with an erotic charge in this naked 'servant' boy. We have seen this careful selection of styles and models in public art as well. The Ara Pacis employs a sedate classicism, with idealised faces and drapery – a style often likened to that of the Parthenon frieze – for the solemn processional reliefs on its side walls (Fig. 1). Different styles are used on other parts of the monument so that, for example, the landscape in its scene of the hero Aeneas sacrificing, which is generally classical in tone, nevertheless includes the sort of impressionistic, receding vista and background details that had been developed first in the Hellenistic period as an effective means for conveying such subjects.

The stylistic pluralism of Roman art, the selection and combination of appropriate elements from past Greek art, has been noted for a long time, but more recently Tonio Hölscher has analysed it in some detail.[15] For Hölscher, it really does amount to a language of images, in which different styles or models or patterns associated with past periods of Greek

[13] Marvin 1993; Perry 2005 (esp. 31–38 on the terms). Cf. Bartman 1988.
[14] Hölscher 2004 – see below.
[15] Hölscher 1987, translated in updated and student-friendly format as Hölscher 2004. For earlier comments on pluralism see e.g. Brendel 1979 (originally 1953) 122–37 and Elsner's Foreword to Hölscher 2004: xv–xxxi.

art and with famous artists not only are considered especially effective and appropriate for certain contexts and subjects, but may even carry various moral associations. Thus the classical style of fifth-century BC Greece, as used in much Augustan political art, may have connotations of *dignitas* and *auctoritas*, or *gravitas* and *sanctitas*.[16] This 'language' is explicitly theorised to an extent by some Roman authors, but no doubt both artists and their customers used and responded to it more or less intuitively. We shall return to the implications of Hölscher's argument shortly.

THE GREEK PERSPECTIVE

The whole story of Roman expansion and artistic assimilation recounted above is approximately true. Nonetheless, it is a partial account in every sense. It is, in particular, a highly Romano-centric account: it is all about how the Romans got an artistic tradition from the Greeks and made it their own. Such a bias is inevitable in a book about Roman art, of course. But we should pause for a moment to consider the view from the Greek world. For it goes without saying that in the eastern Mediterranean Greek art never actually stopped, and to include the art of the Greek lands during this period – certainly in the period of the late republic and early empire – beneath the heading of 'Roman art' is an arbitrary and potentially misleading imposition.

Certainly, many works of art and architecture in the Greek cities were the direct consequence of Roman patronage or the reorientation of Greek communities towards Rome and ultimately the emperor as the new centre of power. From as early as the first century BC philhellene aristocrats were funding public buildings and monuments in the beleaguered city of Athens and elsewhere. Around 51 BC Appius Claudius Pulcher sponsored construction of a monumental entrance to the famous sanctuary at Eleusis; his friend Cicero was almost inspired to adorn Plato's Academy with a new portico.[17] Under the emperor Augustus, at the end of the first century BC, the centre of Athens received the biggest reconfiguration since classical times. The emperor's right-hand man and son-in-law M. Vipsanius Agrippa was probably responsible for a new odeion (small theatre) in its midst, and the rural Temple of Ares was actually moved stone by stone and re-erected here. A new, Roman agora (public square)

[16] All the terms can be translated approximately by their English derivatives. On the application of similar arguments to Augustan art see Zanker 1988b: esp. 239–63.

[17] Eleusis: see e.g. Ridgway 2002: 3–8. Cicero, *Ad Atticum* 19.17.

'of Caesar and Augustus' was completed nearby. The city began to look more Roman, just as Augustus's grand building projects in Rome made the capital look more Greek.[18]

Many further, major imperial building projects followed here and in dozens of other Greek cities during the imperial period. And then there were the products of overt imperial cult: the temples of Rome and Augustus; the dynastic portrait groups honouring the imperial family. One of the most interesting examples of the Romano-centrism of Greeks themselves in this period is the Sebasteion (imperial cult building) at the Greek city of Aphrodisias in Asia Minor.[19] This massive colonnaded building, which recalls the imperial forum complexes in Rome, was built during the first half of the first century AD by two local families. It is dedicated to the local patron goddess, Aphrodite, and the Demos (the deity or personification of the city's citizenry), as well as the emperors of the Julio-Claudian dynasty. Its very numerous relief sculptures included, among other subjects, a series of female personifications of peoples subject to the Roman empire, idealised representations of the imperial family, and even personalised depictions of the individual emperors' role in conquering provinces (on one panel a heroically naked emperor Claudius is shown subduing a female personification of Britain (Fig. 36); on another Nero holds a vanquished Armenia[20]). This is a sophisticated provincial homage to Roman power. It simultaneously celebrates Aphrodisias's own subject position under imperial rule and implies its importance and proximity to the *centre* of power. (The city had, in fact, a privileged status as a Roman ally which gave it independence from the province of Asia.)

These are some of the obvious manifestations of the Roman impact on Greek public art and architecture. But in some ways they are rather superficial. We must set against them the ongoing tradition of Greek art, which continued to be practised in much the same way as before, and which, from a technical point of view, is no less obvious in monuments like the Sebasteion. Insofar as this tradition was affected by Roman rule, we should look for a subtler kind of metamorphosis. It evolved in response to new patterns of patronage.

Some of its earliest surviving signs are on the island of Delos, which was a centre of Mediterranean trade, including the slave trade. Roman

[18] For all the developments in Athens see Shear 1981. Walker 1997 refines the picture. Note general relevance of essays in Hoff and Rotroff 1997 to the issues discussed here.
[19] Smith 1987; Smith 1988b. [20] Smith 1987: 115–17, no. 6; 117–20, no. 7.

Fig. 36. Relief from the Sebasteion in Aphrodisias, Caria, showing the emperor
Claudius's defeat of the personified Britain. Mid-first century AD.

businessmen were active and resident here around the end of the second
century BC, until the sack of the island by King Mithridates VI of Pontus
in 88 BC. In this well-defined period we find some of the earliest public
portraits made by Greek artists, for Greek customers, in order to honour
important Romans. Some of these clearly combined the traditional
heroically idealised bodies that were customary for portraits of Greek
benefactors, with realistic, aged faces which were probably deemed
appropriate to express the qualities of a good Roman patron – in the eyes
of their Delian clients. It may well be, in fact, that the refinement of
'verism' – of detailed realism – in portraiture (see Chapter Two) was a
Greek innovation, a new kind of imagery designed to respond to this sort
of relationship between Roman patrons and Greek client communities.[21]

[21] On Delos and its 'veristic' portraits see Stewart 1979: 65–98; Hallett 2005b: 102–4, 137–58 (with
broader discussion); and esp. Tanner 2000 for their influence on Rome.

Delos offers unusually precise parameters for understanding how artistic patronage might be affected by the presence of Romans in Greek communities. Greek art of the first century BC, which survives in greater quantities but is harder to date, has been used to make general observations about changing patronage in this period. Finds like those of the Mahdia wreck, often comprising 'neo-attic' sculpture – decorative works harking back to the fifth-century BC models – are assumed to have been manufactured primarily for Roman customers. In Ridgway's view, 'the most important lesson to be learned from the Mahdia ship, and from the approximately contemporary Antikythera wreck, is that Greek production during the first century [BC] was already almost entirely directed toward Roman markets'.[22] Ridgway argues that the new market for sculpture stimulated output and fostered new kinds of art, albeit often art that appealed to the (Roman) taste for classicism.[23] This included works with mythological, particularly Homeric themes; Dionysiac imagery appropriate for furnishing Roman houses and villas; and objects like candelabra stands and kraters decorated with 'neo-attic' reliefs. None of these things are at all 'un-Greek', nor do they represent any break in Greek artistic production, or even a radical change of direction in the development of Hellenistic art. But they do respond to, and reflect, the climate of Roman rule.

From this confused pool of evidence (and the examples above merely graze the surface) how are we to say where or when Greek art stops and Roman art begins? No generalisations do justice to the complex role of art in the confrontation of Roman and Greek culture.

And in fact 'confrontation' is a misleading word. As we have already seen, the expression of identity – including 'ethnic' identity – is a significant concern of social histories of art, but it is extremely difficult to discern expressions either of Roman or Greek identity through the art of this period. As late as the Elder Pliny at least (in the 70s AD) some Romans adopted a rhetoric of hostility to some Greek art and its influence on Rome.[24] There are certainly signs, as we have seen, that artistic production was presented as a non-Roman pursuit. Yet in practice Roman culture was already saturated with Greek art by the first century AD; Romans must have been already completely acculturated to it. In fact, paradoxically, Pliny the Elder himself is our best source for ancient Greek art history.

[22] Ridgway 2002: 11. [23] Ibid. passim, but esp. 3–18, 262–75. [24] Pollitt 1978; Stewart 2003: 225–7.

On the Greek side, it is hard to demonstrate any use of art as a weapon of cultural resistance to Rome or a vehicle for self-definition in opposition to the ruling power.[25] It is, however, obvious that certain kinds of artistic heritage – notably religious monuments – were important for the pride, prestige, and identity of Greek cities and their populations, and perhaps for the Greek provinces in general. This appears to be the case particularly around the second and early third centuries AD – that period of Greek cultural revival called 'the Second Sophistic', which we briefly encountered in Chapter Two. One manifestation of this Greek civic pride comes in the local, provincial coinage which Hellenic cities peri-odically put into circulation.[26] Here we regularly encounter prominent buildings and cult statues. Figure 30, for instance, shows the imposing cult statue of the healing god Asklepios in its temple at Pergamon in Asia Minor.

The artistic, as opposed to the religious, significance of such monu-ments need not have been a primary interest for those who celebrated them, though the writings of Pausanias show once again that 'art', 'reli-gion', and 'identity' are not as easily separated as those labels imply. Between about AD 150 and 180 Pausanias, a Greek author from Asia Minor, wrote an educated traveller's (or armchair traveller's) 'guidebook' to mainland Greece, which describes in a style deceptively reminiscent of the modern Baedeker, the sanctuaries and sights and works of art of many cities.[27] His information is invaluable for modern archaeologists (only his comments allow us to understand the imagery of the Temple of Zeus at Olympia or the Parthenon in Athens). The hundreds of sanctuaries mentioned by Pausanias are treated as religious sites: they are not mere museums or historical attractions. And yet, the author also takes a great interest in the subjects and the antiquity of works of art, in their artists and the stories around them.

Pausanias has been taken as a parallel or a guide to the imagery on provincial coins. But he explicitly sets out to discuss not only the heritage of individual cities, but 'all things Greek'.[28] Because of this and some of Pausanias's individual comments on the Romans, certain scholars have looked to him for traces of cultural resistance or even outright hostility to

[25] For one suggestion, at an early stage, see Smith 1981.
[26] Lacroix 1949; Price and Trell 1977. More generally, on artistic responses to the Greek past by cities of Asia Minor, see Newby 2003.
[27] See Habicht 1998 for an introduction to Pausanias. Also Arafat 1997; Alcock et al. 2001.
[28] Pausanias 1.26.4. For the relationship with coins see e.g. Imhoof-Blumer and Gardner 1964 (originally 1885–7).

Roman rule. For Pausanias tends to edit out or play down the material evidence of Roman rule. For instance, the Temple of Rome and Augustus on the Acropolis in Athens is never mentioned, and in one telling comment he deftly restores the 'proper' identity of an old statue that had been rededicated to the emperor Augustus: 'they say the [statue] that bears the inscription saying that it is the Emperor Augustus is Orestes'.[29] But is this resistance, or nostalgia, or merely a bias towards the ancient and interesting?[30] The debate is inconclusive. But perhaps what we do not know is more significant. There is no agreement about whether Pausanias was writing for Greeks or Romans or both.[31] The very subtlety of his political position, if he has one, is the result of the complex melding of Greek and Roman cultures by this period. The distinctions between them certainly did not vanish, but they are no longer so meaningful, and they are more difficult than ever to apply to art.

In this period, the Roman senatorial aristocracy, which was such an important source of patronage for public and private art, was itself largely of eastern, Greek origin.[32] The wealthiest Greek families lived 'international' lives, as active in the administration of the empire as in the care of their own cities. The learned millionaire Athenian Herodes Atticus is an exceptional yet also typical example.[33] Even his fuller name – Tiberius Claudius Atticus Herodes – encapsulates the hybrid culture of the empire in the second century. Consul in AD 143, a friend of the emperors, Herodes Atticus owned villas at Rome and in Greece and bestowed benefactions on Athens, Corinth, Olympia, and Delphi, as well as in Italy. As we can see from the rich artistic finds from his villa at Loukou in the Peloponnese, Greeks like him lived private lives of Hellenic luxury in the traditional *Roman* mould.[34] Their attitude to the classical Greek art of the past had actually come to be mediated by Roman history. Meanwhile, however, Rome itself, which saw less and less of the emperor from the reign of Hadrian (AD 117–38) onwards, had a diminishing practical importance as an imperial capital, which it never quite regained.

[29] Pausanias 2.17.3.
[30] For contrasting views on Pausanias's motives and his attitude to Rome see Elsner 1995: 126–55; Arafat 1997; Habicht 1998: esp. 117–140. For interesting observations on the issue of Greek artistic/cultural resistence see Newby 2003: esp. 199–202.
[31] Habicht 1998: 24–5.
[32] Hammond 1957 (eastern provincials constituting about a fifth of senators of known origin by the reign of Antoninus Pius): Alföldy 1985b: 116–20.
[33] On Herodes see Philostratus, *Lives of the Sophists* 2.1.
[34] On his patronage see Galli 2002; on the villa at Loukou and its art see Spyropoulos 2001.

PROVINCIALISM

We have moved from a Romano-centric view of imperial art to one that starts to accommodate the Greek lands. But we must now look in a different direction, for the concentration on the continuous 'Graeco-Roman' and 'classical' culture of the Mediterranean world, which inevitably dominates any discussion of ancient art, serves to obscure much of the art of the Roman provinces.

There were, in the Roman empire, a number of venerable artistic traditions which differed markedly from the dominant patterns of Graeco-Roman art. In Roman Egypt, the styles of ancient Egyptian art so familiar today continued to be used selectively under Roman rule as they had been under the Hellenistic Greek kings. They were even exported to Italy and elsewhere from the first century BC onward to feed the Roman taste for Egyptiaca. In Egypt itself we find interesting hybrid forms, notably in the decorated mummies of the Fayum region. Here a community of people who perhaps imagined themselves the privileged descendants of Greek settlers sometimes buried their dead with highly realistic painted portraits set into the mummy bandages or even onto coffins of Egyptian style.[35] At Palmyra in Syria, on the important trade-route towards Mesopotamia, sculptural portraits on reliefs inside tomb buildings showed men and women richly clothed and bejewelled in the local manner and with epitaphs in Aramaic script. But their poses and facial features draw upon the classical repertoire.[36] In third- to fourth-century Libya, on the fringes of the Sahara, the local elite constructed enormous, monumental tombs with distinctive carved decoration and friezes with non-Roman subjects and style.[37] Meanwhile in the Near East, it has often been assumed, with a degree of justification, that representational art was disdained, that anthropomorphic cult images were rare. Only slowly did the conventions of Greek and Roman art make an impact here.

By rights, these and other non-classical and hybrid traditions ought to receive as much attention as any Italian or Greek works in a study of the art of empire. But in the space available here, we should look at just one region, at the other end of the empire – the north-western provinces, and more particularly Roman Britain – to try to understand some of the more general problems raised by provincial art.

[35] Doxiadis 1995; Walker 1997. Riggs 2005 for extended, critical discussion.
[36] For these and all Palmyrene art see esp. Colledge 1976. [37] See e.g. Mattingly 2003.

Fig. 37. The Venus Mosaic from the villa at Rudston, Yorkshire.
Third or earlier fourth century AD?

Britain offers a sort of crucible in which to observe the sudden impact of classical artistic traditions on a land which had previous been only indirectly influenced by the Mediterranean.[38] It is not true that pre-Roman Britain had only abstract, Celtic imagery and no figurative art; but it is almost true. It was also largely unused to larger scale sculpture and completely unfamiliar with the domestic arts of wall-painting and mosaic. Cultural interchange between Roman territories and Britain arises on a significant scale only with Caesar's short-lived invasion of 55–54 BC, and the 'Romanisation' of art in Britain only begins after Claudius's decisive conquest of England in AD 43. So we can trace the spread of Roman artistic culture more clearly here than in most parts of the empire.

The results are frankly disappointing (Figs. 31 and 37). Notoriously, the great philosopher and Romano-British archaeologist R. G. Collingwood criticised the art of the province for 'a blundering, stupid ugliness that cannot rise to the level of . . . vulgarity'.[39] While subsequent scholars have

[38] For Romano-British art in general see Toynbee 1964; Henig 1995; Millett 1990: 112–17.
[39] Collingwood and Myres 1937: 250.

occasionally tried to defend or redeem Romano-British art, with equally subjective judgements, few would make great claims for the achievements of most of the art made in Britain, in most media. The same is true of the majority of the Roman provinces, and especially of the Gallic and Germanic provinces adjacent to Britain. This is one reason why the provinces tend to be marginalised in general discussions of Roman art (and even here I cannot claim to have given them the emphasis they really deserve). Another, more important reason for their neglect is that art history tends to privilege originality, creative independence, and influence. Provincial art often seems to be a poor imitation of a Roman tradition that was itself derived from Greece.

These objections lose much of their value if we are interested in the way art works in society, rather than in the story of artistic development. Increasingly there has been an interest in the social context of Romano-British and other provincial art.[40] Even perceived differences in quality can be explained in such a light. For example, let us suppose that Collingwood was right. Suppose for the sake of argument that Romano-British art is just plain bad. Then what is the reason for this lack of quality? For badness does not occur in a social vacuum. We need to ask questions about the degree of specialised skill exhibited by the artists. Were they unskilled amateurs – 'ordinary people' – or trained incompetents? Were the customers satisfied? If not, why did they not get something better? Could they afford it? Was the labour available? Was there the level of demand for certain kinds of art-work which would lead to a flourishing and competitive market?

These are important questions that can occasionally be brought into sharper definition by specific cases. So, for example, we might ask why there is a fall-off in quality in the same kinds of provincial tombstones when they were produced respectively in Germany and Britain for similar customers (Figs. 38 and 39). The level of demand may be a crucial factor here.

But of course, to answer these sorts of questions one needs to unpack the notion of 'badness' and to ask in very clear terms what we mean by it.[41] In fact such questions are unfashionable, and studies of provincial art have tended to attribute the 'non-classical' characteristics of provincial art to the only partially Romanised tastes of provincials, or to their own preferences and aesthetic needs (for example, the non-naturalistic,

[40] See esp. Henig 1995: esp. 58–77; Millett 1990: 112–17; Scott 2000.
[41] For an important analysis of the issue of quality see Johns 2003a; Johns 2003b.

Fig. 38. Gravestone of the cavalryman Iulius Ingenius. Mainz, *c.* 70s AD.

simplified appearance of some Romano-British art is attributed to a Celtic
fondness for the abstract). Thus most scholars who have been prepared to
take an interest in provincial art are now inclined to understand it on its
own terms without making critical judgements.

Whatever approach is adopted, Rome, or at least the sophisticated
Roman art of the Mediterranean, has usually provided the benchmark
for evaluating provincial art. Even those who do not make negative
judgements about it are interested to examine how far Roman artistic

Fig. 39. Gravestone of Mantinia Maerica (?) and her mother.
York, second/third century AD.

conventions have penetrated cultures absorbed within the empire. And so
'Romanisation' has been the key, underlying concept. Romanisation does
not apply only to the forms of art – to its *appearance* – but also to its
usage. For example, honorific statuary appears to have been employed to a
much lesser degree in the north-western provinces than in most other
parts of the empire. In Britain the evidence of statuary is very sparse
indeed. This in turn possibly reflects a lack of interest on the part of local

aristocrats in euergetism – in public benefactions – which commonly
resulted in the reward of statues. No doubt there were alternative means
of acquiring prestige and exhibiting status in the society of Roman
Britain.[42]

In recent years a number of archaeologists interested in all aspects of
provincial material culture have strongly criticised the notion of
Romanisation, to the extent that the term is beginning to fall from use
(often to be replaced by consideration of 'identity').[43] There are several
main objections to the concept. For a start, some regard it as a hang-over
from the scholarship of Europe's own imperial age. For instance, British
ancient historians in the early twentieth century explicitly compared the
British and Roman empires. It is argued that they saw Roman archaeology
through the lens of a self-justifying imperialism, and that we have
inherited their terms of reference. In contrast, a 'post-colonialist'
archaeology should look at the real people of a province like Britain, not
just the 'elite' attested in ancient literature. Their material culture helps us
to do this, but not if we continually measure it against Rome.

One effect of this argument is to shift attention onto non-Roman
elements in provincial art, and even to present them as expressions of a
resistant culture, challenging or denying Roman values to differing
extents. So for example, Miranda Aldhouse-Green has argued that a lot of
simple Romano-British votive reliefs look as they do because of the ideas
and requirements of indigenous cult, and not because they are failed
attempts to imitate classical art.[44] (She suggests that one relief from the
Cotswold area, significantly cruder than that in Figure 31, 'displays a range
of contra-normative features, which may be read as contesting *romani-
tas*'.[45]) Even for those who do not embrace such an approach, 'Roman-
isation' may seem to over-emphasise the active influence of Rome and to
imply that provincials were simply passive recipients of this externally
imposed culture. In fact, such cases of 'influence' are nearly always
stimulated by the tastes and preferences of the provincials, and not
'imposed' at all.

Another objection to Romanisation, one which is rather more widely
held still, is that the concept is simplistic. It implies a clear sense of what
Romanness is and how it was diffused. In reality, as we have already seen,

[42] Millett 1990: 80–85; Stewart 2003: 174–9.
[43] See e.g. Mattingly 1995; Hingley 2005: 30–46; Webster 2003 on art. For a revised concept of
 Romanisation see esp. Woolf 1998.
[44] Green 1998; Aldhouse-Green 2003; Aldhouse-Green 2004. Cf. Webster 2003.
[45] Aldhouse-Green 2003: 42.

it is no simple matter to define Roman culture, and especially not Roman art. Nor can everything be explained simply by relating the periphery of the empire to its centre. Artistic trends moved, for example, between provinces. Different groups in the provinces had differing tastes and used art in different ways. Occasionally Italy could even be 'influenced' by the art of the provinces.

The so-called funerary banquet reliefs illustrated in Figures 38 and 39 offer one relatively well-known example of the limitations of 'Romanisation'. These scenes came to be very popular on tombstones and in other funerary sculptures and paintings in many parts of the empire, especially in Egypt and Syria, in Greece and Asia Minor, in the Balkans (modern Bulgaria and its neighbours), in Germany and in Britain.[46] They show the deceased reclining to eat and drink at leisure, presumably in the afterlife. Often servants and relatives are in attendance. To the eyes of the art historian this imagery is unambiguously classical in the sense that it belongs to the Greek tradition of naturalistic representation, originates in Greece and Asia Minor, and appears to spread from that region in the late Hellenistic and imperial periods. It is interesting to see how and why it is diffused, who uses it, and how it is transformed. For instance, in Europe the image seems to be spread by the army, and in Germany it appears mainly on tombstones of cavalry auxiliaries; but when it reaches Britain it is mainly popular with civilians. Yet this is not straightforwardly a case of 'Romanisation'. In fact, the image appears relatively rarely in Italy and does not seem to stem from there. The only major body of examples from Rome consists of numerous tombstones – a chance survival – of the imperial horseguard who were recruited in the northern provinces and obviously brought their own funerary preferences with them to the capital.[47] The funerary banquet reliefs are a good reminder of the importance of the army (which in the imperial period was very largely recruited from non-citizens in the provinces) in spreading aspects of Roman art and culture. The process is not predictable nor, paradoxically, is the city of Rome of central importance.

So while some scholars seek to use the idea of 'Romanisation' in a more subtle way that recognises these problems, others have discarded the term altogether. This is unfortunate, because it is clear that, for all the cultural diversity of the empire, its various provinces and populations had much in

[46] Generally see Noelke 1998; Dunbabin 2003: 103–10; Stewart (forthcoming, b).
[47] On their images see Busch 2003.

common.[48] Art above all served to provide a common language of empire, not only for those large sections of the population who made or purchased sculptures, painting, mosaics, and the other art-forms that have concerned us, but also for those who used and viewed them. No part of the empire altogether lacked decorated villas. No part of its population was unfamiliar with the image of the emperor on coins or in statuary.

UNCLASSICAL ROMAN ART

There is another reason why we should guard against fragmenting the study of provincial art or taking Rome out of the equation. The picture so far presented is a conventional one, and is broadly correct: Rome inherited from Greece the classical artistic tradition of representing people and things in a more or less idealised but generally faithful, naturalistic manner. This tradition continued in Greece, Italy, and some other parts of Mediterranean lands under Roman rule. In contrast, in other provincial regions, we find either discrepant local traditions with their own conventions or else much simplifying, perhaps unskilled or ill-informed efforts to imitate classical imagery. But, of course, the reality is more complicated, and in fact there is no sharp distinction even between Italy and the fringes of the empire.

The truth is that everywhere in the empire, even in Italy and Rome itself, one can find many works of art which seem either to ignore or to defy the conventions of the classical tradition.[49] For example, reliefs like that in Figure 40 tend to simplify their subjects, with rather abstract, unrealistic figures. This particular piece is a frieze slab from around a household shrine in the House of Caecilius Iucundus at Pompeii. It apparently represents the devastating earthquake that hit the town in AD 62. Towards the centre we see what is probably the main temple in the forum: the Capitolium or Temple of Jupiter. The monuments around it are toppling; equestrian statues beside its steps are disintegrating. To the right is a (subsequent?) scene of sacrifice, with an oddly articulated bull being led to a decorated altar. Sacrificial implements float like hieroglyphs to the left and right. This scene is highly legible – almost sign-like – but in departure from the principles of the classical tradition it does not represent things as they would plausibly appear. Not only are the proportions of figures unnaturalistic, but their spatial relationship to one another is

[48] Note Hingley 2005 for an attempt to avoid a fragmented account of imperial culture.
[49] See e.g. Felletti Maj 1977.

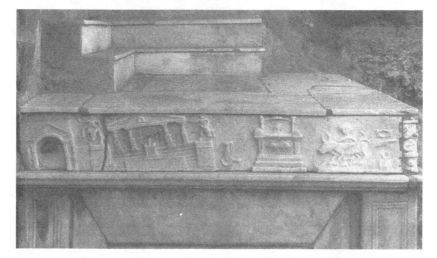

Fig. 40. 'Earthquake relief' from the House of Caecilius Iucundus, Pompeii. AD 62–79.

inaccurate. It is the *idea* of the scene that is communicated rather than its *appearance*.

Here we need to make a distinction that is sometimes ignored. Features such as those described above can be found throughout Roman art, even in monuments by skilled craftsmen which appear to be very much in the classical tradition. For example, there is a distortion of scale and space in the frieze of Trajan's Column (Fig. 26), even though the figures are, individually, highly naturalistic and broadly 'classical'. Such a distortion is necessary for the lucid rendering of a continuous narrative in such a low relief field. Similarly, a skewed 'bird's eye perspective' – a simultaneously frontal and aerial view of objects – is employed throughout Roman art where this is necessary to depict circular objects or buildings (like amphitheatres) or circular motion (as in the cavalry displays on the base of the Column of Antoninus Pius) in a clear fashion.[50] What we are dealing with in the Pompeian earthquake relief is almost certainly something rather different. It is probably the work of a sculptor who is used to carving in a consistently non-classical idiom.

That is not to say that the style is not appropriate both to its subject (because it successfully conveys something that is very hard to represent naturalistically) and to its context (since other shrines are often decorated with rather bold, 'iconic' imagery).[51] No doubt these factors have motivated

[50] Cf. Bianchi Bandinelli 1970: 249–50; Hölscher 2004: 44–5. [51] See generally Fröhlich 1991.

Fig. 41. Inscribed wall-painting of a bar scene, from the Caupona (bar) of Salvius, Pompeii. First century AD (before AD 79). The characters' words are inscribed on the painting. The figure on the left calls to the bar-maid carrying a cup and jug, 'Over here!'; the middle figure shouts, 'No, it's mine!' The woman responds, 'Whoever wants it, take it! Oceanus, come and drink!'

the customer's choice of artist (who might be a local craftsman or a even a semi-skilled member of the household). The apparently prosperous owners of this house chose the skills of quite different artists for their wall-paintings and other domestic art, as was appropriate. But the point is that the style of representation is not simply a choice from a repertoire. It is surely due partly to the background of the artist – particularly the tradition in which he has learned his craft.

There are many other cases where the context and function of a work of art make the use of relatively 'un-classical' imagery – or rather of artists who work in this style – acceptable and suitable.[52] So, for example, the sorts of genre paintings appropriate for the walls of a bar (scenes of 'everyday life', with drinking and gaming figures calling out to each other in colloquial Latin), as in Figure 41, would be quite wrong for the erudite

[52] Cf. Kampen 1981b: esp. 72–82 on style.

settings for reception of visitors and dining that we encountered in the House of the Vettii.[53] In a sense we should view this kind of imagery alongside the repertoire of Greek styles in Roman art: as one thread in a pluralistic artistic culture, in which form was linked to function.

However, there is a certain hierarchical, social distinction to be made between these sorts of works and the more 'classical' works with which this book has mainly been concerned. In the past a number of scholars have seen Roman art in terms of a contrast between 'popular' art like the earthquake relief and the bar paintings, and 'court' art – the refined, Greek-style, classical works favoured by the Roman aristocracy. Ranuccio Bianchi Bandinelli was most famous for this approach, and it was he who coined the term 'plebeian art', which is still sometimes employed.[54] For Bianchi Bandinelli, the classical tradition that seems to dominate Roman art was merely a veneer, favoured by the upper classes, overlaid upon native Italian traditions which were patronised by the lower social classes, and which less obviously stemmed from Greece.

Today perhaps most Roman art historians would criticise his claims as overly simple, two-dimensional, flattening out the full variety and complexity of Roman art, and too much influenced by the author's Marxist political views. It should be noted that Bianchi Bandinelli himself recognised that his terminology was a simplification.[55] Nevertheless, his approach has been influential because, first, it was an attempt to take 'primitive' Roman art, in Italy as well as the provinces, seriously; and second, it was an attempt to understand artistic style with regard to its social context. Others have built on his work. Bianchi Bandinelli's desire to understand artistic differences specifically with regard to class reflects not only his own politics but the academic concerns of his time. Rather more recently Natalie Kampen has tried to present a more three-dimensional account of 'plebeian' Roman art by considering gender alongside social stratification in a study of funerary reliefs and other works at Ostia, the imperial port of Rome.[56] She finds that realistic representations of women actively at work, as opposed to those that marginalise female work or show women in a subordinate role, are consistently rendered in these 'non-classical' styles, and that they belong to a cultural milieu towards the lower end of the social scale: those whose

[53] On bar paintings see Kampen 1981b: 103, 155 no. 48; Clarke 2003: 160–70.
[54] See esp. Bianchi Bandinell 1967; Bianchi Bandinelli 1970: 51–71. See also Rodenwaldt 1940; Felletti-Maj 1977.
[55] Bianchi Bandinelli 1967: 7, 17–19; Bianchi Bandinelli 1970: 63–4. [56] Kampen 1981b.

self-representation is relatively distanced from the prevailing Roman ideal of female passivity and domesticity. Thus, the topical issue of gender allows us to see just one way in which the social hierarchy of Roman art might be complicated. There are undoubtedly other such factors still to be analysed in making sense of the pluralism of Roman imperial art.

<center>LATE ANTIQUITY</center>

It is not the chief aim of this book to present a narrative or developmental history of Roman art, but it will already be clear that changes in its forms and usage are intimately linked to changes to the society within which art was embedded. Consequently, having looked repeatedly at Rome's inheritance of the classical, Greek artistic tradition, we should finish with some observations about 'Late Antiquity', the period from around the third to the fifth centuries AD, in which that tradition appears, at first sight, to dissolve.[57]

'Late Antique art' (as it is often known) shares some of the characteristics of earlier provincial art as outlined above, both in its appearance and in its use. Let us consider function first. Very broadly, art in the third, fourth, and fifth centuries continues to perform the same roles. It commemorates the dead, honours the living, celebrates the imperial family, creates the backdrop for domestic life, and provides images of the divine. Writers in this period do not seem to be strongly aware of any discontinuity in the uses of art. Some of the rhetoric of art descriptions, such as literary praise for the realism of masterpieces of sculpture and painting, remains as it had been for centuries. And yet that apparent continuity belies very significant changes in artistic production.[58] Sometimes these are obvious; for example, Christian art gradually supplants overtly pagan religious images, although, as we shall see, mythological art survives. Other changes are harder to explain. For instance, the age-old tradition of portrait statuary begins to wane, with an initial, sudden drop-off in numbers of new monuments before the fourth century. Statues continue to be made for some people – including the emperor and regional governors – even as late as the seventh century, in what is usually considered the 'Byzantine' period. But the numbers attested by surviving works,

[57] On Late Antique art generally see e.g. Bianchi Bandinelli 1971; Elsner 1998a (with further references); Elsner 1998b.
[58] On these issues see Stewart 2007a.

literary evidence, and inscriptions are tiny compared with the earlier empire.[59]

As in those provinces like Britain where statuary never thrived, it seems likely that the absence of honorific portraits is bound up with a general reduction in public investment and benefaction by wealthy families.[60] In what was perhaps an increasingly hierarchical society, such forms of civic generosity, to be rewarded by statues, were less favoured by a (sometimes astronomically rich) aristocracy with interests extending across the empire.[61] The case of Rutilius's father mentioned in Chapter Three is a late example of the custom.

In the same period we find that those public constructions, monuments, and statues that *were* set up very frequently make use of 'spolia' – reused or unused materials from earlier periods.[62] The most famous example of this practice is the Arch of Constantine, which was erected by the senate and people of Rome around AD 312 to 315 in honour of the emperor, after he had ousted his rival, Maxentius, from the city. It is a beautiful and impressive triumphal monument covered with sculptures that represent the emperor's good deeds and achievements in (civil) war and in peace. But almost none of it was newly made. Its marble veneers, decorations, and the sculptures (and probably very more much more of the structure itself) largely comprise first- and second-century spolia. Absolutely typical of monuments of its period, the Arch of Constantine has been used by commentators for five centuries or more to encapsulate the perceived decline of Graeco-Roman art.

This is not only because of the use of spolia. Those parts of the arch's sculptures that were made at the start of the fourth century, most notably the friezes that run around the middle of the structure, have none of the confident naturalism displayed by the earlier sculptures (Fig. 42a). In fact, the friezes have just the sort of characteristics already encountered in some earlier provincial and 'non-classical' art: the frontality of figures, their relative lack of differentiation, their flat, unmodelled forms (accentuated by carving with a drill), the unnatural proportions and rendering of spatial recession.

To a greater or lesser extent, these features are typical of much late Roman art and indeed the art of the Middle Ages, to which, in a sense, they belong.[63]

[59] See Stichel 1982; Smith 1985: 209–21; Stewart 2007a. [60] Cf. Smith 1999: 173.
[61] Overview in Scott 2000: 106–12.
[62] On spolia see e.g. Kinney 1997; Elsner 2000; Elsner 2004: 278–80 with further references.
[63] Though there are risks in viewing them in this way: Elsner 2004: esp. 276–7 for critique.

Are we really dealing with the decline and disintegration of the classical tradition? The question has been fought over for more than a century.[64] It is a particularly resonant debate for us, because it is implicitly (and sometimes explicitly) related to arguments about twentieth-century art and its deliberate tendency to depart from traditional naturalism – from the representation of the world 'as it really appears'. Is it not likely, many have suggested, that the forms of late Antique Art represent not a decline, but rather (as in modern art) a change of tastes and expectations? Perhaps a shift in what was required of art: for example, a need to represent the status of the emperor or the narratives of Christianity with the greatest symbolic clarity? Viewed in this light, Late Antique style reflects a different mode of viewing, not a failure to meet earlier standards. Like provincial art, therefore, it should be judged on its own terms. As for the Arch of Constantine, it has been regarded as an altogether more subtle effort to present the ruler in the mould of his good predecessors, the spolia serving to evoke this imperial heritage.[65]

While this attitude has perhaps come to prevail among Roman art historians, and may have a substantial element of truth in it, especially in respect to this monument, there is a risk once again that we may end up ignoring the potential for some late Roman art to be *bad*. At the very least we need to recognise that, whatever drove the disappearance of classical naturalism from certain categories of Late Antique art, the supply of materials and skills that fuelled earlier artistic production was simply ceasing to exist. Indeed, much the same can be said of modern western art, regardless of whether or not one approves of its course of development.

Bianchi Bandinelli recognised the analogies between Late Antique art, provincial art, and 'plebeian art' of the earlier empire and looked to these for a sociological explanation for the changes in artistic style. His argument is that the period saw the rise of a new elite, with imperial, military, and bureaucratic power moving into the hands of people from lower social strata, provincials and the 'middle classes'.[66] Consequently, he suggests that works like the frieze of the Arch of Constantine represent the ascendancy of the tastes of those people: that Late Antique art is 'plebeian art' in a new context. Once again, while this argument requires very broad

[64] For decline see e.g. Berenson 1954 (relating to modern art); cf. Spivey 1995. Against decline see e.g. Peirce 1989; Elsner 2000. Cf. Elsner 1998a: esp. 739–42; Elsner 2004, both with general historiographical discussion.

[65] See note 62 above.

[66] Bianchi Bandinelli 1961b. Cf. Bianchi Bandinelli 1971: 41–103 (rather obscure).

(a)

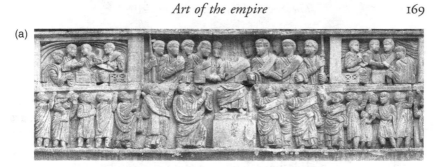

Fig. 42 a. 'Largitio' (largesse) scene from the frieze on the Arch of Constantine.
Rome. AD 312–15.

(b)

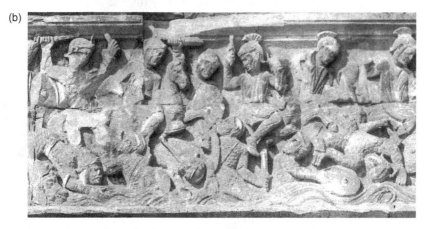

b. Battle scene from the frieze on the Arch of Constantine. Rome. AD 312–15.

(c)

c. Battle scene from an architectural frieze. *c.* late first century BC.

generalisations and may be more satisfying than accurate, it offers a helpful way of thinking about the making of art, not simply as a dis-embodied visual language, or as a symptom of changing tastes, but as something produced by and responsive to society.

One qualification must be stated, in conclusion, if the above account of late Roman art is to be even vaguely truthful. In this period, as before, art was highly pluralistic – it continues to afford examples of great diversity in style, and format, and subject matter. It is very likely that some of the principles of Tonio Hölscher's 'language of images' can be applied even to this late material. In other words, we ought not to talk generally about 'Late Antique style', since the approaches to representation adopted by artists, or the different traditions represented by diverse artists, are related to the kinds of work that they are making: to the type of monument, its format, its context, and what it depicts. The three examples in Figure 42 demonstrate this. The scene of Constantine distributing largesse can easily be used, as above, to exemplify the non-classical traits of Late Antique sculpture. But in certain settings similar stylistic features can be found in much earlier public works (for instance, in the comparable friezes in the arches of Septimius Severus, Trajan, and Titus).[67] Conversely, when the frieze of the Arch of Constantine represents the chaos and confusion of battle (Fig. 42b), it resorts to a different style of composition, a much less frontal, more intricate mêlée of horses and bodies that is descended from Hellenistic Greek battle scenes, and which can be much more closely paralleled in early imperial work (Fig. 42c).[68] There is a risk, therefore, that we will over-emphasise changes in late Roman art by selective use of examples, and by failing to compare like with like.[69]

Indeed, owing in part to new finds and to the redating of certain works previously believed to be from the earlier empire, it is clearer than ever before that in some contexts the classical tradition of naturalistic art continued to thrive.[70] As wealthy patrons of art and architecture ceased to invest in public buildings and the interest of cities in public monuments and statues declined, the patronage of domestic and luxury art thrived, perhaps as never before. This applies to certain centres of production for domestic sculpture, notably Aphrodisias.[71] Many of the finest, and most naturalistic, Roman mosaics across the empire, in areas such as north Africa, Cyprus, and Syria, date to around the fourth century AD or even

[67] Cf. Bianchi Bandinelli 1971: 63–5, 73. [68] Hölscher 2004: 38–46, esp. 39.
[69] See also Eastmond and Stewart 2006. [70] See e.g. Kiilerich 1993; Eastmond 2006.
[71] See Bergmann 1999; e.g. Moltesen 2000; Stirling 2005.

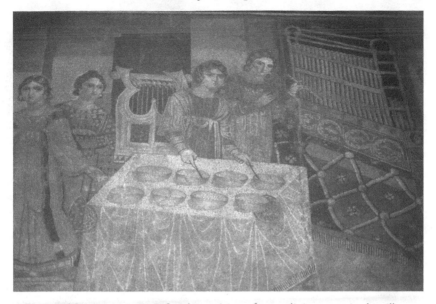

Fig. 43. Mosaic representing female musicians, from a dining room in the villa at
Mariamin, Syria. *c.* end of fourth century AD.

later (Fig. 43).[72] Huge hoards of late Roman silver have been found,
decorated by highly skilled craftsmen.[73] Some of the most sophisticated
carved ivories to survive from antiquity come from this period, while we
also have survivals of religious and secular illustrated books.[74]

Imagery of pagan mythology, including the world of Dionysus, fre-
quently dominates these forms of traditional, Late Antique art, and some
have argued that they reveal the determinedly conservative tastes of a
pagan aristocracy, holding out against the tide of, now established,
Christianity.[75] But no such explanation is necessary. Many of these works
belong to a context that we have already briefly examined in a much
earlier period: the environment of a cultivated leisure that prosperous and
educated Romans sought to construct in the domestic sphere, and par-
ticularly as the suitable setting for dining.[76] And even on a somewhat

[72] See e.g. Dunbabin 1999; Dunbabin 1978 on Africa; Balty 1977 (note esp. p. 98 on the late dating of
my Fig. 43) and Kondoleon 2000 on Syria (latter including various essays). Cf. Scott 2000 on
Britain.

[73] Johns 1990 (overview); Leader-Newby 2004.

[74] For overview of thriving 'minor arts' such as these, with references, see Elsner 1998a: 737–8; Elsner
2004.

[75] See Bowersock 1990: esp. 4–5; 49–53. [76] Cf. Scott 2000; Stirling 2005.

lower social level of artistic imagery, such as the decorated textiles that survive from Egypt, the traditional mythical imagery, which remained part of Roman education, is widespread.[77] It seems that, to an extent, such imagery remained acceptable and popular among most Roman Christians. As such, it ensured the survival of Roman artistic forms for centuries into the Middle Ages.

[77] On the role of traditional education in perpetuating classical imagery see Leader-Newby 2004.

Bibliographical essay

SOURCES OF INFORMATION

This book is not a handbook or introduction to Roman art, but there are a number of good volumes which serve that purpose in different ways, and which are of use to more than just the novice.

Stewart 2004 is both a basic introduction to Roman art and an historiographical survey of the discipline, intended to give further bibliographical directions. Strong 1988 is an authoritative survey of the material arranged both chronologically and by medium and with good notes and bibliography, but it is not well illustrated and is now somewhat out of date. Brilliant 1974 is also a vintage text, but it was ahead of its time with its highly perceptive thematic and chronological survey. Henig 1983b offers good introductory essays on various media and themes. For its illustrations particularly, Ramage and Ramage 2004 (as well as earlier editions) is excellent. So also is D'Ambra 1998, which has already been cited in this book. In many ways I share D'Ambra's social-historical concerns and, though aimed at a general audience, her book is a very good introduction to the social history of Roman art. Zanker 2007 encapsulates in a short and accessible survey (but so far only in German) many of the interests and approaches of this most influential of commentators on Roman art. Finally, two volumes in the Oxford History of Art series offer recent, critical and theoretically informed analyses of the earlier and later periods of Roman art respectively. Beard and Henderson 2001 in particular aims to debunk myths about Roman art and its place in the classical tradition; while Elsner 1998b is a thematic, sociologically orientated survey that bridges the boundary between classical and Christian art. Both are extremely well illustrated and accessible.

There are also various good introductory texts on particular media or art-forms. Note especially the following. Sculpture: Kleiner 1992 (immensely rich in carefully discussed and illustrated examples and historical background; less so on the social context); Schollmeyer 2005 (very good, short overview in German, paying attention to all aspects, including contexts and functions). Wall-painting: Ling 1991. Mosaic: Ling 1998; Dunbabin 1999. On architecture, which I have largely avoided here, see the rather old-fashioned but authoritative Ward-Perkins 1981; and for a more up-to-date overview, Wilson-Jones 2000. Finally, Claridge 1998 is an invaluable guide of unparalleled accuracy to the monuments of Rome.

The full potential of websites is yet to be realised in this field. There are countless sites offering *some* information, *some* pictures. Note, however, the following:

> The Stoa Consortium, hosting among other resources P. Allison's 'Pompeian Households: An Online Companion', and the McMaster Trajan Project with its excellent illustrations of Trajan's Column: www.stoa.org
>
> The British Museum's image database, with good pictures and information on some hundreds of Roman artefacts in the collection: www.thebritishmuseum. ac.uk/explore/introduction.aspx
>
> For online access to various journals, including *JRS* (see below) and the *American Journal of Archaeology*, see JSTOR (requires an institutional subscription at present): www.jstor.org
>
> Recent volumes of *AJA* are freely available: www.ajaonline.org
>
> *Bryn Mawr Classical Review* is a good place to look for full, scholarly reviews of books on Roman art: ccat.sas.upenn.edu/bmcr/

Finally, the photo-sharing website flickr.com contains thousands of images relevant to Roman art, many of them with 'Creative Commons' copyright licences that make them easy to use legitimately for, e.g., educational purposes. Within that site the 'Chiron' group especially is dedicated to making images available for classical teaching and research. This site carries many of my own photographs (under the screen-name 'Tintern'), including colour images of the House of the Vettii and other sites mentioned in this book.

The most valuable academic journal for Roman art history is probably the *Journal of Roman Archaeology* with its excellent reviews, original research, and scholarly debates. *The Journal of Roman Studies* also regularly publishes articles on art. *Römische Mitteilungen* (=*Mitteilungen des Deutschen Archäologischen Instituts*) is one of the leading publications for German work on Roman art.

Among the many relevant reference works, it is perhaps worth highlighting two multi-volume enterprises that have not so far been cited here: the *Lexicon Iconographicum Mythologiae Classicae* (Zurich, 1981–) is an immensely rich survey of works featuring figures from Graeco-Roman myth and religion; and *Pompei: pitture e mosaici* (Rome, 1990–1999) documents nearly all the known paintings and mosaics of Pompeii.

As for ancient sources, there can hardly be a literary text of the Roman period which does not have some bearing on art; but see especially: Cicero, *Verrine Orations* (*In Verrem*); Vitruvius, *On Architecture* (*De Architectura*); Pliny the Elder, *Natural History* (*Naturalis Historia*); Dio Chrysostom, *Olympian Oration* (*Oratio XII*); Pausanias, *Description of Greece* (*Hellados periegesis*). Many more sources are reproduced and discussed in Pollitt 1983.

THE CHARACTER OF THE ART-HISTORICAL LITERATURE

To experience the various kinds of 'social-historical' approach to Roman art, one could start with many of the texts cited throughout this book, and notably Clarke

2003, Kampen 1981b, Kampen 1995 (a general, methodological essay), Leach 2004, Zanker 1988b, Wallace-Hadrill 1994, and most recently, the articles in D'Ambra and Métraux 2006. Once again D'Ambra 1998 offers an overview of Roman art as seen in this perspective, and Smith 2002 is an excellent introductory essay in methodology. It is always interesting to note the differences in material, methods, and arguments employed by authors who might be labelled variously as 'historians', 'archaeologists', or 'art historians' (most of the above fall into the last category). More generally, Wolff 1993 is a well-established textbook introducing theoretical approaches to the social production of art (but not addressing antiquity), while Burke 2001 is a more down-to-earth introduction to the historical use of images.

In reality there are now few books and articles in the field which do not betray some influence from the social history of art. But naturally the basic publication of material still absorbs much energy. In the century or more since Roman art emerged as a discrete field of scholarship, there have been thousands of empirical studies of individual works or groups of objects. These include the documentation of excavations, museum catalogues, and journal articles publishing new discoveries or analysing old ones. Such work continues, along with the gradual growth of corpora like the *Corpus Signorum Imperii Romani* (mainly on Roman provincial sculpture) or *The Roman Mosaics of Britain* (commenced 2002), or the venerable *Die antiken Sarkophagreliefs*. There is much more of this work to be done. However, it must also be acknowledged that primary works of publication have not been without some serious flaws. Classical archaeologists are especially prone to wishful (and wilful) thinking and unfounded assumptions as they try to make attractive sense of the perplexing fragments at their disposal.

So besides the inevitable, endless task of re-evaluating the material and advancing new ideas, a burgeoning literature is devoted largely to debunking myths that have become firmly established and passed on unquestioned among scholars, as 'factoids'. Petersen 2006 (cited in Chapter Two), which tackles dubious assumptions about freedmen and their artistic patronage, is a very good example of this kind of study.

In recent years, however, there has been more and more literature that seeks not only to question what others have argued, but fundamentally to change the terms of debate. It has been influenced by the social history of art in other disciplines, but also reflects a weakening of divisions between sub-disciplines with, for example, ancient historians and scholars of Latin and Greek literature taking an increased interest in visual material (e.g. Henderson 1996). Jas Elsner's work (e.g. Elsner 1995; Elsner 1996b; Elsner 2007) is perhaps representative of a generation of Roman art historians who have, rather eclectically, embraced theoretical models, particularly post-modern perspectives, applying them to familiar questions or works of art. For instance, Elsner considers ancient cultures of viewing (rather than purely formal characteristics of the works themselves or the intentions of artists), and the relationship between visual imagery and texts. Sometimes such scholarship has been attacked for its speculative nature and its tendency to play with ideas as much as seeking the 'right answer'. It has

occasionally been criticised for allegedly lacking empirical rigour and for being 'theoretical' (though in fact we have to look elsewhere – e.g. Tanner 2000 – for systematic theorising on Roman art). There is indeed a gulf between these sorts of works and traditional, positivistic, and empirical treatments of Roman art, yet it is also worth remembering that the subject, perhaps because of its inherent problems (such as the difficulty of defining or characterising Roman art), has always stimulated ambitious, provocative and, for that matter, theoretical ideas. Two of the foundational texts in the historiography of Roman art, Wickhoff 1900[1] and Riegl 1901, are still regarded as major contributions not only to classical art history, but to cultural history in general.

[1] Originally published in German in 1895, as an appendage to a facsimile of the Vienna Genesis manuscript – *Die Wiener Genesis*. Its English translation was due to E. Strong, herself a pioneer of Roman art history.

Bibliography

Alcock, S. E., J. F. Cherry, and J. Elsner (eds.) (2001) *Pausanias: Travel and Memory in Roman Greece* (Oxford)

Aldhouse-Green, M. (2003) 'Alternative Iconographies: Metaphors of Resistance in Romano-British Cult-Imagery', in Noelke (2003), 39–48

(2004) *An Archaeology of Images: Iconology and Cosmology in Iron Age and Roman Europe* (London)

Alföldy, G. G. (1979) 'Bildprogramme in den römischen Städten des Conventus Tarraconensis: das Zeugnis der Statuenpostamenta', in A. Blanco et al. (eds.), *Homenaje a Garcia y Bellido*, vol. 4 (Madrid), 177–275

(1985a) *Römische Statuen in Venetia et Histria: epigraphische Quellen* (Heidelberg)

(1985b) *The Social History of Rome*, transl. D. Braund and F. Pollock (London and Sydney)

Allison, P. M. (1995) 'Painter-Workshops or Decorator's Teams?', *Mededelingen van het Nederlands Instituut te Rome (Antiquity)* 54: 98–108

(2001) 'Using the Material and Written Sources: Turn of the Millennium Approaches to Roman Domestic Space', *AJA* 105: 181–208

Anderson, J. C. (1997) *Roman Architects and Society* (Baltimore and London)

Andreau, J. (1974) *Les affaires de Monsieur Jucundus* (Rome)

Angelicoussis, E. (1984) 'The Panel Reliefs of Marcus Aurelius', *RM* 91: 141–205

Arafat, K. W. (1997) *Pausanias' Greece: Ancient Artists and Roman Rulers* (Cambridge)

Balty, J. (1977) *Mosaïques antiques de Syrie* (Brussels)

Barthes, R. (1993) *Mythologies*, selected and transl. by A. Lavers (London)

Bartman, E. (1988) '*Decor et duplicatio*: Pendants in Roman Sculptural Display', *AJA* 92: 211–25

(1991) 'Sculptural Collecting and Display in the Private Realm', in Gazda (1991), 71–88

(1999) *Portraits of Livia: Imaging the Imperial Woman in Augustan Rome* (Cambridge)

(2001) 'Hair and the Artifice of Female Adornment', *AJA* 105: 1–25

Barton, T. S. (1994) *Power and Knowledge: Astrology, Physiognomics, and Medicine under the Roman Empire* (Ann Arbor, MI)

(1995) 'Augustus and Capricorn: Astrological Polyvalency and Imperial Rhetoric', *JRS* 85: 33–51

Bauer, F. A. (1996) *Stadt, Platz und Denkmal in der Spätantike: Untersuchungen zur Ausstattung des öffentlichen Raums in den spätantiken Städten Rom, Konstantinopel und Ephesos* (Mainz)

Baxandall, M. (1980) *The Limewood Sculptors of Renaissance Germany* (New Haven, CT and London)

Beard, M. and J. Henderson (2001) *Classical Art: From Greece to Rome* (Oxford and New York)

Beard, M., J. North and S. Price (1998) *Religions of Rome*, 2 vols. (Cambridge)

Becatti, G. (1951) *Arte e gusto negli scrittori latini* (Florence)
(1957) *La colonna di Marco Aurelio* (Rome)

Beck, R. (1984) 'Mithraism Since Franz Cumont', *ANRW* II 17.4: 2002–2115

Bell, A. A. (1989) 'A Note on Revision and Authenticity in Pliny's Letters', *American Journal of Philology* 11: 460–6

Bell, H. I. (1924) *Jews and Christians in Egypt: The Jewish Troubles in Alexandria and the Athanasian Controversy, Illustrated by Texts from Greek Papyri in the British Museum* (London)

Berenson, B. (1954) *The Arch of Constantine: or, The Decline of Form* (London)

Bergamasco, M. (1995) 'Le δι δαεκαλικαί nella ricerca attuale', *Aegyptus* 75: 95–167

Bergmann, B. (1991) 'Painted Perspectives of a Villa Visit: Landscape as Status and Metaphor', in Gazda (1991), 49–70

Bergmann, M. (1999) *Chiragan, Aphrodisias, Konstantinopel: zur mythologischen Skulptur der Spätantike* (Wiesbaden)

Bevan, E. R. (1940) *Holy Images: An Inquiry into Idolatry and Image-Worship in Ancient Paganism and in Christianity* (London)

Bianchi Bandinelli, R. (1950) 'Il "Maestro delle Imprese di Traiano"', in R. Bianchi Bandinelli, *Storicità dell'arte classica*, 2nd edn (Florence), 209–228 (reprinted from *Le Arti* 2 (1939), 325ff)
(1961a) 'Archeologia e cultura', in R. Bianchi Bandinelli, *Archeologia e cultura* (Milan and Naples), 3–45
(1961b) 'La crisi artistica della fine del mondo antico', in R. Bianchi Bandinelli, *Archeologia e cultura* (Milan and Naples), 189–233
(1967) 'Arte plebeia', *Dialoghi di Archeologia* 1: 7–19
(1970) *Rome: The Centre of Power. Roman Art to AD 200*, transl. P. Green (London)
(1971) *Rome: The Late Empire. Roman Art AD 200–400*, transl. P. Green (London)

Bieber, M. and G. Rodenwaldt (1911) 'Die Mosaiken des Dioskurides von Samos', *JDAI* 26: 1–22

Birley, A. R. (1999) 'A New Governor of Britain (20 August 127): L. Trebius Germanus', *ZPE* 124: 243–8

Borg, B. E. (1996) *Mummienporträts: Chronologie und kultureller Kontext* (Mainz)

Boschung, D. (2002) *Gens Augusta: Untersuchungen zu Aufstellung, Wirkung und Bedeutung der Statuengruppen des julisch-claudischen Kaiserhauses* (Mainz)

Botti, G. and P. Romanelli (1951) *Le sculture del Museo Gregoriano Egizio* (Vatican)

Bourdieu, P. (1977) *Outline of a Theory of Practice*, transl. R. Nice (Cambridge)

Bowersock, G. W. (1990) *Hellenism in Late Antiquity* (Cambridge)
Bradley, K. (1994) *Slavery and Society at Rome* (Cambridge)
Brendel, O. J. (1979) *Prolegomena to the Study of Roman Art* (New Haven, CT and London) (mainly reprint of article in *MAAR* 21 (1953): 7–73)
Brilliant, R. (1974) *Roman Art from the Republic to Constantine* (London)
 (1984) *Visual Narratives: Storytelling in Etruscan and Roman Art* (Ithaca, NY and London)
Brown, P. R. L. (1971) *The World of Late Antiquity: AD 150–750* (London)
Brubaker, R. and F. Cooper (2000) 'Beyond "Identity"', *Theory and Society* 29: 1–47
Buonopane, A. (1998) '*Statuarius*: un nuovo documento epigrafico', *ZPE* 120: 292–4
Burford, A. (1972) *Craftsmen in Greek and Roman Society* (London)
Burke, P. (1992) *The Fabrication of Louis XIV* (New Haven, CT and London)
 (2001) *Eyewitnessing: The Uses of Images as Historical Evidence* (London)
Busch, A. W. (2003) 'Von der Provinz ins Zentrum – Bilder auf den Grabdenkmäler einer Elite-Einheit', in Noelke (2003), 678–94
Butterworth, A. and R. Laurence (2005) *Pompeii: The Living City* (London)
Calabi Limentani, I. (1958) *Studi sulla società romana: il lavoro artistico* (Milan and Varese)
Carroll, M. (2006) *Spirits of the Dead: Roman Funerary Commemoration in Western Europe* (Oxford)
Castriota, D. (1995) *The Ara Pacis Augustae and the Imagery of Abundance in Later Greek and Early Roman Imperial Art* (Princeton, NJ)
Ciancio Rossetto, P. (1973) *Il sepolcro del fornaio Marco Virgilio Eurisace a Porta Maggiore* (Rome)
Cichorius, C. (1927) 'Zu römischen Malern', *Rheinisches Museum für Philologie* 1927: 325–7
Claridge, A. (1993) 'Hadrian's Column of Trajan', *JRA* 6: 5–22
 (1998) *Rome: An Oxford Archaeological Guide* (Oxford and New York)
 (1999), review of Conlin 1997, *The Classical Review* 49: 528–30
Clarke, J. R. (1991) *The Houses of Roman Italy, 100 B.C.–A.D. 250: Ritual, Space, and Decoration* (Berkeley, Los Angeles, and London)
 (1998) *Looking at Lovemaking: Constructions of Sexuality in Roman Art, 100 B.C.–A.D. 250* (Berkeley, Los Angeles, and London)
 (2003) *Art in the Lives of Ordinary Romans: Visual Representation and Non-Elite Viewers in Italy, 100 B.C.–A.D. 315* (Berkeley, Los Angeles, and London)
Clarke, T. J. (1974) 'The Conditions of Artistic Creation', *Times Literary Supplement* 24 May, 1974: 561–2
Coarelli, F. (2000) *The Column of Trajan* (Rome)
 (ed.) (1980) *Artisti e artigiani in Grecia: guida storica e critica* (Rome and Bari)
Coleman, K. (ed.) (1988) *Statius* Silvae *IV* (edition with English translation and commentary) (Oxford)
Colledge, M. A. R. (1976) *The Art of Palmyra* (London)
Collingwood, R. G. and J. N. L. Myres (1937) *Roman Britain and the English Settlements* (Oxford)

Conlin, D. A. (1997) *The Artists of the Ara Pacis: The Process of Hellenization in Roman Relief Sculpture* (Chapel Hill, NC)

Cornell, T. J. (1987) 'Artists and Patrons', in T. J. Cornell, M. H. Crawford, and J. A. North (eds.), *Art and Production in the World of the Caesars* (Milan), 17–35

Coulton, J. J. (1977) *Greek Architects at Work: Problems of Structure and Design* (Ithaca, NY)

Crawford, M. (1983) 'Roman Imperial Coin Types and the Formation of Public Opinion', in C. N. L. Brooke et al. (eds.), *Studies in Numismatic Method Presented to Philip Grierson* (Cambridge), 47–64

Croisille, J.-M. (ed.) (1997) *Pline l'ancien. Histoire naturelle. Livre XXXV, La peinture* (text, transl. and introduction) (Paris)

Dacos, N. (1968) 'Fabullus et l'autre peintre de la Domus Aurea', *Dialoghi di Archeologia* 2: 210–26

D'Ambra, E. (1996) 'The Calculus of Venus: Nude Portraits of Roman Matrons', in N. B. Kampen (ed.), *Sexuality in Ancient Art: Near East, Egypt, Greece, and Italy* (Cambridge), 219–32

(ed.) (1993) *Roman Art in Context: An Anthology* (Englewood Cliffs, NJ)

(1998) *Art and Identity in the Roman World* (London)

D'Ambra, E. and G. P. R. Métraux (eds.) (2006) *The Art of Citizens, Soldiers and Freedmen in the Roman World* (Oxford)

D'Arms, J. H. (1981) *Commerce and Social Standing in Ancient Rome* (Cambridge, MA and London)

Davies, G. (2005), 'What Made the Roman Toga *virilis?*', in L. Cleland, M. Harlow, and L. Llewellyn-Jones (eds.), *The Clothed Body in the Ancient World* (Oxford), 121–30

Della Corte, M. (1965) *Case ed abitanti di Pompei*, 3rd edn (Naples)

Dillon, S. (2006) *Ancient Greek Portrait Sculpture: Contexts, Subjects, and Styles* (Cambridge)

Dodge, H. and J. Ward-Perkins (1992) *Marble in Antiquity: Collected Papers of J. B. Ward-Perkins* (London)

Donderer, M. (1989) *Die Mosaizisten der Antike und ihre wirtschaftliche und soziale Stellung* (Erlangen)

(1996) *Die Architekten der späten römischen Republik und Kaiserzeit: epigraphische Zeugnisse* (Erlangen)

Donohue, A. A. (1988) *Xoana and the Origins of Greek Sculpture* (Atlanta, GA)

(1997) 'The Greek Images of the Gods', *Hephaistos* 15: 31–45

Doxiadis, E. (1995) *The Mysterious Fayum Portraits: Faces from Ancient Egypt* (London)

Dunbabin, K. M. D. (1978) *The Mosaics of Roman North Africa: Studies in Iconography and Patronage* (Oxford)

(1986) 'Sic erimus cuncti . . . The Skeleton in Graeco-Roman Art', *JDAI* 101: 185–255

(1999) *Mosaics of the Greek and Roman World* (Cambridge)

(2003) *The Roman Banquet: Images of Conviviality* (Cambridge)

Duncan-Jones, R. (1982) *The Economy of the Roman Empire: Quantitative Studies*, 2nd edn (Cambridge)

Duthoy, R. (1978) 'Les Augustales', *ANRW* II 16.2: 1254–309

Eastmond, A. et al. (eds.) (2006) *The Road to Byzantium: Luxury Arts of Antiquity* (London)

Eastmond, A. and P. C. N. Stewart (2006) 'Ancient Classicism in Retrospect', in Eastmond (2006), 75–81

Eck, W. (1972) 'Die Familie der Volusii Saturnini in neuen Inschriften aus Lucus Feroniae', *Hermes* 100: 461–84

 (1996) 'Epigrafi e costruzioni sepolcrali nella necropoli sotto S. Pietro: a proposito del valore di messaggio delle iscrizioni funebri nel contesto dei complessi sepolcrali', in W. Eck, *Tra epigrafia, prosopografia e archeologia: scritti scelti, rielaborati ed aggiornati* (Rome), 251–69

Eisner, M. (1986) *Zur Typologie der Grabbauten im Suburbium Roms* (*Römische Mitteilungen* suppl. 26) (Mainz)

Eliav, Y. (2000) 'The Roman Bath as a Jewish Institution: Another Look at the Encounter between Judaism and Greco-Roman Culture', *Journal for the Study of Judaism* 31: 416–54

Elsner, J. (1994) 'Constructing Decadence: The Representation of Nero as Imperial Builder', in J. Elsner and J. Masters (eds.), *Reflections of Nero: Culture, History and Representation* (London), 112–27

 (1995) *Art and the Roman Viewer* (Cambridge)

 (1996a) 'Image and Ritual: Reflections on the Religious Appreciation of Classical Art', *Classical Quarterly* NS 46: 515–31

 (1996b) 'Inventing Imperium: Texts and the Propaganda of Monuments in Augustan Rome', in Elsner (1996c), 32–53

 (ed.) (1996c) *Art and Text in Roman Culture* (Cambridge)

 (1998a) 'Art and Architecture', in A. Cameron and P. Garnsey (eds.), *The Cambridge Ancient History*, vol. XIII, *The Late Empire A.D. 337–425* (Cambridge), 736–61

 (1998b) *Imperial Rome and Christian Triumph: The Art of the Roman Empire AD 100–450* (Oxford and New York)

 (2000) 'From the Culture of *Spolia* to the Cult of Relics: The Arch of Constantine and the Genesis of Late Antique Forms', *PBSR* 68: 149–84

 (2003) 'Archaeologies and Agendas: Reflections on Late Ancient Jewish Art and Early Christian Art', *JRS* 93: 114–28

 (2004) 'Late Antique Art: The Problem of the Concept and the Cumulative Aesthetic', in S. Swain and M. Edwards (eds.), *Approaching Late Antiquity: The Transformation from Early to Late Empire* (Oxford), 271–308

 (2007) *Roman Eyes: Visuality and Subjectivity in Art and Text* (Princeton, NJ and Oxford)

Erim, K. T. and J. Reynolds (1989) 'Sculptors of Aphrodisias in the Inscriptions of the City', in N. Basgelen and M. Lugal (eds.), *Festschrift für Jale Inan* (Istanbul), 517–38

Evans, E. C. (1969) *Physiognomics in the Ancient World* (Philadelphia)

Evans, J. D. (1992) *The Art of Persuasion: Political Propaganda from Aeneas to Brutus* (Ann Arbor, MI)

Evers, C. (1994) *Les portraits d'Hadrien: typologie et ateliers* (Brussels)

Feeney, D. (1998) *Literature and Religion at Rome: Cultures, Contexts, and Beliefs* (Cambridge)

Felletti Maj, B. M. (1977) *La tradizione italica nell'arte romana* (Rome)

Fergola, L. and M. Pagano (1998) *Oplontis: le splendide ville romane di Torre Annunziata* (Torre del Greco)

Fernie, E. (1995) *Art History and its Methods: A Critical Anthology* (London)

Finney, P. C. (1994) *The Invisible God: The Earliest Christians on Art* (New York and Oxford)

Fittschen, K. (1972) 'Das Bildprogramm des Trajansbogens zu Benevent', *Archäologischer Anzeiger* 87: 742–88

Flower, H. (1996) *Ancestor Masks and Aristocratic Power in Roman Culture* (Oxford)

Forbis, E. (1996) *Municipal Virtues in the Roman Empire: The Evidence of Italian Honorary Inscriptions* (Stuttgart and Leipzig)

Freedberg, D. (1989) *The Power of Images: Studies in the History and Theory of Response* (Chicago)

Fröhlich, T. (1991) *Lararien- und Fassadenbilder in den Vesuvstadten: Untersuchungen zur 'Volkstümlichen' pompejanischen Malerei* (Mainz)

Fuchs, W. (1963) *Der Schiffsfund von Mahdia* (Tübingen)

 (1973) 'Die Bildgeschichte der Flucht des Aeneas', *ANRW* I 4: 615–32

Furtwängler, A. (1893) *Meisterwerke der griechischen Plastik: kunstgeschichtliche Untersuchungen* (Leipzig)

Galinsky K. (1996) *Augustan Culture: An Interpretive Introduction* (Princeton, NJ)

Galli, M. (2002) *Die Lebenswelt eines Sophisten: Untersuchungen zu den Bauten und Stiftungen des Herodes Atticus* (Mainz)

Garnsey, P. and R. Saller (1987) *The Roman Empire: Economy, Society and Culture* (London)

Gauer, W. (1974) 'Zum Bildprogramm des Trajansbogen von Benevent', *JDAI* 89, 308–35

Gazda, E. K. (1973) 'Etruscan Influence in the Funerary Reliefs of Late Republican Portraiture', *ANRW* I 4: 855–70

 (ed.) (1991) *Roman Art in the Private Sphere: New Perspectives on the Architecture and Decor of the Domus, Villa, and Insula* (Ann Arbor, MI)

 (ed.) (2002) *The Ancient Art of Emulation: Studies in Artistic Originality and Tradition from the Present to Classical Antiquity* (Ann Arbor, MI)

Gell, A. (1998) *Art and Agency: An Anthropological Theory* (Oxford)

George, M. (2006) 'Social Identity and the Dignity of Work in Freedmen's Reliefs', in E. D'Ambra and G. P. R. Métraux (2006), 19–29

Giuliani, L. (1986) *Bildnis und Botschaft: hermeneutische Untersuchungen zur Bildniskunst der römischen Republik* (Frankfurt)

Giuliano, A. (1953) 'Iscrizioni romane di pittori', *Archeologia Classica* 5: 263–70

Gleason, M. W. (1995) *Making Men: Sophists and Self-Representation in Ancient Rome* (Princeton, NJ)

Gleason, P. (1983) 'Identifying Identity: A Semantic History', *Journal of American History* 69: 910–31

Gonzáles, J. (1984) 'Tabula Siarensis, Fortunales Siarenses et Municipia Civium Romanorum', *ZPE* 55: 55–100

Goodlett, V. C. (1991) 'Rhodian Sculpture Workshops', *AJA* 95: 669–81

Gordon, R. L. (1979) 'The Real and the Imaginary: Production and Religion in the Graeco-Roman World', *Art History* 2: 5–34

 (1990) 'The Veil of Power: Emperors, Sacrificers and Benefactors', in M. Beard and J. North (eds.), *Pagan Priests: Religion and Power in the Ancient World* (London), 201–31

 (1996) *Image and Value in the Graeco-Roman World* (Aldershot and Brookfield, VT)

Grabar, A. (1967) *The Beginnings of Christian Art, 200–395* (London)

 (1969) *Christian Iconography: A Study of its Origins* (London)

Graser, E. R. (1940) Appendix, in T. Frank, *An Economic Survey of Ancient Rome*, vol. 5 (Baltimore)

Green, M. (1998) 'God in Man's Image: Thoughts on the Genesis and Affiliations of Some Romano-British Cult Imagery', *Britannia* 29: 17–30

Gregory, A. P. (1994) ' "Powerful Images": Responses to Portraits and the Political Uses of Images in Rome', *JRA* 7: 80–99

Gruen, E. S. (1992) *Culture and National Identity in Republican Rome* (Ithaca, NY)

Guzzo, P. G. (ed.) (2006) *Argenti a Pompei* (Milan)

Habicht, C. (1998) *Pausanias' Guide to Ancient Greece*, 2nd edn (Berkeley, Los Angeles, and London)

Hales, S. (2003) *The Roman House and Social Identity* (Cambridge)

Hall, J. (1999) *The World as Sculpture: The Changing Status of Sculpture from the Renaissance to the Present Day* (London)

Hallett, C. (1995) 'Kopienkritik and the Works of Polykleitos', in W.G. Moon (ed.), *Polykleitos, the Doryphoros and Tradition* (Madison, WI), 121–60

 (2005a) review of P. Zanker and B. C. Ewald, *Mit Mythen leben: die Bilderwelt der römischen Sarkophage*, in *Art Bulletin* 87: 157–60

 (2005b) *The Roman Nude: Heroic Portrait Statuary 200 BC–AD 300* (Oxford)

Hammond, M. (1957) 'Composition of the Senate, A.D. 68–235', *JRS* 47: 4–81

Hannestad, N. (1986) *Roman Art and Imperial Policy* (Aarhus)

Hassel, F. J. (1966) *Der Trajansbogen in Benevent: ein Bauwerk des römischen Senates* (Mainz)

Hedrick, C. W. (2000) *History and Silence: Purge and Rehabilitation of Memory in Late Antiquity* (Austin, TX)

 (2006) *Ancient History: Monuments and Documents* (Malden, MA, Oxford and Carlton, Victoria)

Henderson, J. (1996) 'Footnote: Representation in the *Villa of the Mysteries*', in Elsner (1996c), 234–76

Henig, M. (1983a) 'The Luxury Arts: Decorative Metalwork, Engraved Gems and Jewellery', in Henig (1983b), 139–65

 (ed.) (1983b) *A Handbook of Roman Art: A Survey of the Visual Arts of the Roman World* (London)

(1995) *The Art of Roman Britain* (London)

Henig, M. and M. Vickers (eds.) (1993) *Cameos in Context: The Benjamin Zucker Lectures, 1990* (Oxford)

Héron de Villefosse, A. (*c.* 1895) *Le Trésor d'argenterie de Boscoreale (près de Pompei)* (Paris)

Hesberg, H. von (1992) *Römische Grabbauten* (Darmstadt)

Hesberg, H. von and P. Zanker (eds.) (1987) *Römische Gräberstrassen: Selbstdarstellung, Status, Standard* (Munich)

Hiesinger, U. W. (1975) 'The Portraits of Nero', *AJA* 79: 113–24

Hill, P. V. (1989) *The Monuments of Ancient Rome as Coin Types* (London)

Hingley, R. (2005) *Globalizing Roman Culture: Unity, Diversity and Empire* (London and New York)

Hoff, M. C. and S. I. Rotroff (eds.) (1997) *The Romanization of Athens: Proceedings of an International Conference held at Lincoln, Nebraska (April 1996)* (Oxford)

Holliday, P. J. (ed.) (1993) *Narrative and Event in Ancient Art* (Cambridge)

Holliday, P.J. (2002) *The Origins of Roman Historical Commemoration in the Visual Arts* (Cambridge)

Hölscher, T. (1984) *Staatsdenkmal und Publikum: vom Untergang der Republik bis zur Festigung des Kaisertums in Rom* (Konstanz)

(1987) *Römische Bildsprache als semantisches System* (Heidelberg)

(2004) *The Language of Images in Roman Art*, transl. A. Snodgrass and A. Künzl-Snodgrass, with Foreword by J. Elsner (Cambridge)

Huskinson, J. (1994) *Roman Sculpture from Eastern England* (Corpus Signorum Imperii Romani, Great Britain vol. I, fasc. 8) (Oxford)

Imhoof-Blumer, F. and P. Gardner (1964) *Ancient Coins Illustrating Lost Masterpieces of Greek Art: A Numismatic Commentary on Pausanias* (based on articles in *Journal of Hellenic Studies* 6–8 (1885–1887); new edn. enlarged by A. N. Oikonomides) (Chicago)

Jacobson, D. M. and M. P. Weitzman (1992) 'What Was Corinthian Bronze?', *AJA* 96: 237–47

Jashemski, W. F. (1979) *The Gardens of Pompeii, Herculaneum and the Villas Destroyed by Vesuvius*, vol. I (New Rochelle, NY)

Jensen, R. M. (2000) *Understanding Early Christian Art* (London)

Jex-Blake, K. and E. Sellers (1976) *The Elder Pliny's Chapters on the History of Art* (Chicago) (reprint of 1896 edition)

Johns, C. (1990) 'Research on Roman Silver Plate', *JRA* 3: 28–43

(2003a) 'Art, Romanisation, and Competence', in Scott and Webster (2003), 9–23

(2003b) 'Romano-British Sculpture: Intention and Execution', in Noelke (2003), 27–38

Johnson, A. C., P. R. Coleman-Norton, and F. C. Bourne (1961) *Ancient Roman Statutes: A Translation, with Introduction, Commentary, Glossary, and Index* (Austin, TX)

Jordanova, L. (2000) *History in Practice* (London)

Joshel, S. (1992) *Work, Identity, and Legal Status at Rome: A Study of the Occupational Inscriptions* (Norman, OK and London)

Kampen, N. B. (1981a) 'Biographical Narration and Roman Funerary Art', *AJA* 85: 47–58

 (1981b) *Image and Status: Roman Working Women in Ostia* (Berlin)

 (1995) 'On Not Writing the History of Roman Art', *Art Bulletin* 77: 375–8

Kiilerich, B. (1993) *Late Fourth Century Classicism in the Plastic Arts: Studies in the So-Called Theodosian Renaissance* (Odense)

Kinney, D. (1997) 'Spolia: *Damnatio* and *Renovatio memoriae*', *MAAR* 42: 117–48

Kleiner, D. E. E. (1977) *Roman Group Portraiture: The Funerary Reliefs of the Late Republic and Early Empire* (New York)

 (1988) 'Roman Funerary Art and Architecture: Observations on the Significance of Recent Studies', *JRA* 1: 115–19

 (1992) *Roman Sculpture* (New Haven, CT and London)

Kleiner, D. E. E. and S. B. Matheson (eds.) (2000) *I Claudia II: Women in Roman Art and Society* (Austin)

Kleiner, F. S. and C. J. Mamiya (2003) *Gardner's Art Through the Ages: The Western Perspective* (Belmont, CA)

Koch, G. (1993) *Sarkophage der römischen Kaiserzeit* (Darmstadt)

Koch, G. and H. Sichtermann (1982) *Römische Sarkophage* (Munich)

Kockel, V. (1983) *Die Grabbauten vor dem Herkulaner Tor in Pompeji* (Mainz am Rhein)

Kondoleon, C. (1995) *Domestic and Divine: Roman Mosaics in the House of Dionysos* (Ithaca, NY and London)

 (ed.) (2000) *Antioch: The Lost Ancient City* (Princeton, NJ and Worcester, MA)

Koortbojian, M. (1995) *Myth, Meaning, and Memory on Roman Sarcophagi* (Berkeley and London)

Kragelund, P., M. Moltesen, and J. S. Østergaard (2003) *The Licinian Tomb: Fact or Fiction?* (Copenhagen)

Kuttner, A. L. (1995) *Dynasty and Empire in the Age of Augustus: The Case of the Boscoreale Cups* (Berkeley, Los Angeles, and Oxford)

Kyrieleis, H. (1971) 'Der Kameo Gonzaga', *Bonner Jahrbücher* 171: 162–93

Lacroix, L. (1949) *Les reproductions de statues sur les monnaies grecques: la statuaire archaïque et classique* (Liège)

Lahusen, G. (1983) *Untersuchungen zur Ehrenstatue in Rom: literarische und epigraphische Zeugnisse* (Rome)

 (ed.) (1984) *Schriftquellen zum römischen Bildnis I: Textstellen, von den Anfängen bis zum 3. Jahrhundert n. Chr.* (Bremen)

Laurence, R. (1994) *Roman Pompeii: Space and Society* (London)

Lawn, N. (2001) 'Libertina nobilitas: Image and Aspiration in the Art of the Augustales' (unpublished MA dissertation, Courtauld Institute of Art)

Lawson, K., W. A. Oddy, and P. T. Craddock (1986) 'A Fragment of Life-Size Bronze Equine Statuary from Ashill, Norfolk', *Britannia* 17: 333–9

Leach, E. W. (2004) *The Social Life of Painting in Ancient Rome and on the Bay of Naples* (Cambridge)

Leader-Newby, R. (2004) *Silver and Society in Late Antiquity: Functions and Meanings of Silver Plate in the Fourth to Seventh Centuries* (Aldershot and Burlington, VT)

Leen, A. (1991) 'Cicero and the Rhetoric of Art', *American Journal of Philology* 112: 229–45

Lehmann-Hartleben, K. and E. C. Olsen (1942) *Dionysiac Sarcophagi in Baltimore* (New York and Baltimore)

Lepper, F. A. and S. Frere (1988) *Trajan's Column: A New Edition of the Cichorius Plates* (Gloucester)

Levi, A. (1931) *Sculture greche e romane del Palazzo Ducale di Mantova* (Rome)

Levick, B. (1982) 'Propaganda and the Imperial Coinage', *Antichthon* 16: 104–16

Ling, R. (1991) *Roman Painting* (Cambridge)
 (1998) *Ancient Mosaics* (London)
 (2000) 'Working Practice', in R. Ling (ed.), *Making Classical Art: Process and Practice* (Stroud and Charleston, SC), 91–107

Lippold, G. (1956) *Die Skulpturen des Vaticanischen Museums* Bd. III.2 (Berlin)

Loewy, E. (1885) *Inschriften griechischer Bildhauer* (Leipzig)

L'Orange, H. P. (1947) *Apotheosis in Ancient Portraiture* (Oslo)

Luni, M. (2001) *Statue di bronzo a Foro Sempronii e in città del versante medioadriatico* (Urbino)

MacMullen, R. (1980) 'Women in Public in the Roman Empire', *Historia* 29: 208–18

Maiuri, A. (1929) *Pompeii* (Novara)

Malbon, E. S. (1990) *The Iconography of the Sarcophagus of Junius Bassus* (Princeton, NJ and Oxford)

Martin, F. (1996) 'The Award of Civic Honorific Statues in Roman Italy, c. 31 BC–c. AD 500' (unpublished PhD thesis, University of London)

Marvin, M. (1993) 'Copying in Roman Sculpture: The Replica Series', in D'Ambra (1993), 161–88
 (1997) 'Roman Sculptural Reproductions, or Polykleitos: The Sequel', in A. Hughes and E. Ranfft (eds.), *Sculpture and its Reproductions* (London), 7–28

Mathews, T. F. (1993) *The Clash of Gods: A Reinterpretation of Early Christian Art*, revised edn (Princeton, NJ)

Mattingly, D. J. (ed.) (1995) *Dialogues in Roman Imperialism: Power, Discourse, and Discrepant Experience in the Roman Empire* (*JRA* supplement no. 23) (Portsmouth, RI)
 (2003) 'Family Values: Art and Power at Ghirza in the Libyan Pre-Desert', in Scott and Webster (2003): 153–70

Mattusch, C. C. (1994) 'Bronze Herm of Dionysos', in Salies et al. (1994), 431–50
 (2005) *The Villa dei Papiri at Herculaneum: Life and Afterlife of a Sculpture Collection* (Los Angeles)

Mau, A. (1882) *Geschichte der dekorativen Wandmalerei in Pompeji* (Berlin)
 (1896) 'Scavi di Pompei 1894–95. Reg. VI, Isola ad E della II', *RM* 11: 3–97

Mazzoleni, D. and U. Pappalardo (2004) *Domus: Wall Painting in the Roman House* (Los Angeles)

Megow, W.-R. (1987) *Kameen von Augustus bis Alexander Severus* (Berlin)

Mendel, G. (1912) *Catalogue des sculptures grecques, romaines et byzantines*, vol. 1 (Constantinople)

Meyboom, P. G. P. (1984) 'Fabullus démasqué', in J. A. de Weale et al. (eds.), *Om de tuin geleid: een feestbundel aangeboden aan prof. dr. W. J. Th. Peters ter gelegenheid van zijn vijfenzestigste verjaardag* (Nijmegen), 31–9

Millett, M. (1990) *The Romanization of Britain: An Essay in Archaeological Interpretation* (Cambridge)

Mols, S. T. A. M. and E. M. Moormann (1993–4) '*Ex parvo crevit*: proposta per una lettura iconografica della Tomba di Vestorius Priscus fuori Porta Vesuvio a Pompei', *Rivista di Studi Pompeiani* 6: 15–52

Moltesen, M. (2000) 'The Esquiline Group: Aphrodisian Sculptures in the Ny Carlsberg Glyptotek', *Antike Plastik* 27: 111–29

Moretti, G. (1948) *Ara Pacis Augustae* (Rome)

Morris, I. (1992) *Death-Ritual and Social Structure in Classical Antiquity* (Cambridge)

Mouritsen, H. (1997) 'Mobility and Social Change in Italian Towns during the Principate', in H. M. Parkins (ed.), *Roman Urbanism: Beyond the Consumer City* (London)

Müller, F. G. J. M. (1994) *The So-Called Peleus and Thetis Sarcophagus in the Villa Albani* (Amsterdam)

Murray, C. (1981) *Rebirth and Afterlife: A Study of the Transmutation of Some Pagan Imagery in Early Christian Funerary Art* (Oxford)

Muth, S. (1998) *Erleben von Raum – Leben im Raum: zur Funktion mythologischer Mosaikbilder in der römisch-kaiserzeitlichen Wohnarchitectur* (Heidelberg)

 (1999) 'Bildkomposition und Raumstruktur: zum Mosaik der "Grossen Jagd" von Piazza Armerina in seinem raumfunktionalen Kontext', *RM* 106: 189–212

Najbjerg, T. (2002) 'A Reconstruction and Reconsideration of the So-Called Basilica in Herculaneum', in T. McGinn et al., *Pompeian Brothels, Pompeii's Ancient History, Mirrors and Mysteries, Art and Nature at Oplontis, and the Herculaneum 'Basilica' (JRA* supplement no. 47) (Portsmouth, RI), 123–65

Neils, J. (2001) *The Parthenon Frieze* (Cambridge)

Neudecker, R. (1988) *Die Skulpturenausstattung römischer Villen in Italien* (Mainz)

Newby, Z. (2003) 'Art and Identity in Asia Minor', in Scott and Webster (2003), 192–213

Niemeyer, H. G. (1968) *Studien zur statuarischen Darstellung der römischen Kaiser* (Berlin)

Nock, A. D. (1946) 'Sarcophagi and Symbolism', *AJA* 50: 140–70; reprinted in Z. Stewart (ed.) (1972) *Essays on Religion and the Ancient World*, vol. 2 (Oxford), 606–41

Noelke, P. (1998) 'Grabreliefs mit Mahldarstellung in den germanisch-gallischen Provinzen – soziale und religiöse Aspekte', in P. Fasold et al. (eds.), *Bestattungssitte und kulturelle Identität: Grabanlagen und Grabbeigaben der frühen römischen Kaiserzeit in Italien und den Nordwest-Provinzen* (Cologne), 399–418

(ed.) (2003) *Romanisation und Resistenz in Plastik, Architektur und Inschriften der Provinzen des Imperium Romanum* (Mainz)

Nollé, J. and M. M. Roxan (1997) 'Militärdiplom für einen in Britannien entlassenen "Dacien" ', *ZPE* 117: 269–76

Oliver, A. (1996) 'Honors to Romans: Bronze Portraits', in C. C. Mattusch et al. (eds.), *The Fire of Hephaistos: Large Classical Bronzes from North American Collections* (Cambridge, MA): 138–60

Pagano, M. (1996) 'La nuova pianta della città e di alcuni edifici pubblici di Ercolano', *Cronache Ercolanesi* 26: 229–62

Pandermalis, D. (1971) 'Zur Programm der Statuenausstattung in der Villa dei Papiri', *AM* 86: 173–209

Patterson, J. R. (1992) 'The City of Rome: From Republic to Empire', *JRS* 82: 186–215

Peirce, P. (1989) 'The Arch of Constantine: Propaganda and Ideology in Late Roman Art', *Art History* 12: 387–418

Pekáry, T. (1985) *Das römische Kaiserbildnis in Staat, Kult und Gesellschaft, dargestellt anhand der Schriftquellen* (Berlin)

Perry, E. (2005) *The Aesthetics of Emulation in the Visual Arts of Ancient Rome* (Cambridge)

Petersen, L. H. (2003) 'The Baker, His Tomb, His Wife, and Her Breadbasket: The Monument of Eurysaces in Rome', *Art Bulletin* 85: 230–57

(2006) *The Freedman in Roman Art and Art History* (Cambridge)

Pfanner, M. (1989) 'Über das Herstellen von Porträts: ein Beitrag zu Rationalisierungsmassnahmen und Produktionsmechanismen von Massenware im späten Hellenismus und in der römischen Kaiserzeit', *JDAI* 104: 157–257

Pollini, J. (1987) *The Portraiture of Gaius and Lucius Caesar* (New York)

(1993) 'The Gemma Augustea: Ideology, Rhetorical Imagery, and the Creation of a Dynastic Narrative', in Holliday (1993), 258–98

Pollitt, J. J. (1974) *The Ancient View of Greek Art: Criticism, History and Terminology* (New Haven, CT)

(1978) 'The Impact of Greek Art on Rome', *TAPhA* 108: 155–74

(1983) *The Art of Rome, c. 753 B.C.–A.D. 337: Sources and Documents* (Cambridge and New York)

Poulsen, F. (1945) 'Talking, Weeping and Bleeding Sculptures: A Chapter of the History of Religious Fraud', *Acta Archaeologica* 16: 178–95

Poulsen, V. H. (1951) 'Nero, Britannicus and Others: Iconographical Notes', *Acta Archaeologica* 22: 119–35

Price, M. J. and B. L. Trell (1977) *Coins and their Cities: Architecture on the Ancient Coins of Greece, Rome, and Palestine* (London)

Price, S. R. F. (1984) *Rituals and Power: The Roman Imperial Cult in Asia Minor* (Cambridge)

Ramage, N. H. and A. Ramage (2004) *Roman Art: Romulus to Constantine*, 4th edn (Englewood Cliffs, NJ)

Rawson, E. (1975) 'Architecture and Sculpture: The Activities of the Cossutii', *PBSR* NS 43: 36–47

Reynolds, J. and L. Bacchielli (1996) 'Lucius Sosius Euthycles, *zographos* and *bouleutes*', *Libya Antiqua* n.s. 3: 45–50

Riccardi, L. A. (1998) 'The Mutilation of the Bronze Portrait of a Severan Empress from Sparta: "Damnatio Memoriae" or Christian Iconoclasm?', *AM* 113: 259–69

(2000) 'Uncanonical Imperial Portraits in the Eastern Roman Provinces: The Case of the Kanellopoulos Emperor', *Hesperia* 69: 105–32

Richardson, L. (2000) *A Catalog of Identifiable Figure Painters of Ancient Pompeii, Herculaneum, and Stabiae* (Baltimore and London)

Richter, G. M. A. (1965) *The Portraits of the Greeks*, 3 vols. (London) (also abridged and revised volume, ed. R. R. R. Smith (Ithaca, NY, 1984))

Ridgway, B. S. (1984) *Roman Copies of Greek Sculpture: The Problem of the Originals* (Ann Arbor, MI)

(1995) 'The Wreck off Mahdia, Tunisia and the Art-Market in Early 1st c. B.C.', *JRA* 8: 340–7

(2002) *Hellenistic Sculpture III: The Styles of ca. 100–31 B.C.* (Madison, WI)

Riegl, A. (1901) *Die Spätrömische Kunstindustrie* (Vienna) (= *Late Roman Art Industry*), transl. R. Winkes (Rome, 1985)

Riggs, C. (2005) *The Beautiful Burial in Roman Egypt: Art, Identity, and Funerary Religion* (Oxford)

Rockwell, P. (1991) 'Unfinished Statuary Associated with a Sculptor's Studio', in R. R. R. Smith and K. T. Erim (eds.), *Aphrodisias Papers 2: The Theatre, a Sculptor's Workshop, Philosophers, and Coin-Types* (*JRA* supplement no. 2) (Ann Arbor, MI), 127–43

Rodenwaldt, G. (1935) 'Über den Stilwandel in der antoninischen Kunst', *Abhandlungen der preussischen Akademie der Wissenschaften* (Philos.-Hist. Klasse) 3: 1–27

(1940) 'Römische Reliefs Vorstufen zur Spätantike', *JDAI* 55: 12–43

Romm, J. S. (1990) 'Wax, Stone, and Promethean Clay: Lucian as Plastic Artist', *Classical Antiquity* 9: 74–98

Rose, C. B. (1997a) *Dynastic Commemoration and Imperial Portraiture in the Julio-Claudian Period* (Cambridge)

(1997b) 'The Imperial Image in the Eastern Mediterranean', in S. E. Alcock (ed.), *The Early Roman Empire in the East* (Oxford), 108–120

Ryberg, I. S. (1967) *Panel Reliefs of Marcus Aurelius* (New York)

Salies, H. with H.-H. von Prittwitz und Gaffron and G. Bauchhenß (eds.) (1994) *Das Wrack: Der antike Schiffsfund von Mahdia*, 2 vols. (Cologne)

Saller, R. (2000) 'Status and Patronage', in A. K. Bowman, P. Garnsey, and D. Rathbone (eds.), *The Cambridge Ancient History*, 2nd edn, vol. XI, *The High Empire, A.D. 70–192* (Cambridge), 817–54

Scheid, J. and V. Huet (eds.) (2000) *La Colonne Aurélienne. Autour de la Colonne Aurélienne: geste et image sur la colonne de Marc Aurèle à Rome* (Turnhout)

Schmidt, E. E. (1973) *Die Kopien der Erechtheionkoren* (*Antike Plastik* 13) (Berlin)

Schollmeyer, P. (2005) *Römische Plastik: Eine Einführung* (Darmstadt)

Scholz, B. I. (1992) *Untersuchungen zur Tracht der römischen Matrona* (Cologne, Weimer, and Vienna)

Scott, S. (2000) *Art and Society in Fourth-Century Britain: Villa Mosaics in Context* (Oxford)

(2003) 'Provincial Art and Roman Imperialism: An Overview', in Scott and Webster (2003): 1–7

Scott, S. and J. Webster (eds.) (2003) *Roman Imperialism and Provincial Art* (Cambridge)

Segala, E. and I. Sciortino (1999) *Domus Aurea*, English edn (Milan)

Sehlmeyer, M. (1999) *Stadtrömische Ehrenstatuen der republikanischen Zeit: Historizität und Kontext von Symbolen nobilitären Standesbewusstseins* (Stuttgart)

Settis, S. (ed.) (1988) *La Colonna Traiana* (Turin)

Shear, T. L. (1981) 'Athens: From City-State to Provincial Town', *Hesperia* 50: 356–77

Sherk, R. K. (ed.) (1988) *The Roman Empire: Augustus to Hadrian* (Cambridge)

Simon, E. (1967) *Ara Pacis Augustae* (Tübingen)

Smith, R. R. R. (1981) 'Greeks, Foreigners, and Roman Republican Portraits', *JRS* 71: 24–38

(1985) 'Roman Portraits: Honours, Empresses, and Late Emperors', *Journal of Roman Studies* 75: 208–21

(1987) 'The Imperial Reliefs from the Sebasteion at Aphrodisias', *JRS* 77: 88–138

(1988a) *Hellenistic Royal Portraits* (Oxford)

(1988b) '*Simulacra Gentium*: The *Ethne* from the Sebasteion at Aphrodisias', *JRS* 78: 50–77

(1996) 'Typology and Diversity in the Portraits of Augustus', *JRA* 9: 30–47

(1998) 'Cultural Choice and Political Identity in Honorific Portrait Statues in the Greek East in the Second Century A.D.', *JRS* 88: 56–93

(1999) 'Late Antique Portraits in a Public Context: Honorific Statuary at Aphrodisias in Caria, A.D. 300–600', *JRS* 89: 155–89

(2002) 'The Use of Images: Visual History and Ancient History', in T. P. Wiseman (ed.), *Classics in Progress: Essays on Ancient Greece and Rome* (Oxford), 59–102

Smith, R. R. R. et al. (2006) *Roman Portrait Statuary from Aphrodisias* (*Aphrodisias* II: *Results of the Excavations at Aphrodisias in Caria Conducted by New York University*) (Mainz)

Sogliano, A. (1898) 'La Casa dei Vettii in Pompei', *Monumenti Antichi* 8: cols. 233–388

Spivey, N. J. (1995) 'Stumbling Towards Byzantium: The Decline and Fall of Late Antique Sculpture', *Apollo* 142(401): 20–3

Spyropoulos, G. (2001) *Drei Meisterwerke der griechischen Plastik aus der Villa des Herodes Atticus zu Eva/Loukou* (Frankfurt and New York)

Squarciapino, M. F. (1943) *La scuola di Afrodisia* (Rome)

Steiner, D. T. (2001) *Images in Mind: Statues in Archaic and Classical Greek Literature and Thought* (Princeton, NJ and Oxford)

Stemmer, K. (ed.) (1995) *Standorte: Kontext und Funktion antiker Skulptur* (Berlin)

Stevenson, J. (1978) *The Catacombs: Rediscovered Monuments of Early Christianity* (London)

Stewart, A. F. (1979) *Attika: Studies in Athenian Sculpture of the Hellenistic Age* (London)

Stewart, P. C. N. (2003) *Statues in Roman Society: Representation and Response* (Oxford)

 (2004) *Roman Art* (*Greece and Rome* New Surveys in the Classics no. 34) (Oxford)

 (2006) 'The Image of the Roman Emperor', in R. Maniura and R. Shepherd (eds.), *Presence: The Inherence of the Prototype within Images and Other Objects* (Aldershot and Burlington, VT), 243–58

 (2007a) 'Continuity and Tradition in Late Antique Perceptions of Portrait Statuary', in F. A. Bauer and C. Witschel (eds.), *Statuen und Statuensammlungen in der Spätantike – Funktion und Kontext* (Wiesbaden), 27–43

 (2007b) 'Gell's Idols and Roman Cult', in R. Osborne and J. Tanner (eds.), *Art's Agency and Art History* (Malden, MA and Oxford), 158–78

 (forthcoming, a) 'Baetyls as Statues? Cult Images in the Roman Near East', in Y. Eliav, E. Friedland, and S. Herbert (eds.), *The Sculptural Environment of the Roman Near East: Reflections on Culture, Ideology, and Power* (Leuven), 293–310

 (forthcoming, b) '*Totenmahl* Reliefs in the Roman Northern Provinces: A Case-Study in Imperial Sculpture'

Stichel, R. H. W. (1982) *Die römische Kaiserstatue am Ausgang der Antike: Untersuchungen zum plastischen Kaiserporträt seit Valentinian I (364-375 v. Chr.)* (Rome)

Stirling, L. M. (2005) *The Learned Collector: Mythological Statuettes and Classical Taste in Late Antique Gaul* (Ann Arbor, MI)

Strong, D. E. (1973) 'Roman Museums', in D. E. Strong (ed.), *Archaeological Theory and Practice: Essays Presented to Professor William Francis Grimes* (London), 247–64

 (1988) *Roman Art*, 2nd, revised edn (London)

Stuart, M. (1939) 'How Were Imperial Portraits Distributed throughout the Roman Empire?', *AJA* 43: 601–15

Stuart-Jones, H. (1912) *A Catalogue of the Ancient Sculptures Preserved in the Municipal Collections of Rome: The Sculptures of the Museo Capitolino* (Oxford)

Sydenham, E. A. (1920) *The Coinage of Nero* (London)

Takács, S. A. (1995) *Isis and Sarapis in the Roman World* (Leiden, New York, and Cologne)

Tanner, J. J. (1992) 'Art as Expressive Symbolism: Civic Portraits in Classical Athens', *Cambridge Archaeological Journal* 2: 167–190

 (1999) 'Culture, Social Structure and the Status of Visual Artists in Classical Greece', *PCPhS* 45: 136–75

(2000) 'Portraits, Power, and Patronage in the Late Roman Republic', *JRS* 90: 18–50

(ed.) (2003) *The Sociology of Art: A Reader* (London and New York)

(2006) *The Invention of Art History in Ancient Greece: Religion, Society and Artistic Rationalisation* (Cambridge)

Taylor, R. (2003) *Roman Builders: A Study in Architectural Practice* (Cambridge)

Thomas, A. (1995) *The Painter's Practice in Renaissance Tuscany* (Cambridge)

Thompson, M. L. (1960–1961) 'The Monumental and Literary Evidence for Programmatic Painting in Antiquity', *Marsyas* 9: 36–77

Torelli, M. (1982) *Typology and Structure of Roman Historical Reliefs* (Ann Arbor, MI)

(1997) ' "Ex his castra, ex his tribus replebuntur": The Marble Panegyric on the Arch of Trajan at Beneventum', in. D. Buitron-Oliver (ed.), *The Interpretation of Architectural Sculpture in Greece and Rome* (Washington, DC), 145–77

(1998) 'Il culto imperiale a Pompei', in S. A. Muscettola and G. Greco (eds.), *I culti della Campania Antica* (Rome), 245–70

Touchette, L.-A. (1995) *The Dancing Maenad Reliefs: Continuity and Change in Roman Copies* (London)

Toynbee, J. M. C. (1934) *The Hadrianic School: A Chapter in the History of Greek Art* (Cambridge)

(1951) *Some Notes on Artists in the Roman World*, Collection Latomus, 6 (Brussels)

(1964) *Art in Britain under the Romans* (London)

(1971) *Death and Burial in the Roman World* (London) (reprinted 1996)

Treggiari, S. (1969) *Roman Freedmen During the Late Republic* (Oxford)

Trimble, J. F. (2000) 'Replicating the Body Politic: The Herculaneum Women Statue Types in Early Imperial Italy', *JRA* 13: 41–68

(2002) 'Greek Myth, Gender, and Social Structure in a Roman House: Two Paintings of Achilles at Pompeii', in Gazda (2002), 225–48

Van Bremen, R. (1996) *The Limits of Participation: Women and Civic Life in the Greek East in the Hellenistic and Roman Periods* (Amsterdam)

Van Staten, F. T. (1981) 'Gifts for the Gods', in H. S. Versnel (ed.), *Faith, Hope and Worship: Aspects of Religious Mentality in the Ancient World* (Leiden), 65–151

Van Voorhis, J. A. (1998) 'Apprentices' Pieces and the Training of Sculptors at Aphrodisias', *JRA* 11: 175–192

Varner, E. R. (2000) (ed.) *From Caligula to Constantine: Tyranny and Transformation in Roman Portraiture* (Atlanta, GA)

(2004) *Mutilation and Transformation: Damnatio Memoriae and Roman Imperial Portraiture* (Leiden)

(2006) 'Reading Replications: Roman Rhetoric and Greek Quotations', *Art History* 29: 280–303

Vermeule, C. C. (1987) *The Cult Images of Imperial Rome* (Rome)

Veyne, P. (1988) 'Conduct without Belief and Works of Art without Viewers', *Diogenes* 143: 1–22

(1990) *Bread and Circuses: Historical Sociology and Political Pluralism*, abridged with introduction by O. Murray, transl. B. Pearce (London)

Vout, C. (2005) 'Antinous, Archaeology and History', *JRS* 95: 80–96

Waelkens, M. (1982) *Dokimeion: die Werkstatt der repräsentativen kleinasiatischen Sarkophage. Chronologie und Typologie ihrer Produktion* (Berlin)

Walker, S. (1990) *Catalogue of Roman Sarcophagi in the British Museum* (London)
 (1997) 'Athens under Augustus', in Hoff and Rotroff (1997), 67–80

Walker, S. and M. Bierbrier (1997) *Ancient Faces: Mummy Portraits from Roman Egypt* (London)

Wallace-Hadrill, A. (1981) 'The Emperor and his Virtues', *Historia* 30: 298–323
 (1986) 'Image and Authority in the Coinage of Augustus', *JRS* 76: 66–87
 (1990) 'Roman Arches and Greek Honours: The Language of Power at Rome', *PCPhS* 216: 143–81
 (1994) *Houses and Society in Pompeii and Herculaneum* (Princeton, NJ)

Warden, P. G. and D. G. Romano (1994) 'The Course of Glory: Greek Art in a Roman Context at the Villa of the Papyri at Herculaneum', *Art History* 17: 228–54

Ward-Perkins, J. B. (1981) *Roman Imperial Architecture*, 2nd edn (London)

Webster, J. (2003) 'Art as Resistance and Negotiation', in Scott and Webster (2003), 24–51

Whitehead, J. K. (1993) 'The "Cena Trimalchionis" and Biographical Narration in Roman Middle-Class Art', in Holliday (1993), 299–323

Whitmarsh, T. J. (2005) *The Second Sophistic* (Oxford)

Wickhoff, F. (1900) *Roman Art: Some of its Principles and their Application to Early Christian Painting*, transl. and ed. Mrs S. Arthur Strong (London and New York)

Wiegand, T. (1894) *Die puteolanische Bauinschrift sachlich erläutert* (Leipzig)

Wilson-Jones, M. (2000) *Principles of Roman Architecture* (New Haven, CT and London)

Wirth, T. (1983) 'Zum Bildprogramm der Räume n und p in der Casa dei Vettii', *RM* 90: 449–55

Witschel, C. (1995a) 'Römische Kaiserstatuen als Tempelkultbilder', in Stemmer 1995: 253–7
 (1995b) 'Römische Tempelkultbilder', in Stemmer 1995: 250–3
 (2002) 'Zum Problem der Identifizierung von munizipalen Kaiserkultstätten', *Klio* 84: 114–24

Wojcik, M. R. (1986) *La villa dei papiri ad Ercolano: contributo alla ricostruzione dell'ideologia della nobilitas tardorepubblicano* (Rome)

Wolff, J. J. (1993) *The Social Production of Art*, 2nd edn (London)

Wood, S. E. (1999) *Imperial Women: A Study in Public Images, 40 BC–AD 68* (Leiden, Boston, and Cologne)

Woolf, G. (1998) *Becoming Roman: The Origins of Provincial Civilization in Gaul* (Cambridge)

Wrede, H. (1981) *Consecratio in formam deorum: Vergöttlichte Privatpersonen in der römischen Kaiserzeit* (Mainz am Rhein)

(2001) *Senatorische Sarkophage Roms* (Mainz)

Zanker, P. (1968) *Forum Augustum II: Das Bildprogramm* (Tübingen)

(1975) 'Grabreliefs römischer Freigelassener', *JDAI* 90: 267–315

(1982) 'Herrscherbild und Zeitgesicht', in *Römisches Porträt: Wege zur Forschung eines gesellschaftlichen Phänomens* = *Wissenschaftliche Zeitschrift der Humboldt-Universität zu Berlin* 2/3: 307–312

(1983) *Provinzielle Kaiserporträts: zur Rezeption der Selbstdarstellung des Princeps* (Munich)

(1987) *Augustus und die Macht der Bilder* (Munich)

(1988a) 'Bilderzwang: Augustan Political Symbolism in the Private Sphere', in J. Huskinson, M. Beard, and J. Reynolds (eds.), *Image and Mystery in the Roman World* (Gloucester), 1–21

(1988b) *The Power of Images in the Age of Augustus*, transl. A. Shapiro (Ann Arbor, MI)

(1995) *The Mask of Socrates: The Image of the Intellectual in Antiquity*, transl. A. Shapiro (Berkeley, Los Angeles, and Oxford)

(1998) *Pompeii: Public and Private Life* (Cambridge, MA and London)

(2007) *Die römische Kunst* (Munich)

Zanker, P. and B. C. Ewald (2004) *Mit Mythen leben: die Bilderwelt der römischen Sarkophage* (Munich)

Zazoff, P. (1983) *Die antiken Gemmen* (Munich)

Zimmer, G. (1982) *Römische Berufsdarstellungen* (Berlin)

Index